splatter flicks

HOW TO MAKE LOW-BUDGET HORROR FILMS

sara caldwell

ALLWORTH PRESS
NEW YORK

To all those brave filmmakers
with a demented concept,
creative problem-solving skills,
and minimal production
budgets—embrace the horror!

10 09 08 07 06 5 4 3 2 1

Published by Allworth Press
An imprint of Allworth Communications, Inc.
10 East 23rd Street, New York, NY 10010

Cover design by Derek Bacchus
Interior design by Sharp Des!gns, Lansing, MI
Page composition/typography by SR Desktop Services, Ridge, NY
Cover photography: © Anthony Pepe/Demonic Pumpkins FX

ISBN: 1-58115-443-7

Library of Congress Cataloging-in-Publication Data
 Caldwell, Sara C.
 Splatter flicks: how to make a low budget horror film/Sara Caldwell.
 p. cm.
 Includes index.
 ISBN 1-58115-443-7 (pbk.)
 1. Horror films—Production and direction. 2. Low budget motion pictures.
 I. Title.

 PN1995.9.H6C35 2006
 791.43'6164—dc22

 2006016401

Printed in Canada

table of contents

acknowledgments

Thank you to Tad Crawford, publisher, and Nicole Potter-Talling, senior editor, of Allworth Press for their continued belief and encouragement in the development of my third book. As always, I greatly appreciate Michael Madole's efforts with the promotion, Jessica Rozler's immaculate and all-seeing eyes on copyediting and editorial suggestions, as well as all of the other Allworth staff for their exceptional support. Thanks also to my good friend Jerry Vasilatos of Nitestar Productions for his invaluable help with research.

My immense gratitude to the film professionals who generously shared their experience, insights, and snippets of horror: screenwriter Lisa Morton; filmmakers Michael Hein of MooDude Films, TJ Nordaker, co-director of *The Janitor*, Larry Fessenden of Glass Eye Pix, and Stevan Mena, writer/director of *Malevolence*; cinematographer Bud Gardner; production designer Katherine Bulovic; wardrobe designer Lynn McQuown; special effects artists Anthony Pepe of Demonic Pumpkins FX and Randy Cabral, special effects coordinator of the *Charmed* television series; editor Ross Byron; composer Vincent Gillioz; and distributor Alex Afterman of Heretic Films.

Many personal thanks to family and friends. To my parents, Robert and Pilar Coover, who raised me on the best of cinema, from the esoteric to the macabre, from very early in life; to my children, Dylan and Chloe, for sharing many a fun fright night on the couch with me; to Mark Conroy for accepting my darker side and loving my lighter one; and to my great gal pals Joni Brander, Cathleen Fox, April Victory, Jade Mansueto, Kerry Luby, and Sunni Boswell—you know why!

Thanks also to my colleagues at College of the Canyons for giving me the opportunity to educate and inspire a new generation of filmmakers and to my students for demonstrating that the passion for independently minded art (and horror) still lives on.

As in every other book I have written, I want to acknowledge Dr. Daniel F. Bassill, President and CEO of the Tutor/Mentor Connection in Chicago, Illinois. Dan battles the daily demons for children in extreme poverty and has striven for almost thirty years to show them a brighter path. As such, he is a rare hero not often found on the silver screen. Likewise is my former tutee, Isaiah Brooms, a remarkable young man who has crossed many dangerous bridges to find his place in the world. Similar to independent filmmaking, fulfilling dreams starting from the point of abject poverty is a long-term process that takes dedication, untold effort, and a dash of humility, qualities that make the end results well worth the journey.

Fifteen percent of royalties from this book are being donated to the Tutor/Mentor Connection (www.tutormentorconnection.org).

introduction

I was sixteen when my father took me to a screening of *Night of the Living Dead* with a warning that it was the scariest movie ever made. I had to admit that it was pretty damn scary, and more than two decades later I still cower at the opening graveyard scene. Thanks to my parents' broadminded outlook on life, I was weaned on diverse cinema and grew to love horror and science fiction. I watched almost every classic B-movie out there as a kid, from the 3-D *Creature from the Black Lagoon* to *The Wolf Man*. I was also a huge *Twilight Zone* fan, never missing a single episode.

As I ventured through life and into a film/video career, my passion for horror never waned. Now, teaching college film and screenwriting courses, I see a similar passion in my students, the majority of whom base their early projects on this seamy genre. It's really no surprise. Young people are attracted to the dark side as they explore the nuances of life, questioning what they held to be "true" in childhood as intellect blooms. What more powerful and entertaining form of human exploration is there than horror? Effectively done, it probes and unmasks our worst fears and insecurities, its allure making us both master and slave to our own demons. It's also just plain fun.

While many of my students pay little heed to old black and white films, I point out that some of the best classic horror films were made even before their parents or grandparents were born. The early 1930s were a burgeoning era in Hollywood horror (primarily produced through Universal Studios) and audiences witnessed *Island of Lost Souls*, *Frankenstein*, and *The Mummy*, to name a few. These early films, influenced by German expressionist silent cinema, were Gothic in style, with settings that included creepy castles, spooky mansions, and foggy terrain. The stories were often derived from Gothic or Victorian novels, such as Mary Shelley's *Frankenstein* or Bram Stoker's *Dracula*. The success of these films relied on a rather predictable but satisfying structure and a fun escape for Depression-weary audiences. They typically included a heroine who would be lured into the villain's trap and a hero who had to fight to save her for the sake of true love. Whether a mad scientist or a count in a castle, the villain was often charismatic and powerful and had a unique sidekick to help him accomplish his evil deeds. Interestingly, plot structures haven't changed much over time, though characterization, especially that of the heroine, certainly has, as will be explained later.

The earliest horror gems were made before the Hays Code was strictly enforced. The Hays Code (nicknamed for one of its administrators and former postmaster general, Will H. Hays) was adopted in 1930 and set film guidelines on sex, violence, religion, and crime, although it was not strictly enforced until the establishment in 1934 of the Production Code Administration. This window of time between adoption and enforcement enabled a few rule-breakers to

seep through. For example, Tod Browning's *Freaks* was released in 1932, though it was banned in England for thirty years due to its raw portrayal and sexual overtones. The Hays Code was abandoned by the Motion Picture Association of America (MPAA) in 1967 and replaced with a film rating system that exists today. Until then, most films were released with a minimum of extreme violence.

The 1940s were an interesting period in horror. During the war, horror films were banned or heavily censored in Britain and were essentially an American product. Hollywood studios took few risks to appeal to a strictly domestic audience but released such classics as Val Newton's *Cat People*, *I Walked with a Zombie*, and *The Body Snatcher.*

With dramatic technological advances taking place in the fifties, horror shifted from gothic toward science fiction, introducing us to schlock Martian invasion movies and other unearthly threats. Gimmicks like 3-D were also utilized for horror and science fiction films, such as *House of Wax*, *It Came from Outer Space*, and *The Creature from the Black Lagoon*. These low-budget B-movies are fondly remembered for their cheesy effects, overacting, and often ridiculous plots. During this time, Hammer Films, a renowned British company specializing in the genre since the 1930s, began outputting classic horror remakes, often with legendary genre actors Peter Cushing and Christopher Lee.

The sixties saw a floodgate of revamped and new horror. Hammer Films shocked us with the likes of *Brides of Dracula*, *The Curse of the Werewolf*, *Phantom of the Opera*, and *The Evil of Frankenstein*. Once the Hays code was replaced by the MPAA rating system, more violence began to appear in films. This was especially true in independent cinema, which was loaded with more carnage, violence, and sex than had ever been witnessed. The late sixties and seventies are often described as the golden age of horror filmmaking, with movies like George Romero's *Night of the Living Dead*, Tobe Hooper's *Texas Chainsaw Massacre*, and John Carpenter's *Halloween*. These filmmakers placed the monsters in our everyday lives and set a trend for suburban backdrops. And then there was Troma, a vanguard outfit started in 1974 by Lloyd Kaufman and Michael Herz, best known for its first film, *The Toxic Avenger*, and much loved as the perverse antithesis of Hollywood.

The 1980s brought us horror series and splatter comedies with classics such as *Friday the 13th*, *A Nightmare on Elm Street*, and *The Evil Dead*. Horror retained an audience appeal in the nineties with *Scream* and the independent phenomenon *The Blair Witch Project.*

In the last decade, filmmaking has gone through enormous changes as digital technology has allowed independent filmmakers to make movies more easily outside the studio system. Most distribution companies now boast a slew of low-budget horror fare released straight to DVD. These films have attracted an unusual fan base not often found in other genres—fans who thrive on the diversity of bizarre subject matter or new takes on old monsters and themes,

and who follow their favorite filmmakers' and actors' careers (ultimately helping to fund them).

Pursuing the horror genre is one of the most viable ways for a filmmaker to enter the film industry with minimal finances and some hope of distribution. Consequently, scores of would-be filmmakers are attracted to the genre, although they are not necessarily very knowledgeable of the craft.

The purpose of this book is to explain the importance of the craft with a particular focus on the horror genre from story development and planning through distribution and marketing. Professional filmmakers in all facets of the industry share their wisdom and unique insights attained from firsthand experiences. Their words are inspiring and brutally honest concerning the realities of the industry. Heeding their advice will arm you well as you venture into this dark, uncertain world. Enter it knowledgeably and prepared, creatively and bravely, and there is nothing you can't do, as gross and fearsome as that might be!

— Sara Caldwell

PART I:
SETTING THE STAGE

Horror has been one of the most consistently popular film genres since the dawn of cinematography. Ever since Hollywood introduced shock fare like *Dracula* and *Frankenstein* in the 1930s, audiences have flocked in droves to let vampires, zombies, mummies, ghosts, monsters, aliens, evil spirits, madmen, and other ghouls haunt their dark sides.

Horror is often combined with other genres, such as science fiction, fantasy, supernatural, and thrillers. They range from those that tap into the irrational or unknown to suggest horror in subtle ways to films commonly termed "splatter flicks," "slashers," or "spookfests," which are loaded with blood, sex, and violence. Originally associated with the exotic, iconic, and eerie settings, horror films of today are typically staged in contemporary, everyday environments, giving them an unsettling familiarity.

The success of horror films is not dependent on large budgets or star presence. Those that do become classics have managed to capture the true essence of the genre, keeping spine-tingling dread and suspense going for ninety minutes plus.

That means, if you're an aspiring filmmaker with a taste for the macabre, you're in luck—you don't need to be a movie mogul to work in this genre. But, while you may not need deep pockets, you will need a plan. You'll need to spend some time assessing the necessary skills, and then acquiring or polishing them. You will need to think about your potential creation: What is the story you want to tell, and how do you want to tell it? Those thoughts will become the blueprint for your film—the screenplay. In order for that play to end up on the screen, you will have to figure out how to scare up some financing. And before you can begin shooting you'll need to go through pre-production, the crucial organization and planning period for a film.

Today, the digital age is benefiting independent horror filmmakers, allowing them the ability to produce feature-length films on a shoestring. Chapter 4 is

devoted to the way digital technology has transformed the independent horror film industry, and in chapter 6, you will find out how TJ Nordaker made *The Janitor*, a darkly satirical effort splashed with seven gallons of blood, for a mere $2,000.

CHAPTER I:

Doing It Yourself: The pros and cons of Making a Low-Budget Horror film

"Win, lose, or draw, make your film. You're never going to go anywhere sitting down and looking at those scripts you wrote."

—Michael Hein, Filmmaker/Festival Director,
the New York City Horror Film Festival

There are many advantages to making low-budget horror films, especially with new DVD markets that were unimaginable only ten years ago. At the same time, there are no shortcuts to making material that matters or finding an audience that cares, regardless of genre. Making films is a financial, emotional, and personal risk. As statistics show, the odds are against independent films ever seeing the light of day, let alone making a profit. At the same time, filmmakers who manage to pull this off are an encouraging example that it's plausible and possible to make a successful independent film. Part of their success may have been from sheer luck, but the majority stems from passion, determination, and hard work.

How Much Do You Need to Know?

Filmmakers who pursue horror filmmaking typically have a lifelong love and fascination for the genre. Making a career of one's passion is everyone's dream. However, many filmmakers jump into the process prematurely without

having taken the time to understand the craft and genre or appreciate what separates predictable "dime-a-dozen" slashers from cult classics. These filmmakers are often more interested in exploiting the genre than in embracing it. They believe that if there is enough blood and sex, it will sell, regardless of quality, so why bother with artistry? As in any creative field, there are no shortcuts to long-term success that would speed up or circumvent the learning process. This fact applies to every phase of making a film, from writing a good story to visually translating that story into something creepy and memorable.

"There will always be a glut in the market of people who just shoot 170 hours of digital tape because it's cheap, and they still won't have a good film," says Bud Gardner, a highly experienced cinematographer in New York. "Story structure is everything. . . . Knowing how to tell a story is probably the most important part. There are a lot of films that are in limbo, especially digital ones. The scripts aren't strong enough, the acting's weak, the audio's lousy, or the cinematography is over the top and not coherent. Telling a story coherently is something that comes with experience."

FILM SCHOOL OR SCHOOL OF HARD KNOCKS?

My students often ask me if it's necessary to go to a major film school to succeed as a director. The answer, of course, is no, though I do believe that film schools offer a host of benefits not easily attained in the outside world, such as equipment availability, on-campus locations, student discounts for everything from rentals to permits, unique movie screenings you won't see at the mall, as well as access to professional faculty who work in the industry and who can provide real-world insights and contacts.

"I would say that it's important for a filmmaker to have a basic understanding of the business side of it and also, if you're going to be directing, the proper way of directing," suggests New York filmmaker Michael Hein. "Being the director of the New York City Horror Film Festival, I see about four hundred independently made shorts and features each year, and there are all different levels. You can get lucky and have a really good, inbred understanding of how to make an exciting film, but there's an awful lot of it that can be taught that is very helpful. I never went to film school, but I learned by working with directors, working on feature films. So I would say it's not a necessity, but it certainly helps."

"I think it's a great learning tool because it allows you to fail," adds Los Angeles filmmaker TJ Nordaker. "It's great to fail at film school, but it's also good to network and see how you work with other people. It forces you to go out

there and start shooting something. Film school is not a necessity at all. The big filmmakers out there are split half and half as to who went to film school and who didn't. My advice to filmmakers who want to get into but can't afford it is don't put yourself into debt at NYU or UCLA or one of these huge schools. If you can, go take some community courses and learn that way. I would also watch as many directors' commentaries as possible. I mean, that's film school right there. Get some DVDs and listen to low-budget commentary tracks, and you'll learn a lot, I mean an awful lot. And read the books as well. Most important is just going out there and shooting stuff."

Ultimately, it is not necessary to attend a film school, but it is certainly in your interest to learn the craft however you choose to pursue it. Schools do offer opportunities that one can't get with on-the-job training, such as those mentioned in the first paragraph above. On the other hand, learning on location as an intern or production assistant will give you professional hands-on experience you won't find in the classroom.

SHORTS VERSUS STRAIGHT TO FEATURES

There is debate about whether directors should get their hands wet making shorts or dive straight into a feature. Short films allow directors to experiment inexpensively and, perhaps more importantly, make mistakes that are part of the learning process. At the same time, shorts cost money, so why not invest in a feature-length project that has a better chance of selling and distribution?

Screenwriter Lisa Morton believes in the value of shorts, especially in today's world, as it is now a simple, inexpensive way to improve one's skills. "If I was starting again, one big change I would absolutely make is I would start with a short film," Lisa asserts. "I believe that's the way to go now, because for one, I think it increases your chances of directing your own material. You get to learn on the fly that way, and the great thing is with the new technologies these days, you don't have to spend a fortune any longer to make a film. When I was starting off, I did major in film in college, and even putting together a ten-minute short on 16mm was the price of a down payment on a car."

TJ Nordaker suggests utilizing local opportunities to make short films for minimal budgets, as well as airtime opportunities, such as public cable access. "There is a cable access show in most towns. Shoot a bunch of short films. It's a great outlet to get your films out there. Cable access is free. They will train you how to use their equipment and train you how to use their editing facilities. It's all free."

Michael Hein has a differing opinion about making shorts versus going after the feature, believing that if you're going to invest time and money, you might as well go for the big bang.

"My first project as a director was making a feature, but that's because I was working in the horror genre. I knew lots of distributors, and I knew lots of people who were going to help me out along the way. You can't ever make any money off a short, regardless of what people seem to think. I recently signed a deal to produce a television show for Fangoria TV, which is a newly announced company. It was basically bought out by a production company just to use the name Fangoria on their network. And we were already in development with the show *Killer Shorts*, which I'll be co-producing and hosting—and it's a venue for short films.

"One of the things I've been trying to work out is to try to get some compensation for the filmmakers. However, it's very, very difficult when you make a short film. The most IFC will ever pay for the acquisition of a short film is $1,000, and then they own it completely. You can't make any other deals on the film, you can't renegotiate with them or anyone else, and you can't go to festivals without permission. It's very rare that a quality short film would be made for $1,000, so you're not even making your budget back on licensing it out. So really, while I love short films, if it's a good film, it's still just a calling card and about gaining your chops up to direct your first feature. It's just my opinion, but if you are headstrong enough to dive in, by the time you're done with your feature, at least you have a chance to make some money off your film."

The Name Game

Unlike films in most other genres, horror films do not require big-name, Hollywood talent for success, though of course star presence never hurts. The most popular horror films to date have rarely showcased celebrities unless they were remakes or were funded by a studio.

"Getting name talent involved in a low-budget film is very difficult because of the money," says New York City filmmaker Michael Hein. "SAG scale is around $650 to $750 a day.[1] And if a person is name talent they're not going to work for scale, so it's very difficult and very expensive."

[1] With ultra-low budget filmmaking on the rise, SAG has made some concessions and will allow members to work for much less—however, be aware that unions require bonds and have other restrictions that may make them too pricey for you.

So, how does a genre filmmaker overcome this apparent contradiction? By employing actors, whose work, while not seen on mainstream television, is followed by aficionados of horror. As Michael says, "It's very, very important to at least try to get some interest from an actor who has a name within the genre." In fact, a new breed of talent has emerged from the low-budget world of horror, including a host of voluptuous scream queens who have a modicum of fame and a definitive fan base. Putting aside a bit of your budget, in order to hire an up-and-coming scream queen, might improve distribution odds. Chapter 9 explores in more detail the issues of names and talent.

The Industry Perception

The horror genre is often negatively perceived, as reflected in ample debates on its merit and general neglect in major film festivals. This black sheep of cinema has often been ignored or vilified by critics for a number of reasons, from the perception that horror films are trashy, exploitive, predictable, and provoke violence to the banal reality of the usual glut of teen slashers, tiresome remakes, and empty exploits that sell on box cover art alone.

"There's this fetish element to horror where it's a sister to porn in that regard," says filmmaker Larry Fessenden, who produced a trilogy of intelligent horror films comprising *Habit*, *Wendigo*, and *No Telling*. "My favorite interview question when I've done conventions is, 'What's the body count?' It's literally like, 'How many murders are there in the movie, and how were they done?'"

These negative perceptions unfortunately overshadow some of the heartfelt, experimental work being made. Larry shares some sound advice for improving public perception of your film. Start with some introspection about why you are making the movie in the first place:

"Whatever your storyline or format, do something that's worthwhile, and don't do it just to get into the magazines. You'll never fail if you've said something that's true to your heart. It's bullshit to make movies just for the sake of it. It's the last thing we need."

"The first thing you should do is study up on the genre and then forget all the rules," suggests special effects artist Anthony Pepe of Demonic Pumpkins FX in New York. "If you decide to make a vampire movie, don't put the vampires in dark lace running around a castle in the night and spouting poetry. C'mon, we've seen it. No one's going to reinvent the wheel with a horror movie. It's been done every other way till Sunday. You can only kill a person so many ways, know what I mean? So take what you know and make it your own. I think if you

get more involved in the script, it'll make a better horror movie. I can go to Blockbuster and rent twenty to thirty different horror movies, and they all pretty much have the same formula: teenagers get lost in the woods, teenagers get lost in the house, teenagers get locked in the house. Change it around a bit and make it something more creative. If you make an original movie, you can definitely sell it."

The Fans

The "blood and boobs" slashers generally do not make it to mainstream markets, yet they have a faithful, enthusiastic fan base that is always keen for more product. "People know that if you make a horror movie, geeks like me will rent every one that comes out," says TJ Nordaker.

Unlike other genres, horror fans can border on the obsessive, making the genre a part of their personal identity, from Gothic wardrobes to the posters hanging on their walls. Filmmakers and their fans have a rather symbiotic relationship, both dependent on one another for the creation and appreciation of the craft. Fans appreciate filmmakers who have unique takes on traditional fare, a focus on favorite type of theme, or a track record of producing heart pounding results.

Bucks for Blood

Independent horror films can be made on minimal budgets, as mentioned earlier. In fact, it is not unusual for a feature-length independent horror film to be made for less than $5,000. This is only made possible because of today's inexpensive technology. In chapters 3 and 4 you will learn about various ways in which to budget and find funding for your film and take advantage of digital technology.

Studios have long recognized the power of the horror genre, not only with respect to audience appeal, but also profits. According to the Internet Movie Database (www.imdb.com), the movie Saw (2004), distributed by Lions Gate, is one of the twenty most profitable films of all time, based on return on investment. It was made for $1.2 million, and as of this writing, has grossed $71,955,063 for a 2,989.13 percent return. A number of independent filmmakers have found fame and fortune in this genre, spawning classics from *Night of the Living Dead* to *The Blair Witch Project*. To date, *The Blair Witch Project* remains the most profitable film based on return on investment with a whopping 354,614.29 percent return on its original $35,000 budget. Horror films have also proven to have financial longevity. The highest grossing horror film of

all time, *The Exorcist,* has brought in over $357 million worldwide since 1973. Studio remakes have also reaped tremendous monetary reward. The 2003 remake of *The Texas Chainsaw Massacre* had a production budget of $13 million and has grossed over $96 million worldwide. Retreads have proven extremely lucrative, as studios can remake classic horror films and sell them on the title alone at far less cost than the originals. Horror films also have an international appeal that opens profitable markets outside the United States. However, very few independent horror films see this level of success.

While horror films are often box-office smashes for a studio, theatrical release is a rare opportunity for independent filmmakers, though this is certainly not confined to the genre. Therefore, a filmmaker must usually rely on finding a suitable distributor or self-distributing a project on DVD.

Funds for independent films are sometimes acquired from a distributor; the filmmaker is paid a flat fee to produce the project without retaining any rights. While the filmmaker is assured decent distribution, no royalties are shared, and the filmmaker often has little control over the story and required number of sex and blood scenes. For filmmakers who self-produce without distribution in place, recouping one's money is an obvious challenge and requires a great deal of networking and tenacity. Chapter 12 will explore distribution in depth.

"You can make a feature onto video, that's true, and that's wonderful, but the real issue is how you can get distribution, and somewhere in there is the idea of how you can get paid back," says Larry Fessenden. "It's a bit of a fantasy that people from nowhere can just support themselves making movies. It's a bit of an exaggeration that we find with the current crop of kids coming out of school. They think it's all going to self-perpetuate but it actually requires tremendous sacrifice to be a filmmaker and it helps to see it for what it is. You're trying to put a vision on screen and not everyone is going to buy it."

While there are enormous obstacles and risks to making films, from funding through distribution, there are many opportunities in the horror niche. As the independent filmmakers interviewed in this book will attest, with a good dose of passion, dedication, craft, talent, and savvy, you can overcome the odds.

CHAPTER 2:

from script to scream

"I would be amazed if there were writers who wouldn't prefer to write suspense versus gore."

—*Lisa Morton, Screenwriter, Los Angeles*

What makes a great horror film—the kind that keeps us on the edge of our seats in nail-biting suspense until the eleventh hour when good or evil will reign? As with films in any genre, the foundation is a well-crafted story and strong, credible characters and plots. The process of creating a strong story and characters should be taken very seriously. All the special effects in the world will not disguise or repair a poor story. Ross Byron, an editor who has been in the position of trying to "fix it in post," shares an interesting visual analogy:

"The story is the tree. You can hang all the Christmas ornaments on it that you want as long as the tree is strong enough. You can't really fix it in post. All you can do is make up a new road, take a fork, and hopefully you'll get to the same spot where the audience understands what's happening so you don't lose them in the story. One thing, though, is, you can't shine a turd."

The story you want to tell is important, whether it is serious, humorous, gory, or psychologically motivated. The story you set on paper is the base on which all of the other elements of filmmaking will be built. It is critical to take the time to develop unique and original characters and plots, unifying themes,

and techniques to build suspense—remaining budget-conscious as you write— you will go a long way toward finding an audience that appreciates the story you have to share. These elements are explored in more detail below.

Original Spins

A common gripe from both critics and audiences is that there is nothing new in horror, given the continuous slew of remakes, sequels, and copycats that rehash old plots and monsters. Regardless, some original, creative reinventions have bubbled up to the surface, as Michael Hein, co-creator and director of the New York City Film Festival describes:

"I think horror is in a great place right now. In the last few years I've seen some horror films I've really, really enjoyed. So I'm happy with where the genre is going. The problem I see is with all these remakes. Are there no original ideas out there?"

Special effects artist Anthony Pepe is a little more pessimistic about the current trend in horror films but has faith in the independent world: "The problem right now with horror films, I think, is that they're becoming cookie cutter and starting to run out of ideas again. The independent horror industry will always be there though. It will never die out. It's the Hollywood horror movies that come and go. It's the whole Hollywood sequel thing that leaves a bad taste in everyone's mouth."

So how will you make your story unique? Writer/director Stevan Mena's film *Malevolence* has been compared to a number of classics including *Psycho* and *Halloween*. While paying tribute to his favorite films, Stevan infused themes that were important to him.

"I find that insane; *Malevolence* in the same breath as *Halloween?*" says Stevan. "*Malevolence* was really a love letter to all my favorite horror movies: *Psycho*, *Halloween*, *The Shining*, *Alien*, *Texas Chainsaw*, etcetera. I just felt that this stuff has been done so many times, and the blueprint is there. People can claim they're reinventing the wheel because their killer has a unique mask or a different knife, but they are all riffs of *Psycho*. If Alfred Hitchcock didn't make *Psycho*, none of these films would even exist. They exist because Hitchcock, with his incredible respect, was able to explore subject matter that most sane people would find horrifically unsuitable as entertainment. But once he used his stature to establish that there was a market for these films, he paved the way. But if you think your idea for a slasher film is revolutionary, then you live in a bubble. So it's all homage. What I tried to do differently was to build a story.

Malevolence does have a deep storyline within it. It's truly about child abuse, and the perpetuating cycle of violence. But without the other films (of the *Malevolence* trilogy), it's hard to see the whole picture."

As Stevan suggests, the story will be most powerful if it includes themes that are important to you. If you are personally invested in your script, it is more likely that it won't be riddled with clichés and predictable characters and plots.

Structuring Your Plot

Horror films usually follow the traditional three-act Hollywood story structure. In this structure, the film opens with a "tease," an enticing scene to draw audiences in, and the hero and villain are introduced in the first act. Building tension, conflict, and turning points occur in act two, ending in a "crisis" point where all seems lost for the hero. In act three, the hero finds the resolve to overcome the villain, resulting in a final showdown. At the end, the hero typically comes to a new understanding that is tied into the thematic elements of the story. Audiences are certainly familiar and comfortable with this structure in every genre of Hollywood films. At the same time, breaking the rules can produce fascinating results. Imagine *Night of the Living Dead* with a happy Hollywood ending. It would have lost much of its disturbing power and underlying messages of vigilantism. Whatever story structure you choose, the key is to avoid stereotypes and clichés, of which audiences are more than weary.

Avoiding Cliché Characters

To avoid cliché characters, you need to spend considerable time developing your people and identifying their unique qualities. Some questions to help this process are:

1. Have I seen my character on the screen before?
2. What differentiates my character from typical heroes or heroines?
3. What unique personality traits, strengths, and weaknesses does my character have?
4. Does my character have a history that has influenced his or her beliefs and attitudes?
5. Is my central character too "good"; should there be more shades of grey?
6. How is my villain atypical of other monsters on screen?
7. Are my villain's actions random or motivated, and how so?

8. Is my villain completely evil, or does he or she display some weakness or trace of morality?
9. Are my hero and villain of equal strength, whether physically or intellectually, so that their battles make sense?
10. What is the motivating factor that brings my central character and villain together, and how does this connect to the central theme of my story?

CREATING A HEROINE

The role of women in horror films has been the subject of much critical debate, as in the past they were usually portrayed as victims of psychotic killers and crazed monsters who subjected them to horrifically violent danger or death. What is still true today is that it is often while they are engaged in sex that young victims are slaughtered, suggesting that they should be punished for the sin. Only the "good girl," the one who generally resists sexual advances, manages to survive, as if survival is a reward for her chastity. The good girl is one of the most common character devices used in horror, pitting a strong, resourceful heroine who finds the will to survive against an evil being without a conscience (e.g., *A Nightmare on Elm Street*, *Halloween*, and *Scream*). While this "beauty and the beast" model has had its share of successes, the horror world is reaching a point of saturation, and the predictability of this type of heroine is killing the suspense.

Lisa Morton, a rare Southern California native, is a multitalented screen-writer with a strong conviction about her craft. She agrees that these stereotypes have worn thin and has worked to resist them. "I think women would like to see horror films in which the women on screen are not just being knifed to death by some psycho. For the woman to be the survivor she must be absolutely chaste, which is a thing I would love to destroy in a movie sometime. In the script that my agents are shopping now, called the *Patchwork Man*, it's about a heroine who's trying to track down a vicious killer, and she's very young. She's a sixteen-year-old African American, and the night before she's going to pursue the killer, she says to her boyfriend, 'hey, who knows what's going happen tomorrow, let's go for it.' And they do, they have a great time, and that makes them stronger. That of course will probably never end up on screen. All you can do is try."

Some of the most memorable characters of all time (typically created by independent directors not shackled by the studio system) do not conform to the

usual archetypes: they are not helpless victims, or heroic goody-two-shoes. In *Rosemary's Baby*, for example, the heroine did not manage to save her baby from Satan's evil-doers, despite all her efforts, leaving us with a troubling view that evil can indeed reign. Her character had very human vulnerabilities, insecurities, anxieties, and growing paranoia about events too large and improbable to grasp. Had Rosemary beaten or outwitted Satan, the movie would have had a much different and undoubtedly less powerful tone. Her ultimate powerlessness against the devil made the movie that much more credible and engaging.

CREATING A VILLAIN

Many horror villains are characters of pure evil, with no dimension to their personalities outside of their bent for violence and carnage. These villains have been highly successful in films like *Halloween* and *28 Days Later.* In these cases, the protagonist must be that much more dimensional to balance the film and win our support for her survival. Jamie Lee Curtis as gutsy babysitter Laurie Strode was certainly someone worth rooting for.

Villains have also been portrayed in more dimensional ways with success. For example, *Henry: Portrait of a Serial Killer* did not rely so much on graphic depictions of violence but rather on the unpredictable, random motivations of a serial killer. Our forced intimacy with the killer is a jarring, disturbing ride into a psychotic mind that shows enough traces of humanity to make us question his horrendous actions. The popularity of *Silence of the Lambs* was in large part due to the infamous cinematic villain Hannibal Lector, with his idiosyncratic personality and complex relationship with FBI trainee Clarice Starling.

Whether purely evil or multi-dimensional, villains must be as well-developed as their hero or heroine counterparts. They have very powerful motivations that have their origin somewhere in their past. Creating character histories that help explain these motivations will make their actions that much more credible to audiences.

Hero or Antihero?

The hero in many contemporary tales of horror may be an antihero. When Larry Fessenden wrote *Habit*, he used certain conventions, such as the vampire theme, yet with a very contemporary, raw, and intelligent take. The central character is Sam, a lonely, alcoholic young man who becomes consumed by a woman who may or may not be a vampire. The story is gripping and creatively

"The most believable VAMPIRE flick I have ever seen."
— CHICAGO TRIBUNE

Habit DVD Cover

unfolds without the typical resolution of good triumphing over evil. It is more a story of paranoia and self-destruction that leaves very open-ended questions.

"*Habit* is about loneliness and the subjectivity of life's experience," Larry explains. "The movie is constructed to support various interpretations of what happens to the character Sam, because you can never know the truth about someone else's demons, no matter how close you are, and the interpretation you come up with says something about you yourself. And I wanted this lack of resolve to exist for the film, to evoke for the viewer the same kind of disorientation that Sam is going through; what anyone who feels alienated is going through, which is all of us at some time in our lives. Of course, the central preoccupation for any audience is, 'Is Anna a vampire?' And the answer naturally is, 'What do you think?' This is my version of interactive entertainment. You can build a case for both interpretations. I mean, I believe with equal conviction that she is and is not, but either way, Sam believes it, and that's what leads Sam to his demise. I'm speaking of the power of the mind to deceive and deny and how fantasy can shield us from truth."

Lisa Morton has always strived for originality, even if choosing (or being assigned) traditional characters, such as vampires and mutant creatures. In her screenplay for *Thralls* (aka *Blood Angels*), Lisa made the "thralls," who are half-vampire and half-human, into the heroes rather than villains. Her goal was to upend the traditional lore by making the half-vampires empathetic. The thralls don't kill people; rather, they suck just enough blood to survive. Shot in Canada in 2004, the story involves six beautiful thralls who run a rave to escape a full vampire who was once their master.

"I thought for a while that the vampire genre was dead because it's been done so much and there's really no way to make a vampire story anymore,"

says Lisa. "So if you're doing a vampire story and you can't make it scary, what's left? Well, you make them the heroes. So I decided to take that idea and mix it up with some of the things I'd been thinking about with Hong Kong cinema and create something that was told in real time. I'm a big, big fan of Hong Kong cinema, and I've never really seen an American film that's gotten it right. I think a lot of Americans don't realize what is really great about Hong Kong cinema—things like crisscrossing story lines and strange narrative structures, like a story told completely in real time. *Thralls* was written to take place in ninety minutes and includes five vampires who happen to be the heroes and who are kick-ass women. The story centered on the women having to bond together to overcome a common male protagonist, the vampire who created them."

CREATING CHARACTERS ACTORS CAN SINK THEIR TEETH INTO

When Lisa co-wrote the shark thriller *Blue Demon* for Regent Entertainment, she infused humor into her characters to add substance to a rather conventional plot:

"I did get to have fun with the characters, and this actually did kind of survive in the final version of the film. I think when you're making a movie like *Blue Demon,* which you know is going to be a video thriller that could easily be lost on the shelf, you look for ways that will make it stand out, and you know you can't do it with effects or anything that will cost a lot of money. So you try to make really interesting characters that people will like and remember. On *Blue Demon,* it was fun to create a couple who are both brilliant scientists in the middle of a very bitter but sort of funny divorce. And that did turn out to be very effective in the finished film. The other good thing about that is it gives the actors something to do besides look at a blue screen and pretend to be screaming. I think then actors feel that they have real characters, and when they're more involved with it, their performance will be better than just doing something in the typical horror movie clichés."

About Dialogue

Dialogue in movies serves several purposes. It provides information the audience needs to know, helps us understand characters and their motivations, and propels the story forward.

SHARING FACTS

Providing information in dialogue can be tricky, as conveying pertinent facts can slow down the pacing. Tying information to character traits or using it to foreshadow future events can, however, be effective. In this excerpt from *The Shining*, for example, we learn information about Jack's custodial responsibilities at the isolated hotel, the loneliness he and his family will encounter, Jack's goals as a writer, and a hint of the trouble ahead:

> ULLMAN
> Physically, it's not a very
> demanding job. The only thing that
> can get a bit trying up here during
> the winter is eh . . . the tremendous
> sense of isolation.
>
> JACK
> Well, that just happens to be
> exactly what I'm looking for. I'm
> eh . . . I'm outlining a new writing
> project, and eh . . . five months
> of peace is just what I want.
>
> ULLMAN
> That's very good Jack, because eh
> . . . for some people eh solitude
> and isolation can of itself be
> a problem.
>
> JACK
> Not for me.
>
> ULLMAN
> How about your wife and son? How
> do you think they'll take to it?
>
> JACK
> They'll love it.

Another effective example of foreshadowing happens in this scene from *Signs*, when the son, Morgan, shows his father and sister pictures of alien invaders:

```
Graham looks at an illustration of a small, bulbous
headed figure shaking hands with a bearded human.

                    MORGAN
          Or the other reason . . . They're
          hostile. They've used up the
          resources on their planet and are
          looking to harvest our planet next.

Morgan turns the page. There is a picture of a house.
A space ship is hovering over the home shooting laser
beams at it. Beat.

                    GRAHAM
          Looks a little like our house
          doesn't it?

Morgan and Bo lean in closer to look at the picture.
Beat.

                    BO
          The same windows.

                    MORGAN
          (soft)
          That's weird.

The three of them study the picture of the house.
It's on fire. Their eyes move to the front yard. There
are three bodies lying dead on the front lawn. Two
are children.
```

UNDERSTANDING CHARACTERS AND THEIR MOTIVATIONS

Each character's unique voice helps us understand and know him or her better, making us feel more connected to each character's story. Too often, the dialogue for each character is similar. Providing characters with their own style of speaking, based on where they grew up, their socioeconomic status, their jobs, and so forth, adds depth to their personalities. Dialogue between characters also lets us see their differences. In this script excerpt from *Seven*, the divergent personalities of the detectives solving a serial killing—elderly, intelligent Somerset and young, headstrong Mills—is very apparent:

```
INT. SLUM STAIRWELL—MORNING

Mills and Somerset are standing in the middle of one
flight of stairs. Both are highly agitated.

                    SOMERSET
          The way this has gone till now,
          I wouldn't have thought it was
          possible, but we may have
          underestimated this guy.

                    MILLS
          I want him bad. I don't just want
          to catch him anymore. I want to
          hurt him.

                    SOMERSET
          Listen to me. He's all about
          playing games.

                    MILLS
          No kidding! No fucking kidding!

                    SOMERSET
          We have to divorce ourselves from
          emotions here. No matter how hard
```

```
                    it is, we have to stay focused on
                    the details.

                              MILLS
                    I don't know about you, but I feed
                    off my emotions.

                              SOMERSET
                    He'll string us along all the way
                    if we're not careful.
```

Through such dialogue in *Seven* we come to appreciate each partner's strengths and weaknesses and how their combined traits balance each other out in solving the crimes.

MOVING AHEAD

Screenwriting experts and gurus often say if the dialogue or action isn't moving the plot forward it is not essential and should be cut. Obviously this suggestion has been effectively neglected, but using dialogue merely to express opinions or expound on a point not relevant to the story can be wearisome and put the brakes on a story's energy level. In this excerpt from *A Nightmare on Elm Street*, the dialogue connects the characters' dreams and sets up a question for the audience: how can two friends share the same nightmare? It drives the story forward because we want to find the answer.

```
The story has left the room deathly quiet. Especially
TINA seems affected.

                         TINA
                    (quietly)
                    So what about the fingernails?

NANCY remembers, imitating the frightful coincidence.

                         NANCY
                    He scraped his fingernails
                    along things—actually, they
```

```
                    were more like fingerknives or
                    something, like he'd made them
                    himself? Anyway, they made
                    this horrible noise—(imitates)
                    sssssccrrrtttt. . . .

        TINA pales.

                              TINA
                    Nancy. You dreamed about the
                    same creep I did, Nancy . . .
```

WHEN NOT TO USE DIALOGUE

In horror, tension and suspense can be amplified with minimal dialogue, using atmosphere and visuals to guide us into fear. The scene in which Clarice Starling is trapped in the dark in the serial killer's house in *Silence of the Lambs* is a fine example of how tension can be visually built without any dialogue. In the nail-biting scene, Clarice has to use all her senses other than sight to avoid the serial killer who can see her with his nighttime goggles. The tension effectively builds in the description, which fills an entire page in the following way:

```
CLOSE ON CLARICE—LOW ANGLE—

With NORMAL SPEED RESTORED, as the side of her face
hits the floor, and she is gasping, stunned by the
noise and flames; there is blood on her cheek, and an
ugly powder burn, but she ignores them, twisting to
yank her speedloader from her jacket pocket, locking
it blindly onto her gun's cylinder, reloading, right
in front of her face, then rolling onto her stomach,
aiming her gun upward again, blinking her dazzled
eyes, straining to locate him in the darkness . . .
Where is he, where . . . ? Then, as the ECHOES
finally fade, she hears something else—a tortured,
sucking, WHISTLE from perhaps eight feet away . . .
```

The Importance of Theme

Many filmmakers neglect the importance of theme. In film, a theme is a unifying idea that is a recurring element. In Hitchcock's *Vertigo*, for example, there are recurrent themes of fear, loss, and redemption. The main character, Scotty, believes he failed to save the woman he loves. His Achilles heel is his fear of heights, or vertigo, which he blames for his lover's death. Scotty becomes obsessively involved in trying to make up for the past by trying to reinvent another woman in his lover's image, as if that will erase his loss and guilt and will somehow redeem him.

A film's themes provide depth and underpin the main plot and characters. *Eve's Bayou* is a compelling drama about a young girl and her extended family living in Louisiana. Family secrets, the supernatural, and death are prevalent themes. Mirrors are used throughout the film with reflections of the past that help us understand the family's dynamics. The family's history, secrets, and the "accidental" deaths are ever present, through conversations and imagery.

In the horror genre, many themes are fear-based for obvious reasons. For example, the sheriff in *Jaws* is afraid of water; the detective in *Vertigo* has agoraphobia. Thematic elements are typically built around the main character and become fully realized by the end of the film as the character comes to some new understanding based on his or her extraordinary experiences. In *The Sixth Sense*, Malcolm, a psychiatrist, strives to help a young boy, Cole, as redemption for another boy he was unable to help. Through communicating with Cole and understanding his paranormal experiences, Malcolm is able to discover the truth about himself and come to peace with his circumstances. Sometimes characters themselves are thematic, speaking to our moral conscience. The mathematician in *Jurassic Park*, for example, reminds us consistently about the dangers of interfering with nature.

A film's themes are always present, whether in the characters, actions, dialogue, visuals, or other cinematic techniques. As explained in chapter 7, themes can be emphasized visually in recurring motifs; that is, objects, colors, or even dialogue that repeats in some fashion. In *The Sixth Sense* the color red appears on a balloon and on Cole's sweater as a motif for the paranormal, underscoring theme of death in the midst of life. The red stands out in otherwise darkly atmospheric visuals.

Horror films also explore dark global and universal themes, such as the vulnerability of humanity, whether to alien attack or to self-destruction. The

themes in *Invasion of the Body Snatchers*, which was made in 1956 during the Red Scare, revolve around the loss of individuality and emotions through conformity and group thinking. As alien pods take over an entire community, dehumanizing people by replicating their bodies and overtaking their minds, a helpless but resolute small-town doctor fights to combat this evil. If taken in a political context, (i.e., the fear of communism), the theme is certainly apparent in the survivors' paranoia and the uncontrolled spread of the malignant pods.

In *28 Days Later*, it is man's interference with nature that causes widespread demise across most of England, as animals and people infected with Rage savagely kill any non-infected creature in their path. Themes center on the downfall of civilization and the harsh realities of survival in a post-apocalyptic world. In the end, the humans in the military enclave where the main characters seek shelter are as threatening as the Rage-ridden zombies. Such survivalist themes are also evident in films like *Mad Max* and *Lord of the Flies.*

"I do believe that is what horror has to offer, even in the most B-movie tradition," says Larry Fessenden. "They're really approaching themes that are difficult to discuss. Who wants to go to a movie about death necessarily? Of course, there's *Terms of Endearment*, the family cancer movie, or movies about a freak accident, but ultimately those themes are too heavy for drama; whereas, in a horror movie, some sort of confrontation with the dark side happens every ten minutes—be it issues of evil and morality or issues of physical harm or the freak accident—which is on everybody's minds in some way. Every time you get on a plane you have a little tiny horror of things going wrong, so the horror-meister is bound to focus on those. And it's cathartic, hopefully. Of course, a lot of modern films have reduced it only to elements and left behind the thematic parts of these stories."

In his own films, Larry explores mythological themes and the struggle for truth in a chaotic world where people are yearning for meaning. "All of them tend to be about man and nature, man and myth, and I just feel that those very broad themes exist under everything, including our daily lives, our choices of products that we buy," Larry explains. "Every choice we make is based on some sort of world view that we are taking to the table. And I would like to reveal that, or at least discuss it in the genre. Of course, genre itself is a form of mythmaking. Certainly the monsters of today are like the Greek myths that represent certain things, and vampires clearly represent an endless search for life through blood. *Frankenstein* is clearly a story about science and nature. So I find the meaning of life, if you will, through

philosophical horror films. If you watched all my movies at once, God forbid, you would clearly see these themes rehashed and revisited in other ways. I also think what's interesting with my movies, for better or worse, is that they're not only concerned with the human element. There's a feeling of the world beyond them, like the supernatural or just natural. I'm very interested in how contemptuous people are over nature and how alienated people are. So all of these are horror themes."

Probing the following questions will help you identify your script's strengths and weaknesses in terms of theme:

1. What are the underlying themes?
2. Are the themes meaningful and important enough for audiences to identify with or care about?
3. Are the themes consistently touched upon throughout the story, whether visually, audibly, or in dialogue?
4. How are my themes and central characters connected?
5. Are there pauses between horrific acts to allow audiences to breathe and digest what's going on in the story?
6. Does every scene of violence or horror serve a purpose toward furthering my story, or is it simply for the sake of spilling blood?
7. What plot devices have I used to build tension before acts of violence or horror?
8. Are my characters saying too much at critical moments, or can I make more use of non-dialogue action to enhance suspense?
9. How does tension build through the script to give power to the final showdown between my main character and the antagonist?
10. Are my settings and plot unique, or at least presented in an original way, or too similar to other films that have been made?

Suspense and Gore

Many new screenwriters believe that writing scenes with extreme violence and blood will evoke fear and shock on screen and will make a project more commercially viable. While it's true that splatter films sell fairly well in low-budget DVD markets, they rarely leave a lasting impression. It is not so much the horrific acts that frighten us the most; it is the suspense leading up to those actions—the girl trapped alone in a dark basement making that fateful turn, the student filmmakers stuck once more in a tent after dark waiting for the

inevitable besieging, the babysitter staring out the window as the boogie man appears down the street. As Alfred Hitchcock once said, "There is no terror in the bang, only in the anticipation of it."

Many of the greatest horror films of all time have minimal brutality but maximum chills. If you watch classics such as *Rosemary's Baby*, *Invasion of the Body Snatchers*, *The Sixth Sense*, or *The Blair Witch Project*, you will be hard-pressed to cite any actual violence, let alone gory special effects. In these films, our fear stems from the tension built around the unknown that is ever present and dangerous but rarely seen. *Invasion of the Body Snatchers* shows no actual deaths, but it is the change of personas of "normal" citizens that builds the tension. In *The Blair Witch Project*, the flapping of the tent at night, the screams in the distance, and the small clusters of bound twigs discovered in the morning are more frightening than if we had witnessed what actually happened to the victims, for it helps us share in the survivors' perspective and their fear of the unknown.

This is not to say a slew of massacres should be avoided, as there is a fun, campy self-awareness in slasher films that fans love, but even these types of films could benefit from more clever elements of suspense. A bombardment of gore, like too much bad news, has a numbing effect that detaches us from the action.

Cinematographer Bud Gardner, a longtime aficionado of great horror films, agrees that violent trends are numbing us down:

"I'm not a proponent of the body-count thing, because a lot of times you forget it's a horror film. It becomes a war movie. You throw a lot of weapons in a movie with the bullet hits and all that take more precedence over serious horror. I'd much rather not see bullets splattering all over the place and just see little snatches of scary moments and watch the film use music and cinematography and the shot design to build tension. When you build up to these full-body-count type movies, you get numb. They go too far. It's just one effect after another effect.

"So in low-budget films, my recommendation is to show less. Stylize it. On a movie like *The Curse*, we had a werewolf mask and stuff like that, but we opted not to use those effects that much. We made it more psychological by just making the [werewolf] girl's eyes glow, and then cutting to a stylized scene, the guy gets butchered and she wakes up with just a fake arm in her bed. Making a fake arm was a lot easier than trying to have howling werewolves and having her morph into a monster. It also made the movie better. So in that film, less was a whole lot more. And you'd probably have liked the character a whole lot less if she was a vile-looking werewolf."

"I find almost no modern horror films to be scary, and I would love to write a horror movie that actually is scary again," says Lisa Morton. "Unfortunately, with the marketplace these days, the preference seems to be for the fast-moving gory thriller rather than something that slowly builds tension and suspense. You have to try to be conscious of the market, but sometimes it's difficult, because you want to write what you want to write, but you also need to think, 'If I do that, will it ever sell?'"

"In low-budget horror films, you need to build suspense before actually seeing the monster," says editor Ross Byron. "That's how we (as editors) really earn our meal ticket. It's the notes you don't play or what you don't say. People fill in the gaps in their heads anyway, and they're probably thinking of something even scarier."

The following scene from *Halloween,* including camera angles that demonstrate how the scene was edited, illustrates Ross's point of how showing less can add more suspense until the moment of confrontation. In this case, shots of Laurie's point of view, details such as the jack-o'-lantern, and a swinging door are used before the grisly discovery of her three murdered friends. Toward the end of the scene, it takes a while for Michael Myers to come into view, adding to the horror of the moment:

```
INT. SECOND FLOOR HALLWAY

Laurie backs out of the bedroom. Her mouth is open in
speechless horror.

Suddenly a door next to her slowly opens. There is
Lynda standing there, propped up by a chair, staring
at her with glazed, dead eyes.

ANGLE ON LAURIE—CORNER (LIGHTING EFFECT)

Laurie shrinks back into a dark corner. She can only
stare in horror at the sight of her friend.

Suddenly we are aware of something there in the
dark corner.
```

It is almost as if our eyes have suddenly begun to adjust to the darkness and we see the outline of a man standing right behind her.

The outline becomes more and more clear. It is the shape, wearing the mask, the butcher knife in his hand, gleaming, right behind Laurie.

Laurie suddenly moves away from the corner.

The shape lunges out at her.

Filmmaker Stevan Mena omitted humor from his script for *Malevolence* to avoid cliché dialogue and breaking the tension. "Suspense is all in the atmosphere," says Stevan. "I think it's not too hard to create tension. You aim a gun at someone's head and you've got suspense. The hard part is maintaining it, not letting the audience off the hook. That was the reason for consciously omitting any self-referential humor. Once you make a joke, you let the audience off; you're basically telling them, oh see, don't worry, it's only a movie. It's all just a joke. I think some horror directors are unwilling to face the reality of their subject matter. Murder is not funny. Killing someone is serious and affects so much and so many. It's nothing to laugh at. If you do, fine, but don't expect your audience to respect your latter attempts at suspense, because you've already told them you're not taking it seriously yourself. So for me, the way I maintained the suspense was not only what I showed them, but also what I left out."

Unsettling the Familiar

In 1982, *Poltergeist* was a box-office hit because it portrayed the most ordinary of surroundings and characters and forced them into an extraordinary situation. The subtle unsettling of every-day life (e.g., the little girl staring at the TV screen, murmuring, "they're here!") effectively shifted our paradigm about sleepy suburbia and set a trend for middle-class Americana characters and locales that continues today. *Carrie* is a prime example of horror in a normal setting. Here you have traditional American high school life, and its inherent cliques, gone amok when a gifted but scorned girl's happiness is crushed and she seeks untold revenge. *I Know What You Did Last Summer* is a more current example of suburban teen life gone awry after a group of friends accidentally

hits a stranger on a dark road and tries to conceal the crime, only to have vengeance wreaked on them.

There is an interesting aftermath to upsetting the ordinary in cinema. After viewing *Jaws*, how many of your friends were deathly afraid to set foot in the water? Decades later, this film still has an impact on us.

Taking the hero *out* of the familiar can be equally distressing. This "fish-out-of-water" device has been used quite successfully in most genres. The fish-out-of-water is in essence when a character finds him or herself in an unfamiliar environment, giving rise to a host of unexpected consequences. In *Pleasantville,* for example, a brother and sister are transplanted into a *Leave it to Beaver*–type television series, upsetting the tranquil traditions of the town and their TV family with their modern-day thinking.

Make It Something They Can Shoot

All writers would prefer not having creative constraints, but it is worth thinking about how much your film will cost to produce. The higher the budget, the more difficult it will be to sell or make.

"I'm very conscious of budget," says Lisa Morton. "If you open your horror script with the universe exploding and ten million people dying, it won't be read past the first page. You're dead. If you write a script that is very budget-conscious throughout and has an interesting story, obviously your chances of selling it are much, much better than the guy who's got a really great, interesting story, but he's got a fifty-million-dollar script. In *Blood Angel*, I made one mistake by setting it in a rave. Even though it would not have cost a fortune if they had shot it here in Los Angeles, they shot it in Canada where all the extras were apparently hired through agents. I got chewed out by the director at one point for writing a script that had so many extras. I'm thinking, 'you throw a party, you make a rave,' but the extras turned out to be about a fourth of the budget. Sometimes there are things you just can't possibly foresee, but I'm still trying to be conscious of the budget. I have a film that's being shopped right now by my agent, and one of the things that people are responding to very positively is that it has a very reasonable budget. So I think it instantly increases your chances of selling."

Limiting the number of locations, using accessible locations, and restricting the cast and extras will help keep production costs under control, making it easier to sell or fund your screenplay. This can be a relatively easy process that does not have to destroy the core story you are trying to tell. Again using *The Blair Witch Project* as a model, there was one primary location for the majority

of the story (the woods) and minimal characters (three central ones), which is in part why the filmmakers were able to produce the project for about $35,000.

You're An Overnight Success (Not)!!!

Crafting a good story takes time, but the final product—your film—relies on important up-front work. Your script is a blueprint for everything to come, and like building a house, a shoddy blueprint will result in a shoddy final product.

"You have to remember a good thing about the fact you may have to just write and write and write is you will get better as you keep writing," reassures Lisa Morton. "It's not just about continuing to write to persevere, it's also that you improve as you continue to write, which seems like a very obvious thing, but sometimes that's easy to forget. And another reason you have to persevere is so much of it is dependent on dumb luck. And so the longer that you try to stay at it, the more you improve your craft and the chances of sheer dumb luck kicking in."

Once you have written a script, it is extremely important to get objective feedback. Although it is easy to feel offended by criticism, it is important to listen to the feedback without arguing back, as chances are there is some validity to the comment.

"Stop and sit down with ten good friends," suggests Stevan Mena. "Show them your script and ask their opinions. Eight out of ten will say they loved it. Two will say it sucked. Those two are your real friends. Kick the others out and ask those two why they didn't like it. Praise can only inflate your ego. Criticism of ANY kind is always productive, I believe. You can always learn from your mistakes, I hope. Then make sure you are as happy as can be with your script. Once you are satisfied it is the best it can be, tear it up and start over. Do that three or four times before you spend one dime of your friends' and families' hard earned money. Because every rewrite you make on your script, every extra day you plan before the meter is running (crew salary, equipment rental), will improve your chances of winning. The worst thing you can do is rush into it just to prove you can."

Despite her prolific output, Lisa has a grounded perspective of working as a writer in the horror film industry:

"I always laugh when I see someone referred to as an overnight success. There's no such thing. I guarantee you that anyone who says they're an overnight success has been working for at least five years. In my case, *Meet the Hollowheads* was the thirteenth screenplay I'd written and it was the first

one to sell. *Blood Angels* was rejected by a number of companies before it finally had a home. It took about three years for that one to sell. So if you're not someone who deals well with rejection, it's not going to be a good field for you."

DON'T WORRY, THEY'LL FIX IT IN REWRITE

In the theater, the script is the Sacred Word; in film, everybody's a writer. No matter how original elements in a horror film are, there is no guarantee that they will remain unchanged throughout the process. Despite Lisa's original intentions, the script of *Thralls*, like most in any genre, underwent significant changes once it went into production.

"In my original draft of the story, the women did triumph," Lisa remarks. "None of them died, and they had a very happy ending. But that was changed significantly. Unfortunately, that's one place where it did suffer a little bit from a case of sexism. The producers decided the women couldn't all survive, and the women had to turn on each other, so that was very disappointing to me."

While the movie was significantly changed from the original script, Lisa at least enjoyed seeing the opening sequence and appreciates any opportunity to have an original script produced.

"The reward for me was the first five minutes of *Thralls*," says Lisa. "The first five minutes it looked exactly like it was in my head, and it's a feeling beyond description to see these things you've lived with for years suddenly come to life. It's a really amazing, magical feeling. I've heard writing actually compared to magic, and I think in some respects that is pretty accurate. And then, of course, I can write an absolutely brilliant short story and maybe five hundred people will ever read it. But I can write a movie, and even if it's a mediocre movie, maybe ten thousand people will be entertained by it."

Labor of Love

The path of Lisa's first produced screenplay, *Meet the Hollowheads* (aka *Life on the Edge*), was not a smooth one. The 1989 film starring John Glover and Juliette Lewis is already defined as a cult classic by some. The story focuses on a family in a subterranean society whose lives depend on an infrastructure of tubes. An amazon.com reviewer described the film as a "tweaked-out live action cartoon vision of an alternate universe, sort of a *Leave it to Beaver* drops acid and goes to Jupiter."

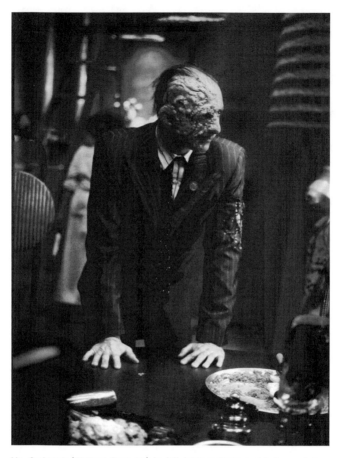

Mr. Crabneck (Richard Portnow) in full burn makeup and between takes during the filming of *Meet the Hollowheads* **(aka** *Life on the Edge***).**

Not surprisingly, the concept for this unique project originated in the special effects world.

"I'd been trying to sell scripts for a while," says Lisa. "I got to know a gentleman by the name of Tom Burman, who is one of the best makeup/effects wizards in the field. And I'd worked around the industry for a while in special effects. I did some model-making on films like *The Abyss* and *Star Trek*, and I had done a little bit of special effects/makeup sculpting for Tom. We became really good friends out of that. And he wanted to write and direct a movie, and I wanted to write one, so we started throwing ideas around to do something where he could use a lot of great makeup effects, work cheaply, and we hoped we could sell him as a director that way. I guess it ended up working."

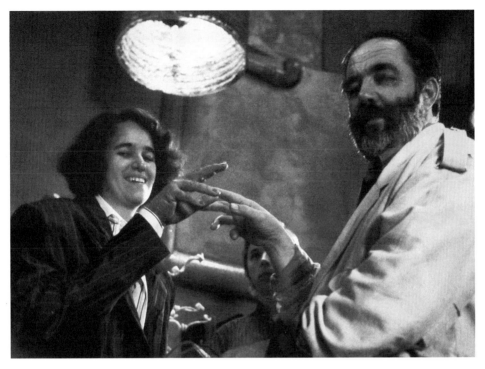

Lisa Morton: "This was taken while shooting a scene in which the family's fearless mom is defending herself from the evil Mr. Crabneck. While clutching a knife, she takes a swing and, much to her surprise, chops off two of Crabneck's fingers. When we got to shooting the effect, it turned out I was the only crewmember whose hand was small enough to fit inside the fake hand with the detachable fingers, so I donned the prosthetic hand and Mr. Crabneck's jacket. Co-writer and director Tom Burman is at right; Tom's left hand is holding the blood pump which will make those severed fingers squirt on cue!"

While they had success in getting the film produced, the aftermath was not as pleasant. The original title, *Life on the Edge*, was changed to *Meet the Hollowheads* (a title Lisa detests), the film was re-cut and re-scored, reviews were mixed, and on a recent DVD release, Lisa's name was omitted. At the same time, the film has found an audience, and Lisa still receives fan mail about the project.

Lisa kept a fascinating journal on her experiences of working on this film, which she converted to book form and posted on her website (*www.lisamorton.com*). In the introduction, she expresses her emotions as a first-time screenwriter and associate producer at the time:

"That's really what this book is about—the creation of a labor of love. In other words, this is the part of filmmaking they don't teach you about in film

school, the part you rarely hear about in interviews or read about in books. I know when I began work on *Life on the Edge* as a first-time screenwriter and associate producer, I had an image in my head, instilled by my college film courses and my lifelong interest in movies, of what feature film production would be like. That image, needless to say, was dashed in a matter of days. Aside from the technical aspect—which I found I was not as well educated on as I'd believed—I was utterly unprepared for the emotional and mental pressures and the day-to-day ups and downs."

These emotional upheavals are common for any first-time filmmaker and in a sense, an essential part of the process. But with each film you make, the experience will help diminish the pressures, and you will have a much stronger sense of what you're getting yourself into.

CHAPTER 3:

Digging up the Money

"So many filmmakers think the odds are against them because of competition and circumstance. And they're right."

—*Stevan Mena, Writer/Director*

Low-budget filmmakers either save enough money to cover basics while trying to secure as much free talent, labor, and gear as possible or they go out to look for funding from distributors or private investors. Finding the money to make and direct your own project is one of the most challenging parts of the film-making process. Not many people are willing to part with hard-earned dollars to support a venture as risky as filmmaking, especially if the director is young and inexperienced. Fortunately, horror films can be made on a shoestring these days, as discussed previously.

If money cannot be found, there are still other ways to get your project off the ground. Signing up for a film class at a community college gives you free access to all their camera equipment, studios, and editing bays. Your local cable access station offers the same opportunities. Networking and supporting other filmmakers will also benefit you when it's your turn to crank the camera and need a crew. Bartering for goods and services or offering credit in exchange for labor and services can greatly reduce costs.

However you approach it, you will still need a budget so you know the exact amount that is needed to bring your story to life.

What's it Going to Cost?

The script breakdown, described in the next chapter, is essential for making an accurate budget, as it lists every location, actor, and item needed for every shooting day. It lets you physically see what costumes, wardrobe, and props you need to beg or borrow in order to keep costs down.

There are two main components to a film production budget—above-the-line and below-the-line. Above-the-line items include the creative elements, such as rights for the initial play, book, short story (if you are using source material created by someone else), and the fees for the writer, producer, director, and actors. On a low budget film where the actors and filmmakers are working for free, this area is often blank!

Below-the-line refers to all of the technical elements such as camera and lighting equipment, production staff, rentals, props, and so forth. The below-the-line area is typically broken down into production, post-production, and distribution. Within each of these categories are line items. For example, the production section would include production staff, camera, lighting and sound equipment, rentals, catering, and so forth. Each line item is then broken down into specific detail. Production staff would include members of the sound department, wardrobe department, art department, camera department, etc. Keep in mind many things can go wrong during production, so it's good to have a contingency fund allocated in your budget to cover such catastrophic moments.

WHAT CAN GO WRONG?

The number of things that can go wrong in preproduction and production are too numerous to list, but Stevan Mena had more than his share while working on his 35mm feature *Malevolence*. His story about the challenges, and his willingness to keep plodding forward no matter what, will scare and inspire you about the process.

"On the first day of principal photography, the AD was driving the actors to the set in a rented van," shares Stevan. "He was trying to read a map and drive and smashed into someone from behind. The damage ended up costing us $15,000 right there because he didn't get the $12-a-day insurance. I fired him, but he still cashed his advance check for the first two weeks.

"And our crew was merciless. They charged us meal penalties for fifteen seconds over. They broke lights on purpose if we went overtime, they dropped a camera and broke a $5,000 lens. They cost me over $10,000 in damages. So before we even started, I was out $25,000 of $200,000 because of incompetence

and jealous colleagues. All members of a first-time director's crew believe they should be the ones directing instead, which is why they all give you dirty looks. At least that's what my PM said.

"Then we lost our principal location, the killer's house. The owner told us we could go in and do whatever we wanted, because he was going to rebuild next year anyway. He charged us a $1,000 location fee. Two weeks and $6,000 into art production costs, we discovered he didn't own the home and that the bank had foreclosed on him two years ago, and that this was his revenge on them, sending us in. I was arrested, but they dropped the charges after we agreed to repair the damage done from our ripping and aging walls. We lost a week of production, with people on salary. All told we lost $14,000 from that. *So* now I was out $39,000 from my $200,000 budget. And we had only shot ten pages of a ninety-page script.

"Then things really got bad. But it's just too depressing to recount. Let's just say that I ended up doing everything, literally, including waking the crew with coffee and donuts to running to the gas station to fill the generator with gas to driving the actors to and from the set after we wrapped. I was determined to finish no matter what. I just couldn't let the people who had believed in me down, or myself. Not to mention that every car (seven) in production was in an accident. Several months later when we went to do a reshoot, I brought along a whole new crew. I was recounting some of this to them while driving, including the car crashes of every vehicle. Later that day, I sent my friend Tim, who was helping as a PA, to pick up the actors. He never returned. He had gotten into a collision on the highway. He was OK, but both cars were totaled.

"While he was gone, we were threatened by a squatter living in the new killer's house we found. I had to hire a security guard. That was expensive. Did I mention the film lab we were using went out of business with all of our negatives locked inside? We had to find one of the techs who used to work there to help us break in and take it from their cold storage. That was crazy. We were running down 31st Street with our arms full of heavy negatives. Then things really got bad . . . "

POST PRODUCTION AND DISTRIBUTION EXPENSES

The post-production section of a budget includes editing, sound, visual effects, music, and any other items associated with the editing process. The distribution section contains marketing and publicity expenses.

Description	Rate	Pre-Production		Production		Post-Production		SUB TOTAL	TOTAL
		Days	Amount	Days	Amount	Days	Amount		
'BELOW THE LINE' COSTS									
PRODUCTION COSTS:									
C.	**PRODUCTION UNIT FEES & SALARIES.**								
C.1	**PRODUCTION MANAGEMENT**								
Production Supervisor									
Production Manager									
Production Coordinator									
Production Secretary									
Production Assistant(s)									
Runner(s)									
Location Scouting									
Location Manager(s)									
Assistant Location Manager									
Unit Manager(s)									
Unit Assistant(s)									
Travel Coordinator									
Transport Manager									
Transport Assistant									
Driver(s)									
Base Office Liaison									
Sub-total			0		0		0	0	0
C.2	**PRODUCTION ACCOUNTANCY**								
Financial Controller									
Production Accountant									
Accounting Assistant(s)									

Item					
Computer Rental Fees					
Software Programs/Licenses					
Sub-total	0	0	0	0	0
C.3 ASSISTANT DIRECTORS & SCRIPT SUPERVISION					
1st Assistant Director					
2nd Assistant Director					
3rd Assistant Director					
Script Supervisor/Continuity					
Sub-total	0	0	0	0	0
C.4 CAMERA CREW					
D.o.P.					
Operator(s)					
Focus Puller(s)					
Clapper Loader(s)					
Video Split Operator					
Camera - Casual					
Steadicam Operator					
Steadicam Assistant					
Sub-total	0	0	0	0	0
C.5 SOUND CREW					
Recordist					
Boom Operator					
Boom Op/Cable Runner					
Audio Playback Operator					
Sound - Casual					

Today there are many sample budgets that can be found online as well as software packages to help make budgeting and calculations easier. Reviewing sample budgets will help you think of items you might not have previously considered, such as transportation costs or location parking fees. If you are renting equipment or other items, you should call all the vendors in your area to get quotes. You can often negotiate better deals than their list prices. Your crew will also have tips on where to get discounts.

Too often, filmmakers focus their budgets on the production costs without paying attention to future distribution expenses. What is the point of getting your film made if you have no funds with which to promote it in festivals or to distributors? As discussed in later chapters, there are hard expenses (e.g., posters, festival fees, DVD or film/video duplication costs, Web site creation, and hosting), so even if you don't have the money now, some thought should be given to how you'll scrounge it up when the time comes.

Your best asset will be the people you surround yourself with. Your crew's experience, ingenuity, and contacts will help you keep your budget under control as long as you treat them with respect, maintain open lines of communication, and have decent craft service.

How and Where to Pinch Pennies

Because it is inexpensive to make a feature these days, there really is no excuse not to do it, other than a desire to maintain one's sanity and not get arrested. Seriously, if you have as much grit as Stevan Mena, there's absolutely nothing that can stop you.

Chances are, you will have crew and talent working for free or for "deferred" payment. Deferred payment, also known as a "backend deal," means you have agreed to pay a percentage of the profit after the film's release instead of a salary during production. Deferred payment is a bit of a joke in the industry. Although your intentions and hopes may be great, time and experience on low-budget independents has made most professionals know they'll never see a dime down the road. So in exchange for free labor, you must at a minimum feed your people and provide plenty of bottled water for long, brutal days under broiling lights. In other words, *feed your crew well*, or some real horror will happen off-screen.

Catering fees add up quickly, because a few bags of chips or stale doughnuts simply won't do without risk of a mutiny. Crews expect a craft service with food that they can graze on continuously and at least one hot meal a day. If you

have connections with restaurants, grocery stores, catering services, or other venues, tap them for discounts and buy in bulk.

Another area where you should never penny-pinch is reasonable scheduling. You may only have a budget for a ten-day shoot. Your crew may have agreed to fourteen-hour days and make allowances for stretching to 16 or 18 hours on special occasions. But once you pass a certain number of hours, especially over the course of a few days, frustration sets in, morale drops, tempers flare, and exhaustion takes over rationale, meaning it can take much longer to do a simple task than one would on a good night's sleep. Obviously you can only work within your financial means, but there is nothing worse than watching your crew or even a few crucial members march off the set.

If your budget is that tight and you envision this as a possible scenario, you may want to consider A and B crews. The A crew would be your master crew for all the principal photography. Your B crew could be a skeleton crew picking up more general shots, such as exteriors, stabling shots, pick-up shots, and so forth. A common option is to break up the shoot over the course of several weekends so that there is a break between the madness. This has some risk, as people might drop out between shoots, continuity has to be tracked that much better, and the whole process is lengthened. Regardless, scheduling within reason is something to strongly consider when planning and budgeting.

Unless you have your own equipment, rentals can quickly add up. As mentioned earlier, signing up for a course at a community college gives you free access to all sorts of gear at a minimum cost. The college where I teach, for example, offers a lab class for less than $50 a semester that allows a student to use all their camera, film, and video equipment, not to mention editing bays and student discounts with local vendors. My students often surprise me with their ingenuity. One student wanted to have a Steadicam for a production but couldn't afford the rental. He rigged a device that mounted the camera on a pole attached to a wooden board he could press against his abdomen. Being able to grip the pole while keeping his eye in the viewfinder and the weight against his body gave him the smooth results he was seeking. I've also seen boom poles made from broomsticks and other clever contraptions that help save significant dollars.

Sets, props, and costumes can also be a monetary challenge. An experienced production designer will be an invaluable asset if he or she has good contacts and expertise in creating or securing items at little to no cost. A production designer should be brought into the planning process early to have adequate time for building or securing materials within the budget constraints.

Actor AJ D'Amato is caught in a tight spot in a crawlspace, production designed by Katherine Bulovic. Photo credit: Anna Maria Prezio.

"A lot of times sets are challenging, because you don't have the money for what you need to do or would like to do, but you've still got to make it work for the cinematographer," says production designer Katherine Bulovic. "So you have to think it out and be creative in other ways. I recently had to build a stone wall within a cave. I was originally planning on renting some scenery, but it fell through. We were shooting in the morning, and I had no other choice except to figure out how to build that wall myself by making some scenery. So I stayed at the Home Depot for a few hours until I figured out what I was going to do and solved it visually and got the set done in the morning. I've done enough walls in my life. You need to be an artist and be sensitive visually about your surroundings. So if someone says 'brick wall,' you have to consider a lot of factors. What period brick wall are we talking about? An ancient castle in England, or are we talking stucco? Are we in Mexico, or are we in Hawaii? On one shoot I had an actor in a crawlspace I constructed, and the director wanted the feeling that the space was cramped and tight with names of previous male victims scratched in blood. I chose short names like Bob so they could be read easier visually. You need to be able to pull these things out of your mind, because with experience, you've gathered a visual history in your creativity box, which is your imagination."

Film Fundraising

We've all heard of some of the unorthodox ways filmmakers have raised funds for their films, such as maxing out credit cards. This is not advised, as the few

credit card success stories you might have heard about are one in a million and you could spend many years paying off an incredibly high-interest debt. This can easily kill your creative spirit as you will undoubtedly feel reluctant about ever making another movie at such a price.

Fundraisers are becoming a popular way to raise small sums of cash toward a production. For example, if you have friends who play in a band, perhaps they would be willing do a concert where all ticket sales go toward the making of the film. You may only raise a few hundred dollars this way, but it's a start.

GOING AFTER REAL MONEY

Your project may be ambitious enough that you need a fairly significant amount to fund the production, at least more than you have in the bank. In this case, you will need to approach others for funding. One way is to seek out larger production companies, which have all the necessary equipment and staffing to make a feature possible. You could suggest to a production company that a partnership relationship be established, which would allow you to use equipment and staffing in exchange for a percentage of the film's profits. Another way is to try to secure a grant, though these are becoming relatively scarce and difficult to acquire. A third approach is to go after private investors, whether that's through a local business or your wealthy Aunt Martha.

In order to convince anyone to write a check, you will need to prove that your film is a worthwhile investment. The first thing investors will care about is the profitability of the film. Films do not need to be high budget or "Hollywood" style to capture investors' attention, as there are plenty of low-budget success stories. However, they will want to see a solid plan of action. This plan should be well delineated in a film proposal that you give them along with your script.

FILM PROPOSAL

Film proposals vary but there are common items that should be included:

1. Story Synopsis—a few paragraphs describing your film
2. Program Structure and Style—the creative approach you intend to take
3. Relevance of the Project—why audiences would want to see your project, perhaps comparing data from other films in a similar genre and budget
4. Production Budget

5. Plans for Marketing and Distribution—your concrete plans for marketing and seeking distribution upon the film's completion.
6. The Production Team—biographies on the key talent and crew members.
7. Pertinent Articles or Resources supporting the relevance of the project
8. Contact Information

To protect investors and yourself, you will need to create a legal entity that describes the investor/filmmaker relationship and agreements. There are many such entities which would take an entire book to describe. If you can't afford an entertainment attorney, talk to filmmakers who have gone through the process and do your research to discover what type of agreement best suits your particular project. I highly recommend *The Independent Film Producer's Survival Guide: A Business and Legal Sourcebook* (Shirmer Books; 2nd Edition, February 2005) for a myriad of important legal and business advice and sample contracts and agreements.

If you do get an investor interested enough to meet with you, you will have to "pitch" that individual in person. A pitch is a sales presentation in which you, by presenting a host of persuasive reasons, try to convince your customer (investor) to buy or take part in your product (the film). This may seem daunting if you are not a salesperson type, but think of it as an opportunity to show your passion and why you believe the film needs to be made. It is a chance to go over your proposal, explain how an investor relationship would work, and how it can benefit the investor. The last point is very important as the investor will want to know, what's in it for me? The need may not just be monetary. Many business types are intrigued by artistic professions so you may be able to tap in on a creative desire. You may also be able to tie your story into the investor's business. For example, if your film predominantly takes place in a dance club, a local dance club may see the potential publicity your project would generate for the club. If you live in a more rural area, local businesses may be more likely to sponsor your film for the good of bolstering community efforts and awareness. Before meeting with an investor, think about why your project would be of particular interest to that investor and use that as part of your pitch.

Trailers are also a viable and popular way to raise funds so that a potential investor can more readily imagine how the film will look, the quality of production, and the story's intrigue. A trailer may consist of a highly dramatic scene in the film or it may be a series of clips cut together like a preview trailer.

Whatever the approach, the goal of the trailer should be to entice potential investors to want to see more and reach deep into their pockets to help make that happen. To get *Malevolence* off the ground, writer/director Stevan Mena found that having a trailer made all the difference:

"I started with about $50,000. I ignorantly thought that was a lot of money. I had it all planned out, two to one ratio, 16mm, do all the work myself. Then about a month before shooting, my partner dropped out, believing we were crazy and getting cold feet. And I guess he was right, but I didn't care. I took my $25,000 and shot a short trailer to generate funding. I was able to raise $200,000, through the help of my cousin Alex and friends and family and some business people we knew. No one cared that I had a competent script, but when they saw the trailer, that sealed it, I guess. When you're trying to get people to invest in film, show them a film. We literally went to everyone who said no, and got them to change their minds overnight. Our final budget was $225,000."

There are many legal issues involved in raising private money. Private investments can be subject to many securities laws and laws relating to contractual arrangements, so it is imperative to have good legal counsel. Yikes, you think—one more expense I can't afford. However, the risks and consequences of not meeting legal requirements can be far greater than *your* investment in an entertainment attorney who can assure that you are doing things correctly.

CHAPTER 4:

planning for gore

"I've worked on a lot of them, and good pre-production
has helped incredibly and made things
move a lot faster than normal."

—*Bud Gardner, Cinematographer, New York*

So your script is written, you've scrambled together some funds and at last you're ready to make your movie. Your enthusiasm is probably pushing you to set a date in the near future so you can actually be doing what you love versus just talking about it. However, pre-planning for a film takes considerable time and care. The more time you spend in pre-production, the more likely it is that your schedule will go according to plan while not breaking the bank. This may seem truly simplistic, but it is surprising how many filmmakers neglect this process, as eager as they are to get something on film or tape.

"Chances are you'll only get one opportunity to do this, if you're lucky," says Stevan Mena. "So make the most of it, because there are millions of people out there waiting to shred your artistic endeavor to pieces. Give them as little ammunition as possible."

The filmmakers quoted in this book usually allow at least four to six months for this crucial stage, if not longer. What you do in this early stage will have a direct impact on the production and post-production stages.

Following are some essential preproduction activities that need to take place:

- Assembling your pre-production team
- Storyboards
- Script breakdown and shooting schedule
- Location scouting and permits
- Budgeting
- Casting of talent
- Crew selection
- Creation of special effects
- Sets, props, and costume procurement
- Acquiring film/video stock and equipment rentals
- Deal memos and other agreements
- Rehearsals

Assembling Your Pre-Production Team

In making a low-budget film, you are never going to have the production army that surrounds a typical Hollywood film. However, whether you have one crew member or twenty, many of the jobs that need to be done are going to be the same. Some of these tasks can be assigned to your best friend on the afternoon of the shoot—"Go pick up the actors at the train station!"—but some of the jobs will be sustained throughout the entire filmmaking process. You should decide who will carry the titles listed below, even if some people will be wearing many hats, before you take another step. It will be critical to your filmmaking process that these roles be brought on board during the pre-production stage for all of the planning that is necessary.

PRODUCER

This person is responsible for the business side of the film and manages the overall production. He or she concentrates on the "big picture," from financing through distribution, allowing the director to focus on the creative aspects.

DIRECTOR

Working with others on her team, the director is in charge of all the creative elements for each scene, including the composition, lighting, content, and performance. In low-budget productions, the director often acts as the First

Assistant Director (AD), who otherwise is responsible for scheduling the shoot. Also, the director typically takes a very hands-on approach in post-production on low-budget projects, including the editing and sound mix.

Some think that the job of first AD should not be taken on by the director, if at all possible. Michael Hein says, "I think a good first AD is important. Somebody who's got experience and is a good go-getter, and, if at all possible, has good people skills. The AD always gives the bad news—always tells people we've got to change this; we've got to work late tonight; we've got to do this; look, you're not carrying your weight; you screwed this up. So the first AD is always the bearer of bad news and usually the person on set that's most disliked. So finding a first AD that has good people skills is essential in my opinion."

DIRECTOR OF PHOTOGRAPHY (CINEMATOGRAPHER)

This role is critical for the overall visual look of a film. The DP works closely with the director in the planning stages to ensure the appropriate film or tape stocks, camera angles, lighting, and so forth are carefully thought out prior to actual filming. In big-budget films, the DP may not actually run the camera, but on a low-budget horror film, chances are he is doing camera and often lighting as well.

"The first person I bring on is the DP," says Michael Hein. "You should really bring that person on immediately."

PRODUCTION DESIGNER

The production designer is in charge of the design of the sets and props and works closely during pre-production with the director and DP to ensure an aesthetic look that matches the director's vision.

"Look for a production designer that has a sense of the aesthetic and doesn't only have film experience as a production designer," Kathleen Bulovic advises. "Most come from the world of theater or from the world of architecture. And if they have any experience like that, that's a benefit. I, myself, come from the world of theater and have worked on a lot of stage plays. I've taken many of those experiences and transferred them to film, and they work very, very well. You know if a production designer has done any theater, he has worked budgets that are much smaller, and he still had to make it work. Also, an artist is visual in a lot of different ways, so seeing that diversity in a portfolio is a plus. I like people that have a sense of color. Of course, today we have DVD

and HD, and we need to be careful with textures on the set so we don't get moiré, where patterns start to vibrate, which they don't do with film. So the production designer needs to have the experience to be aware of all these things."

COSTUME DESIGNER

If your project requires distinctive wardrobe pieces rather than "street" clothes, a costume designer should be sought during pre-production to purchase, rent, or make the articles. Like Katherine, costume designer Lynn McQuown agrees that theater experience can be invaluable for all art department members:

"I think that the best training you can get to do costume design is through a theater program, as it's where you can learn all about costume choices based on character and the history of clothing and fashion, and how color works with light. At the same time, certain projects might require a sense of style, where the person doesn't have to know anything about what somebody wore fifty years ago, such as an MTV music video where they understand the character of the band because they know the band and they just want to create some funky look. Those people are called stylists instead of designers, but it's just as valid."

SPECIAL EFFECTS

If you plan to use special effects in your film, the planning and creation of effects must take place during pre-production. Special effects are mentioned at this point only briefly, because pre-planning for them is very important; however, they are discussed in detail in chapter 8, "SFX—How to Make a Monster."

"After the DP and AD, the next order of business, if it's a heavy effects film, like our film *Dead Serious*, is to get down with your special effects artist," recommends Michael Hein.

"Most people underestimate how much time effects actually take in pre-production and production," warns Anthony Pepe. "Pre-production is the worst. I will usually get the call probably a week or two before they're ready to start rolling. In all honesty, if you're doing any kind of special effects, we should be the first people you call, because of the time involved plus I'm scheduled on other things. I had a guy call me up who wanted a giant German shepherd prop literally in six days. I said, 'Well, I can make it in six days, but the price almost triples because I will have to work almost twenty-four-hour days now.'

"When a director contacts me, before we even start talking money, I ask to see a script. Usually I get a chance to read it, break it down, and understand

exactly what kind of effects the director wants and in which scenes they are going to be played out. And then you'll get a lot of scripts where the directors won't exactly elaborate on the effects, because they're just not in that mindset. They want to make an action movie and say 'oh, this guy gets shot,' instead of elaborating on exactly what happens in that scene. You have to use your own knowledge and bring in questions like, What kind of a gun was it? Where was he standing? How close was he? Things like that determine how the effect is going to be done and what it's going to cost. If it's a wide shot where you see people getting shot in the background, you can cheat it real quick with just a little blood makeup. But if it's a super close-up you might have to go to a fake head with a real gun or some kind of incendiary device. You could create a gunshot either way, and that's just a basic effect. If they start talking monsters and stuff like that, then you have to get involved on the design aspect of what this monster is going to look like. Most directors I've dealt with are not exactly illustrators; so since I'm an illustrator, it helps, because I can draw out what they're thinking and get a good idea of what it's supposed to look like. And then I'll decide what the effects budget's going to be.

"Now when I break down a budget, I usually go with what the supplies cost, how many days it's going to take for me to build it, and how many days I have to be on set. There are so many different factors involved."

LOCATION MANAGER

This person is responsible for finding suitable locations and coordinating necessary permits, parking, and security or police assistance if necessary. It is important to have locations secured early on so that the director and DP can plan storyboards and camera shots around their physical restrictions.

Storyboards

Storyboards are panels of cartoon-like sketches that depict each shot or scene in a film. They provide the first means for visualizing a script from text to images. They also help determine the location, camera setups, and shot compositions. While not essential, storyboards are invaluable for streamlining a production, often helping to save hours on set. Also, they aid in communication between the various film departments. For example, the director, cinematographer, and special effects artist can use storyboards as a visual reference for an effect they are attempting to achieve.

A storyboard page from the "Dinosaur Graveyard" sequence in *Adventures in Dinosaur City*, scripted by Lisa Morton.

Camera blocking, the process of deciding where the camera will be placed to capture the shots as envisioned, is also significantly helped by storyboards, as they provide a visual framework depicting the action and camera directions.

For the artistically impaired, there are storyboarding software products. Some software programs provide templates and clipart to string shots together. Other packages are more comprehensive, combining scriptwriting

and storyboarding software. Even drawing stick figures by hand is better than nothing, as at least it takes you through the process of imagining how each scene might look.

"When at all possible, I highly recommend the director does a storyboard," says Michael Hein. "I didn't my first time out, and I wish I had, even if it's just basic storyboards for each sequence of the film. If you can't afford an artist to storyboard everything, at the very least have storyboards of the major sequences in the film. The biggest thing on an independent feature production is scheduling. Storyboarding helps your blocking out an awful lot. You go in and look at your storyboards and say, 'Okay, this is going to be our first set up, this is going to be our second set up,' and then you can improvise around that if you want or need to."

Of course, innumerable situations can throw a storyboard out the window in the low-budget film world.

"There are various problems that arise that you can't throw money at or you can't fix," says Bud Gardner. "Maybe you lose the location because someone gets greedy at the last minute. You have to be able to think on your feet and improvise around situations that might come up. That's the whole key of doing low-budget movies, being able to think on your feet and still maintain integrity of the story but be willing to alter it a little bit, because shit happens."

Storyboards provide a starting point from which we can deviate. It is a guide, not necessarily a depiction of the final film. It will undoubtedly be changed based on location logistics, improvisational opportunities, or time crunches, much like the script itself is altered in the process. When making his vampire film *Habit,* Larry Fessenden took a flexible approach to the process:

"When I write, I think in camera angles and cuts, and from there I build the movie with drawings and photos, test footage, whatever it is up to the first day of production. And each night during the filming I would prepare these little storyboards to structure the shoot. My ideal way to work is to establish a strong design for each scene through the storyboards, and then to open up to my collaborators when we're on the set so we can use the best ideas that are suggested by the reality of the shoot. It's important to be flexible and to strike a balance between design and spontaneity."

"You should never go out and shoot blind," advises Bud Gardner. "I did a movie called *Gratuitous Sex*, by Paul Richards. I shot four days of cutaways of bullets going out of guns, the chamber rotating. It was all micro-photography, and we did it in my studio after principal photography. He had these horrible stick-figure drawings, but he had it very well planned, and we did different

people's inserts [close-up shots filmed after principal photography for insertion in editing] from the fingernail being colored with nail polish to close-ups of moving lips and whatnot. A lot of people work in more general terms where they have a master shot, close-up, or a dolly shot planned, but until you really get to the physical location, you're not sure if it's really going to work."

OTHER FORMS OF CREATIVE VISUALIZATION

In addition to storyboards, one way to help capture the visual aesthetics you are going for is to find similarly styled images to share with your production designer.

"If you've written a script yourself, and you've visualized it in some way, it would be to your advantage to find pictures for yourself out of books, magazines, or on the Internet, so you can show them to the designer that you bring in," suggests Katherine Bulovic, an experienced film, television, and theater production designer in Los Angeles. "I've had a few people do that, and you get a whole feeling of what they're looking for. Otherwise, the designer can pull some pictures out to see if this is the direction you're thinking of visually. So if you see something you like, gather the image and start making a folder, whether that's in paper or electronic form. The image doesn't necessarily have to be reproduced verbatim; it's about getting inspiration for the direction you want your designer to go in. I've been fortunate, as most directors I have worked with believed in my sense of aesthetic and just let me go with what I needed to do."

The same principle applies to costuming.

"You have to have some kind of visual aid," says costume designer Lynn McQuown. "The costume designer can do sketches or bring things in if they have access to pieces and say this is what we're thinking about. Sketches are best because they force you to think about details, as opposed to imagining something in your head. So renderings are good. Basically, everybody has to talk about the look. The designers need to be in meetings with sketches, fabric samples, or a color palette. There's an idea behind the whole thing that comes from the director, and then within that framework you add your own ideas, but they all have to mesh together with the sets and lights and everything else."

"The production designers are brought into the process at the beginning by the producer and director," explains Katherine Bulovic. "It's imperative for them to have read the script so they know what is going on in the story and what the director's vision is. But if anything needs to be built, you must bring

the production designer on board really early, because you need time to arrange these things. It's important for the production designer to communicate with the costume department. They need to coordinate the look and the feel of the characters and be in communication about color and style and bring that in together with what the director is going for. An experienced production designer knows which shops to go to, whether they're thrift shops or prop houses. People on your crew might even make suggestions. Once we were shooting in a very, very remote location, and I had to find some live trout for a scene. When you're in the middle of the wilderness, there aren't yellow pages to look up 'trout buying.' We were at a stream that had no fish in it, and there was a scene with fish. One of the guys on the set knew the area and remembered he had fished not too far from there, so we sent some PAs to buy fresh trout, and we put them in the river for the fishing scene, and it worked. For me, I think on my feet. I've done so much and learned so much from my experiences of doing this that I can draw from my past. It may be from past shows, theater work, or even work doing visual merchandising. When the need is there, it comes to you."

Script Breakdown

Script breakdowns help you determine how many days it will take to make your movie, and they are usually created by the director and AD, if there is one. The script is literally "broken down" to include every detail of each scene, such as:

- Cast
- Extras
- Special Effects
- Props
- Vehicles/Animals
- Wardrobe
- Makeup/Hair
- Sound Effects/Music
- Equipment
- Miscellaneous Shooting Concerns

Each of these components is physically highlighted on the script with specific colors and notations that are used and accepted by the film industry. From this, the filmmaker can visually see what scenes need which elements and can schedule accordingly. The assigned colors and notations are:

Element	Color
Cast	Red
Extra (Atmosphere)	Green
Extra (Background)	Yellow
Stunts	Orange
Special Effects	Blue
Props	Purple
Vehicle/Animals	Pink
Wardrobe	Circle
Makeup/Hair	Asterisk
Sound Effects/Music	Brown
Special Equipment	Box

With this information, it is much easier to arrange shooting days in a logical order from a practical point of view. For example, if some of the scenes in a film are set in the same location but are not to be consecutive in the final film, it would be more efficient to shoot all of the scenes that occur at that location together than to shoot them in the chronological order in which they are to appear in the final film. After the order is determined, the schedule for the actual days at that location can be determined in light of talent or effects needs. This process will help save time and money, as you will avoid unnecessary set-ups and tear-downs of equipment or having lengthy stunts or makeup changes on already-packed days. The breakdown then results in a shooting schedule that is given to talent and crew. The shooting schedule gives a detailed daily plan with call times and also includes the scene numbers, number of pages in those scenes, and the talent, props, makeup, and wardrobe necessities. The lower the budget and the tighter the shooting schedule, the more important this document will be.

A significant consideration is the safety of your cast and crew. What will happen if someone gets injured or ill on set? It is very important to research and include on the shooting schedule the nearest hospital address, contact information, and directions from your location. On a side note, be sure to have a first-aid kit on set stocked with bandages (large and small), burn cream, aspirin, and other basic medicinal supplies. You might be surprised at how often that kit will be opened.

SAMPLE SHOOTING SCHEDULE

Day/Date	Scene	Int/Ext Day/Night	Shot Descriptions/Summary	Location	Characters	Art Department / Equip / Special Requirements
SHOOT DAY 1						
0800 - 0830			Breakfast on arrival at location			
0900 – 1015	3	Int/Day	Chloe arrives home and overhears Dylan and Neil discussing a recently murdered friend	Chloe's house – kitchen and hallway	Chloe Dylan Neil	Coffee cups Newspaper
1015-1330	7	Int/Day	Chloe and Dylan argue about the murder	Chloe's house - hallway and living room	Chloe Dylan	*STEADICAM*
1330-1430			Lunch (set up in garage)			
1430 – 1800	13	Ext/Int Day/Dusk	The Serial Killer watches Chloe enter her house from behind a tree	Chloe's house – front entrance	Chloe Serial Killer	Mask Hatchet
SHOOT DAY 2						
0800 - 0830			Breakfast on arrival at location			
0900 – 1300	2	Ext/Day	Chloe parks in front of her house and enters	Chloe's house – front entrance	Chloe	Car House keys
1300 – 1400			Lunch (set up in back yard)			
1400 – 1700	15	Int/Dusk	The Serial Killer enters the bathroom where Chloe is taking a shower	Chloe's house – hallway and bathroom	Chloe Serial Killer	Mask Hatchet Towels Bathrobe Blood mix SFX hatchet
1700 – 1800	14	Int/Dusk	The Serial Killer climbs the stairs	Chloe's house – stairway	Serial Killer	Mask Hatchet

Location Scouting and Permits

Scouting locations takes time and is often handled by a location manager, should the budget allow. In low-budget situations, it is usually the filmmaker who does this task, leaning on friends, family, or other contacts to acquire sites.

There are many technical considerations you need to take into account when scouting locations. For example, is there enough power for the lights, or will you need a generator? (If you take a chance on this, at least know where the circuit breakers are.) What external noises, like low-flying planes or heavy traffic, might interfere with sound? Will you need to block sunlight if there are windows and you're planning a "day for night" shoot? When shooting a low-budget short in Chicago years ago, I found the perfect location through a friend—an upscale urban apartment, which was exactly what I was looking for—but I visited it briefly and at a quiet time of day. Once we went into production, the street turned out to be an ambulance route for a nearby hospital. The sound logistics were horrendous, and as I was unable to do multiple takes for lack of time and funds, I had to record separate voice-over tracks to capture the dialogue and use cutaways or reaction shots for those parts where lips didn't synch. I certainly learned a few lessons on that shoot!

There are also creative considerations about a location to take into account. "The location for *Malevolence* was like another character in the movie," says filmmaker Stevan Mena. "A location can really set the tone and supply the right atmosphere. If you shoot a movie in your mom's backyard, people know it."

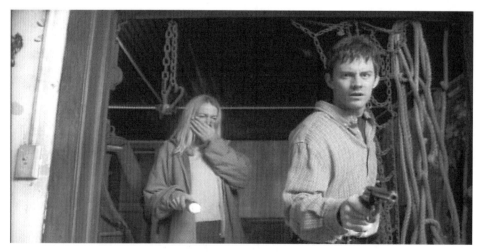

Brandon Johnson and Samantha Dark in the slaughterhouse.

"Just because you have grandma's house that you're able to use, you need to think, as a filmmaker, is grandma's house appropriate for the story?" agrees Katherine Bulovic. "Is this going to look like the type of house your lead characters would live in? If not, how can we modify grandma's house to make it work? A good production designer will do that. He or she will ask questions about the characters, what is their background, how much money do they make? You have to make a story for yourself about the characters so you can start eliminating or adding to a given set that you already have. Maybe your female lead is drinking from a champagne flute. Well, if there aren't any in the house, we have to go get them and bring them in."

As Katherine implies, the locations are also a key component of your overall art direction, which has an impact on the cinematographer's pre-planning process. It is therefore important to involve your cinematographer in the location scouts if possible.

"An important thing is seeing where you'll be shooting the movie, the locations," says Bud Gardner. "They bring in the whole variable of art direction, which I feel is really important to a movie. Have it properly propped, have the right amount of extras to make the scene seem real. It's kind of boring to have two people in a bar with no one else in it. You don't believe it's real. So there are a lot of little elements that you discuss in pre-production."

All films require permits for shooting at any location, with certain cost breaks for students and nonprofit or government organizations. Every state has its own permit applications and fees, which can be easily found through a state's film permit office. Fees vary greatly by state and are influenced by such things as the location (physical and geographical), the size of the film's budget, and the need for police or other city assistance, such as blocking streets to park grip (lighting) trucks and trailers. Today there are a host of sites that can help you acquire permits online, which you will readily find if you search for "film permits."

Despite the legal requirements, most ultra-low-budget productions sneak through the cracks as the funds simply aren't there. While it is usually safe to film in a friend or relative's home or in a remote locale with minimal gear, the consequences of not having a permit can be dire, particularly if you are caught at a time when creativity needs to kick in.

"I worked on a low-budget film where we were at someone's home and getting ready to shoot an evening scene, and we got shut down because we didn't have a permit," recalls Katherine Bulovic. "Even though the woman said it was her home, and she should be able to do what she wants in her home, the town

we were in said you can't, and the police shut us down. We had to re-create the scene in a different home. The scene was about a man and a woman who were angry with each other, and they were having a fight that was leading up to the woman killing the man, but prior to that we still had to get through more of the conflict between the two of them. We tried to match it and became extremely frustrated.

"I had the Polaroids of what my previous set looked like, and I kept going over them, but the new location was just too different and far apart from the visuals we had established at the other place. I told the director we couldn't shoot it from any angle. It wouldn't make any sense, and it wouldn't to the audience, visually. So the director said okay, we will then make believe we are now in her apartment, and not his apartment, and all the action will progress at that point. And that just made it a whole lot easier. But you need a director that's flexible and that's willing to see that if you can't do it one way, you can try it another way. That was refreshing because it really did work."

Low budget productions are all about flexibility. If you are able to acquire a permit, it is strongly suggested as it can save you money, time, and anxiety in the long run.

Budgeting

Information for creating a budget and raising funds was covered in chapter 3. This is a flexible document that may change, even if actual funding does not, as unanticipated expenses can occur. It is important to do a budget in the pre-production stage, even if you are not seeking outside funding, as it will affect all other areas of your production in terms of what is feasible for the allocated items in your budget.

Casting of Talent

SAG has a variety of ultra-low-budget and student film options, which might suit the filmmaker's purposes. There are contracts that will allow you to work with SAG actors and offer them no upfront compensation at all; the problem is that these contracts might contain other kinds of restrictions that would make them unattractive to an independent filmmaker. And of course, it also depends on where you are casting your film. You will have less trouble finding an actor with training, who is eager for professional experience, if you are casting near an entertainment center, like New York or Los Angeles, or near a university that has theater and film departments, than you will in a lower profile location.

When filmmaker TJ Nordaker was in pre-production for *The Janitor*, he and his partner, Andy Signore, spent considerable time in the audition process. There are some hilarious auditions in their behind-the-scenes documentary on the DVD that show just how excruciating this process can be. They placed an ad in a local trade paper and held auditions over a three-day period. Each actor read a scene involving the character he was auditioning for while being videotaped so that the filmmakers could later review and compare talent. Although it was a time-consuming affair, the investment was still worth it, as a less-than-proficient actor can truly murder a scene.

Once you have selected talent, a big problem that can arise is scheduling. If you are not paying your actors, they still need to make a living and so must schedule around their employment and other obligations. They may also get important auditions or better acting opportunities during production, or they may simply flake out on you.

"Our main concern in casting was basically finding people who were going to stick with us," TJ recalls. "Since you're not paying them, they can walk off at any second, and then you're screwed. You have to recast, you have to reshoot. So in the casting, we did a few call-backs to make sure they were interested in doing the project. I think we had them come back five times to read, and we dwindled down to the people who we felt were really on board with the project."

When it came to casting one of the main characters, a young custodian named Willis, the filmmakers had a difficult time finding the right type of actor. The cinematographer for the crew, John Carreon, had been taping the auditions and felt he could do better himself. Although he had no previous theatrical or professional training, he read for TJ and Andy and they liked his unique take on the quirky custodian, landing him the part. As the filmmakers discovered, it is not always the credits on the resume that make an actor credible, but how well he or she understands and transforms the character on paper into a unique living person.

Crew Selection

In addition to your pre-production team, you will need additional crew members to complete your production, such as a composer, a sound engineer, lighting personnel, and post-production support. A common phrase in the industry is that you're only as good as the people you surround yourself with. Your essential crew members, such as the cinematographer, will have plenty of recommendations of people they have worked with before, and it behooves

you to go with their suggestions. The more comfort and familiarity your crew has from working together, the more efficient your production will be.

"Basically, we figure out the financial strategy of the film, what we have to work with, and that determines to me how many crew people I can bring on," says Bud Gardner. "That determines the pace that we can set on a schedule. The more people you have, like on a Hollywood film, you can shoot, edit, and be out in a couple of months. The credit lists are literally with 1,000 people working on them. In the independent world, you don't have that luxury. I work with a lot of first-time directors who have done shorts or a commercial or two or a music video and try to get an idea of what kind of visual style they'd like. When I did *Atrocity Exhibition*, the director wanted it to look like an Andre Tarkovsky [*Solaris*, *Stalker*] movie, and so we used a template of *The Mirror*, one of his lesser known movies, to derive a look from. Tell me a movie that looks a certain way, and we can duplicate it to the best of our ability depending on budget."

Bud recommends finding experienced crew members, especially in areas where your own skills may be lacking:

"You should hire the most experienced person you can if you're inexperienced. Why have an inexperienced co-pilot, when you can have an experienced one that can help you. Experience gets things done faster. Experienced people know all the shortcuts and the tricks that you just have to learn. You're not going to get them just by sticking the camera out the window of your car and shooting landscapes and running around like a monkey in a room with a video camera. If you want to tell a coherent story, have people who know how to do that."

On larger productions, there is a definite sense of hierarchy and separation of duties among departments. There have been many grumbles when one department steps on another one's toes, leading to tension and a pervasive negativity on set. In the low-budget world, this hierarchy can be exceedingly negative, as it takes a team approach to make a project possible. Each crew member must often wear multiple hats and put egos by the wayside. This is an important consideration when selecting a crew. For example, is your sound engineer willing to help the lighting guy tape down cords on set? Is your script coordinator going to object if you ask him or her to run errands for missing props?

In the big-budget world, the department roles and responsibilities do serve a purpose, and the rights of crew members must be respected. But compared to this world, low-budget filmmaking is like the mom-and-pop shop—every family member must do his or her share to keep the business alive.

CREW TITLES AND RESPONSIBILITIES

Following are additional crew roles and responsibilities in addition to the key team members discussed previously. There are many other titles on major film productions, but as they are infrequently used in low-budget films they are not included here.

Assistant Directors (ADs). The assistant directors are the director's link with the cast and crew during production. They communicate everything that needs to be done on schedule. On a low budget production you can usually get by with just a first AD (the primary assistant director) to keep track of scheduling issues, as described earlier.

Script Supervisor. This person makes sure there is continuity between scenes and records information about the filming process, the quantity and quality of shots, and also keeps track of dialogue in case a cue is needed. Ensuring continuity is challenging, especially when shots are done out of sequence. For example, if an actor uses his right hand to pull out an axe and his left hand to wipe blood off his face in a long shot, the script supervisor tracks such details to ensure that they are not altered in other shots that cover the scene.

Sound Mixer and Boom Operator. If shooting on film, a sound crew is essential. Film cameras don't record sound, so it must be captured separately through a sound mixer. Although video does record sound, a sound person is still needed to hook up microphones, operate the boom if required (a pole on which a microphone is mounted to record sound from above or below the action) and listen to the quality of the recording in case there are microphone problems or other audio interferences.

Gaffer, Grips, and Electricians. The gaffer is the chief lighting technician on the set. The gaffer provides the necessary power and equipment to supply the lighting needs in a scene with the assistance of electricians, whether that means using existing power in a building or a generator. The "best boy" is the assistant chief lighting technician and is in charge of organizing equipment and manpower. There are also "grips," who assist with lighting. They work under the guidance of the key grip and set up lighting accessories such as flags, nets, and dolly tracks to control the lighting. In simple terms, the electricians turn

on the lights while the grips create the shadows. On a very low-budget production where you have minimal lights, one lighting person is probably adequate for the job.

Wardrobe, Hair and Makeup. In addition to support for your costume designer, you may need a professional hair and makeup person, particularly if you're going for extreme looks. On most ultra-low-budget productions, one person handles both hair and makeup, with the assistance of the special effects person when necessary.

Production Assistants (PAs). If you can find assistants to work in each department, hooray! In the competitive film industry, there are many students or recent graduates yearning to earn a credit, so you can often find such help at little to no cost by posting your project on an industry Web site. PAs are invaluable in helping to coordinate logistics, find props, run errands, make phone calls, handle parking issues, and "fill in the gaps" if your crew is small.

Caterer and Craft Service. As mentioned in various chapters, you must feed your crew, especially if you're paying them little to nothing. Having snacks, hot meals, and plenty of water is essential for keeping up your crew's energy and spirits. On larger productions, the caterer supplies cooked meals while craft service provides the day- (or night-) long grazing table of snacks, drinks, coffee. On low-budget productions, one person usually handles both jobs and pizza orders are a common lunch staple. Keep your crew's physical state in mind and try to offer fresh fruit, energy bars, and other healthy fare if you plan on fast food meals under budget restraints.

Photographer and Documentary Shooter. In the age of DVD, it is important to capture "behind the scenes" video and stills for promotional purposes. Whether this is someone on your crew or someone you bring in, try to get essential interviews and production highlights so you can edit an additional bonus to your project. Stills for publicity purposes, such as press kits and posters, are also invaluable marketing tools, and are discussed in chapter 13.

Creation of Special Effects

As described earlier, it is important to bring your special effects person into the planning stage early on as it takes significant time to plan and create effects. Much more detail on the special effects process is described in chapter 8.

Sets, Props, and Costume Procurement

You may or may not to bring in a costume designer if your budget is that tight, but someone still needs to be in charge of wardrobe to help match continuity for out of sequence shots. Matching wardrobe can be challenging for horror films. If you are planning a scene with blood, clothes ripping, or other such goop or action, you need to have enough "multiples" (sets of identical clothing). Multiples are also needed if the main characters are wearing the same clothing throughout a film, regardless of effects.

"If the main character's in the same clothing for most of the movie, you have to make multiples, as things wear out or get rumpled or dirty, so for those characters you need more than one thing," advises costume designer Lynn McQuown. "For scenes where there is blood or clothing ripping apart, you have to have multiples. You're generally not going to find multiples in the thrift store, so you either have to have things made or shop on the rack, so money can be a big variable. You need many multiples for effects like blood, as those scenes might be shot over and over again.

"On a children's television pilot I worked on, water gets thrown on the characters who were wearing baseball caps. Hair is easy to dry, but if the caps got wet and they had to reshoot, we knew we needed that back-up, but finding multiples of the same items is hard unless you pay for it. It's also a continuity issue. People notice if something is made a little differently from one scene to the next if you're shooting out of sequence and had a wardrobe change. Multiples do need to match for continuity, and as you don't shoot in sequence, clothing might have to look cleaner or newer in a later shot than an earlier one. And in film, you can't take time out to go run for another shirt with everything else that's going on."

Lynn, who also works at the Palace Costume and Prop Company in Los Angeles, has some good suggestions for saving money on costumes if budgets are an issue:

"Professional rental houses often have discounts for school-related films or small-budget independents. Colleges are a good place to go get costumes if you're doing a time-period piece, because often they teach classes in the construction of clothing, so their storage might have some really great stuff in it. They're also not in the business of making money on rentals. But renting from people not set up specifically for rental is more time-consuming. If you have any friends that work in the industry, or if you like to go to thrift stores, fashions do repeat. It depends on how accurate you need to be. If your film is stylized, then you can adapt things. If it's supposed to be very realistic, I try to find

those costumes for the principals and then cheat stuff for the extras at places like Goodwill. If you have friends that sew or you sew yourself, then you can save money, but that means shopping, designing, and building, and that takes time."

Acquiring Film/Video Stock and Equipment Rentals

If you're making a low-budget movie, chances are you're shooting in digital video, which makes your stock selection pretty straightforward. Your DP will probably provide all stock as part of the package, in addition to the camera gear. You will still need to consider other rentals, such as lighting equipment, general production supplies, and any special filters, camera tracking devices like cranes or dolly tracks, and so forth. Hopefully you have crew members who have access to college equipment or an abundance of their own gear to contribute, but if not you will need to approach rental houses. They typically offer discounts for independent projects and week-long rates, so be sure to check those out and go to more than one place for price lists.

Deal Memos and Other Agreements

It is important to have agreements in place so that there are no misunderstandings with your cast and crew down the road. In the film world, these agreements are called "deal memos." Deal memos differ, but essentially they include information on payment or deferment terms (including payment schedules), maximum hours to be worked per day, overtime terms, any expenses covered, meal breaks, the duration of the project, and anything else that might be pertinent to your specific project. Although this is not the type of legal contract that an attorney would draw up, it is still legally binding so it is important to include as much pertinent information as possible.

- Location releases and permits
- Crew, talent, and composer deal memos
- Insurance agreements
- Equipment rental agreements

Of course, it helps to have an entertainment attorney review the documents you plan to use, but that's hardly feasible on extreme low-budget projects. At a minimum, you should have basic deal memos or letters of agreement you generate yourself to prevent possible misunderstandings about hours, overtime, payment schedules, or the other issues listed above. Following are items that

definitely should be included in a deal memo for crew members working on a low-budget film project.

- Your production company or your name as an individual film-maker and all contact information
- The name of the film project
- The name of the person the deal memo is intended for, along with their job function on set
- Start and completion dates of the project and a compensation agreement should the project run longer than anticipated
- The salary or other agreements for the job the person is doing, plus maximum hourly workdays, breaks, and meal schedules
- The timeframes in which the person will be paid (typically crews are paid on a weekly basis)
- Overtime compensation if you extend maximum hours on a production day
- Coverage of expenses, such as travel, gas, and parking
- Insurance coverage for equipment if the person is providing any
- Ownership issues (this would be necessary if using someone else's existing music tracks, stock footage, etc.)
- Signatures from both parties, as well as copies for both parties

Rehearsals

Rehearsals are extremely important. If actors walk on the set cold with no sense of blocking, action, or direction, you can imagine the consequences and resulting headaches. If your actors are amateurs, they may have no sense of what things like continuity or screen direction mean when you are trying to match shots in a scene. Rehearsals were especially important when preparing to shoot *Malevolence* on 35mm film with a two to one shooting ratio.

"We rehearsed for about four weeks," says Stevan Mena. "Since we could only do one or two takes per scene, we had no choice but to get it right the first time whenever possible. If we did, it meant we could save an extra take for the next scene."

Rehearsals help bring your script to life, as you can physically hear if the dialogue is or is not working. Having actors read lines and share their ideas of what they deem "more natural" can really improve your dialogue at this stage. Rehearsals also give actors a chance to work on reaction, which is

as important as the delivery of lines, especially in a horror film where dramatic facial and vocal expressions need to be drawn out.

More detailed information on the importance of rehearsals is discussed in chapter 9, "A Talent for Terror."

Three Movies in One

The more time you spend on pre-production, the more likely it is that you will end up with the film you set out to make.

"Without that pre-production planning, there's really only so much I can do," warns editor Ross Byron. "There are three movies: the movie you write, the movie you shoot, and the movie you edit. If you do enough good planning, the movie you edit is going to come out stronger and be a good piece. If not, the movie you edit won't be as close to the movie you would have liked it to have been. I get a lot of stuff where we still have to make it up on the fly. There's suddenly internal monologue from the character that wasn't there before, which is one way to save things if the story has gaps. I love it when people call me before they shoot, though rarely do they. I'll ask them to get a lot of cutaways and get those tight shots. Don't just leave me with one master shot. Give me some single shots so we'll be able to cut our way out if we have to."

CHAPTER 5:

The Digital Revolution— friend or foe?

"I love digital editing systems but I'm pleased I grew up with a sense of discipline where you can't just shoot any old thing that comes to mind. You really had to make some choices."

—Larry Fessenden, Filmmaker

Technological advancement in digital media has invaded our personal lives in the form of DVDs, personal computers, cellular phones, PDAs, and countless other formats. It has also revolutionized the film industry.

Back in 1993, twenty-three-year-old Robert Rodriguez became a big sensation with the release of *El Mariachi*, an engaging 16mm film originally intended for the Spanish-language video market. Exceeding expectations, it became a film festival bonanza and broke records as the lowest-budget film ever distributed by a major studio, having an original budget of around $7,000. It was remarkable for the time, but digital technology has changed the paradigm, and filmmakers today are producing feature-length films for half that amount, quality or artistic discretion notwithstanding at times.

I asked a number of the contributors to this book for feedback concerning their firsthand experience of working in both traditional film and new video formats. As with any drastic change in life, there are always going to be pros and cons. But as we all know, there's no stopping it.

Digital video has opened many important doors for filmmakers in every walk of life. Now all people can have a voice. When I helped start the film

Voices Being Shared by the Cabrini Connections Innervision Youth Project (IYP) Group.

program for the Cabrini Connections tutor/mentor program in Chicago back in the early nineties, we were operating with clunky linear ¾-inch gear, which was cumbersome and difficult for students to work with. And before the Internet and DVD capacities were really in place, there were many fewer outlets to get the students' stories out there.

These days, the students have DVD cameras, brand new Mac computers, and the opportunity to express their voices through a variety of Internet-based communication tools. The only limit is the ability of small community-based organizations to attract volunteers from the film, video, and IT industries to help teach youth how to use these tools. (Visit *www.cabriniconnections. net/IYP/Home.htm* to learn more about this innovative program and to view videos from their archives.)

So given all this, what could possibly be a disadvantage? The main question I asked participants in this book is: "While the digital age has brought unquestionable opportunities, has it diminished the craft?"

I teach an introductory film course at College of the Canyons in Santa Clarita, California. Many of the aspiring filmmakers who come to my class are already technically savvy and experienced with digital cameras and editing software. They question the value of learning to use archaic Super 8mm cameras for filming and splicers for editing. I give them this rationale: film costs money and takes more time, so you're going to put far more thought into pre-production, lighting, blocking, and camera angles than you would with video. Editing on a splicer also makes the students far more careful about their selection of shots and the way in which they cut them together. While my class is probably the last time they will ever use Super 8 equipment, I hope that my students take with them an appreciation for the filmmaking craft.

Larry Fessenden learned to edit film on a flatbed (a film-editing table, such as a Steenbeck) and is glad to have had that experience for the same reasons I still instruct with Super 8:

"You have to preconceive each edit and why you're doing it, because you're going to be taping it, and then you might be un-taping it if you don't do the right edit. I've never had to work with overbearing producers, but many producers now expect to see every kind of cut in every place and give their opinion. The potential to water down the artistic impulse, I think, is unfortunate."

Larry is still an avid fan of Super 8. "All my first movies were Super 8, and I still like using that texture on a bigger-budgeted film. I'm producing my next film on Super 8. Of course, you end up transferring to video, but you're still getting the texture, and that's something."

Larry has been in the business long enough to see changes firsthand. He considers current video technology a boon for cash-poor filmmakers.

"In the eighties I was at NYU in the undergraduate program, and you could go upstairs to the video department, which was relatively new, and there was not a soul there. It was absolutely incredible. So I realized there you could make features with sync sound on video, which is incredibly obvious now but wasn't at the time when even MTV wasn't on TV yet."

In the eighties, video was primarily used for television news or live broadcasts. Video stock formats were U-matic (¾-inch) tape for shooting on location and one-inch tape for in-studio or post-production purposes. These cassettes were bulky, like the camera equipment itself, and required an external recording device. Once Betacam (or Beta) SP entered the market, the quality of the video, not to mention portability of equipment without an external video deck, drastically improved. With the technical improvements came the realization, as Larry mentioned, that video could become a new frontier in filmmaking. While the older formats didn't have the aesthetic quality of film, there was a raw look that could now be toyed with for far better results. The fact that video has built in sound with microphone attachment options made the process seem obviously simpler than film.

"That's when I began feeling so passionately that you could make movies for very little money, and it's all about the innovation," Larry Fessenden continues. "In those days, I couldn't actually find distribution. There weren't film festivals. Sundance started in 1991, but I did actually get my video into a video store, which was a great badge of honor for me, but it was obviously not real distribution. So now you have real opportunities, and I think the issue of format

almost is an aesthetic one, based truly on your affection for celluloid. Those of my generation still hold such affection, but it's probably fading."

In today's digital age, ¾-inch tape now looks as archaic as VHS video. Bud Gardner was lugging ¾-inch video decks and equipment in the 1980s when working on shows like *Nova* and appreciates where the technology is headed:

"We had these big clunky decks, then Betacam, which never looked all that good either. The quality of the digital cameras nowadays is quite out there, especially with all the accessories you can use like the Pro 35 system where you are able to use 35mm lenses in front of the chip of the camera. You can shoot outside with wide-open f-stops (camera lens aperture setting that lets you know how much light is coming into the camera so you can manually control it for the desired effect). There are a lot of tools, and the immediacy is great. I have a Panasonic SDX 900. That's what we used on *Dead Serious*. I upgraded my Sony DSL 500 to an SDX so that it shoots at 24p [which gives video a 'film' quality because of the 24 frames per second (fps) rate that matches the motion picture film frame rate]. The audio is superior, and they're great in low light."

SAVING TIME AND MONEY WITH VIDEO

The biggest advantages of video over film on low-budget productions are cost and time savings. With film, you have to make "rushes," a procedure in which the film footage from the day's shoot is sent to a processing lab overnight and screened the next day as "dailies" to see what the camera actually captured in case retakes are needed. In video, access to footage is immediate, so decisions can be made before equipment has been torn down or actors have left the set.

There are other benefits. Purchasing and processing a cartridge of Super 8 film will cost you about thirty to forty dollars, resulting in three and a half minutes of film, which may or may not be the footage you need. If it's not what you need, you'll have to evaluate what mistakes were made and re-shoot, if it's critical. Re-shooting will mean rescheduling (and possibly paying for) a location, and a cast and crew, more film, and more processing. If you'd shot on video, a sixty-minute tape costs about five bucks and you could view the results immediately, without processing. If you didn't have what you needed, you could keep re-shooting until you got the perfect take.

One of Michael Hein's films is *Dead Serious*, a vampire tale about a religious zealot and his terrorist cult who take over a gay bar in New York City with a

serum to "cure" homosexuality. Instead, they discover that their serum has triggered a fright night with the bloodthirsty undead. *Dead Serious* was shot with Bud Gardner's talent and camera equipment and helped make Michael a big proponent of digital video.

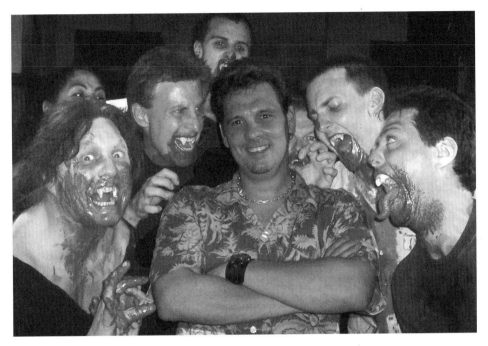

Michael Hein with vampires on the set of *Dead Serious*.

"I defy anyone to tell me that when I project *Dead Serious* in the theater, that this was shot digitally. The color correction we had to do on *Dead Serious* was very minimal and had to do with lighting issues on set, not because it looked like video. The lighting was really dark when we shot it, and it didn't match the cutaways, so we just had to bump up the resolution there. But I highly recommend the Panasonic camera. However, that particular camera is $50,000 with a full high-def lens package, which for a lot of filmmakers is out of range. But eventually the technology is going to be in everyone's hands. Sony put out the first 'prosumer' high-def camera retailing for about $4,000."

A long debated argument between film and video is the aesthetic look. In simple terms, film is a mechanical and chemical process while video is an electronic one. Film has always been considered an aesthetic, organic medium

while video images are harsher and more realistic. The way in which images are captured creates the disparity in look. Digital video tape has significantly fewer pixels of information than film, meaning less sharpness of image. While the newer HD (high definition) 24p cameras have a similar pixel count to 16mm film, they do not have as much dynamic range.

The dynamic range, or range of lightness to darkness, is far greater in film, offering more shades of tonality and color. The ratio of this dynamic range is 1,000:1 in film, compared to about 100:1 in digital video. Film is also recorded at 24 fps, compared to 30 fps with digital video. Today, many filmmakers are using digital cameras that allow a 24 fps to give a more filmic quality to the image. For example, HD 24p cameras do well in shadowy areas yet still lack some of film's nuances because of their lower dynamic range.

Unlike video stock options, there are countless film stocks that have specific imaging characteristics, such as speed or sensitivity to light, contrast, grain, and color. Technology and techniques are, however, rapidly changing. There are improvements in lenses, camera controls, and editing techniques that are helping give video that desired film look.

Screenwriter Lisa Morton also values the knowledge of working with film, while also recognizing the unlimited opportunities digital technology provides:

"I think people may be subconsciously treating videotape as a lesser art form than film. And I think it is good to start off learning on film, but if I was a kid living in the Midwest somewhere, and I wanted to come to Hollywood to make films, the first thing I would do is just go out with any digital camera I could get and make a horror film. If I had ten dollars, I would make a ten-dollar horror film. Maybe next time I'd have twenty dollars and make a twenty-dollar horror film, and it would be better, and eventually I'd make one that's good enough to show people. At this point I would put it online, press my own DVDs, and that's what I would send to people."

The one-man-band filmmaker could also not exist without digital technology. While Super 8 and Super 16 film cameras are portable, they are expensive and require some expertise in understanding lighting and film stocks, and sound has to be captured separately. As Bud mentioned, the old days of video were expensive and cumbersome, and additional crew was needed just to lug it about. The look was also less-than-desirable. Lisa's comment about video being treated as a lesser art form does have a historical context, directly tied to the old "look" of video. Video was originally intended to facilitate real-time broadcasts with emphasis on immediacy over art. It was an ideal television format, especially for fast turn-around news stories shot on the fly, and back in

the day actors were snubbed for being "television trash" versus serious film professionals. This snobbery existed because television was to film what tabloids were to literature—fun shows to watch but hardly serious material. How times have changed since the advent of cable stations like HBO! Now the biggest Oscar winners are clamoring to get onto the small screen, as there is something to be said about the quality, never mind the longevity, of many television series these days.

At least for today, film is still considered an aesthetically superior medium and is the reason Stevan Mena chose to shoot his first film, *Malevolence,* on 35mm, despite all the additional costs that would entail.

"I chose to film in 35mm because I'm a masochist," admits Stevan. "But also because I wanted my teeny tiny film to have some kind of edge over everyone else's. It worked, because when distributors found out it was shot on 35mm, we had no problem getting it to screenings. 35mm carries a perception of value, especially when all of the other filmmakers are shooting DV. When I shot *Malevolence*, DV was still emerging, and it was considered the stamp of student production, similar to the way 16mm was perceived in the eighties. But 35mm is stupidly expensive, and I regretted it only because it just made everything harder. But now that I look back at the finished product, I feel vindicated that the trouble was worth it. Especially when I see *Malevolence* on the big screen. I asked a well-known director, I won't mention his name, this same question about film versus video, and his answer was simply, 'If you wanna be a filmmaker, use film; video is for weddings.'"

Post Production Advances

When Avid introduced nonlinear editing in 1988, it truly revolutionized the post-production process. Nonlinear editing allowed shots to be edited out of sequence and easily changed, whereas linear editing requires projects to be cut in order and changes cannot be made without losing a generation of quality or starting over. The systems were far from cheap, however, so much editing occurred in professional post-production facilities. Today, editing software is relatively inexpensive (around $1,000 on up) and many filmmakers have purchased systems like Final Cut Pro or Avid Xpress to edit in their homes. Simpler consumer-level editing systems sell for as little as $100.

In addition to ease of use and pricing advantages, the new systems offer many options for manipulating the footage, such as compositing, color correction, titling, and effects. Importing and exporting video electronically to various

media is simple and cost-efficient, especially compared to film, which has to be physically handled unless it is transferred to video. These days, most filmmakers transfer film to video during processing to be able to edit digitally. But it's still not cheap. In addition to paying around $120 for a 400-foot roll of 16mm (about twelve minutes), one would need to spend at least $120 more to make a work print or do a video transfer for editing purposes. That means you would spend about $1,200 to purchase, process, and transfer one hour of film. Digital video, on the other hand, can be imported directly into a computer from the camera, meaning there is no cost associated with the process if you are doing it yourself.

Advantages of Digital Video Over Film

- Cost and time effectiveness
- Immediate access to footage on set versus dailies
- Ability to work with smaller crews
- Portability
- Ability for longer or multiple takes
- No film processing or film to tape transfer costs
- Film "look" with superior high definition cameras

Disadvantages of Digital Video, When Compared to Film

- Cheapness often results in shortcutting the learning curve of the craft
- Easy to neglect pre-planning and other important production issues
- Image quality still inferior to film

Where is the Digital Age Headed?

By the time this book gets into print, who knows how much else may have changed, as the technological wave is a virtual tsunami. The digital age has not only changed independent filmmaking, but Hollywood as well. HD cameras are being used for many major productions, the first being *Star Wars Episode II: Attack of the Clones*, which was shot entirely on video with a Sony HDW-F900 camera. Other popular digitally created studio fare includes *Spy Kids 2* and *Once Upon a Time in Mexico* and animated features *Polar Express* and *Toy Story 2*. A DVD feature in *Once Upon a Time in Mexico* includes a "Film Is Dead"

behind-the-scenes feature demonstrating the latest advances in filmmaking such as shooting on HD video. It makes one wonder if the term "filmmaker" will go by the wayside with film itself.

To one extent the future is pretty clear. After some bitter wrangling, 2005 marked the year that Hollywood's top movie studios agreed on a digital standard accord that will uniformly change theater screenings from celluloid to high-definition projected movies. The accord was unveiled by Digital Cinema Initiatives (DCI), a joint venture set up in 2002 by the Disney, Twentieth Century Fox, Paramount, Sony, and Universal and Warner Brothers studios to establish voluntary specifications for a digital cinema standard. A good outcome for independent filmmakers is that they will no longer be required to present expensive 35mm prints for film festivals or other theatrical venues.

High-definition is also making its mark on equipment availability, with unheard-of prices for consumer to professional cameras. Likewise, competitive pricing in digital editing software has also reduced costs, all good news for the cash-strapped creative.

While film is starting to look like a flagging old horse, it will undoubtedly be around for a while and still be used by those who hold the format dear. If you're new to the industry, don't be shy of this old mount, because whatever its age, it always has something new to teach.

PART II:

BLOOD, GUTS, AND ACTION

There is nothing more rewarding to a filmmaker than actually being on set after months of fundraising, planning, and preparation. However, the production phase is no easy ride, as countless things can go awry, from bad weather during an exterior scene to the loss of a location the day you need it. Hopefully, you have assembled a cohesive, knowledgeable team that can help you untangle difficulties once you reach this stage and have back-up plans in place should things go amok.

Part II covers many aspects of low-budget production, from directing to special effects to acting. You will read how two directors with very different styles accomplished their features and overcame difficult monetary and production challenges along the way. The role and responsibilities of the cinematographer during production are also covered, as well as basic lighting and camera techniques that lend themselves to horror and tips for selecting an experienced professional.

Special effects are an important component of most horror film productions. With the help of three specialized special effects experts, you will learn about the different types of effects used in cinema, safety issues, makeup, props, blood concoctions, and the special effects process during production.

Of course no production can go forward without the actors. Part II also addresses the importance of rehearsals and all the considerations a director needs to make when working with talent, such as helping the actors get into character, blocking the actors on set, and directing under more challenging moments such as special effects scenes, fight scenes, emotional scenes, and sex scenes.

CHAPTER 6:

Running the whole show: The Auteur's Nightmare

"My co-director paid for the catering, which was about half the budget for a two-week shoot, and I paid for the effects. That was our whole budget."

—*TJ Nordaker, Los Angeles*

When I ask my students what role they would most like to perform in the film industry at least 90 percent come back with the same response—the director. It is hardly a surprise, as this head position, like the boss of a company, holds the reins. On a film production, the director is typically responsible for:

- Controlling the content (action and dialogue) as defined by the screenplay
- Organizing and selecting the locations, crew members, and talent
- Directing the actors' performances
- Managing technical details such as the cinematography, lighting, and sound
- Guiding the overall artistic vision

Many components of these responsibilities are delegated to other film members, while the director oversees their accomplishment. In the studio

system, the amount of control that a director has varies greatly depending on the size of the project and the director's reputation and experience. But, at the level at which you will be working, if you are making a low-budget, first-time feature it would probably be as an auteur, the French word for "the primary creative force behind the film." The holder of this demanding position is responsible for everything from casting and pre-production tasks to capturing his or her own vision on film and seeing it come to life in post. If the film is being self-made, fundraising, marketing, and distribution tasks are also involved. It is certainly the most challenging position, but also the most rewarding, as it is the director's creative vision that the rest of the crew follows with, hopefully, trust and conviction. But as mentioned before, a director is only as good as the people around him or her, so careful attention must be paid to selecting the best crew and talent available for your dollars. See the discussion of the production team in chapter 4.

If you have never directed a film or watched the process on a film set, it's difficult to imagine everything an independent film director goes through from concept through distribution. While each director's experience is unique, there are many commonalities that directors share on a movie, regardless of budget size. The less experienced you are, the more helpful it is to look at how other directors have accomplished what you are trying to do for ideas and guidance. In their own words, two directors with very different styles will tell you about their journeys through directing a feature.

The Making of *Habit*

In researching this book, I spent considerable time viewing the participants' films. I was especially struck by *Habit*, which was written, directed, and produced by Larry Fessenden. This tale of paranoia, self-destruction, and a possible vampire seductress was described earlier in this book. Larry also stars as the main character, Sam, with Meredith Snider as Ana, his main attraction. Intelligent, exceedingly well planned, and filmed in a loose, John Cassavetes style, this film garnered many accolades, yet had a difficult time finding a market.

Here is what Larry had to say on the making of *Habit* in excerpts from the behind-the-scenes documentary on the DVD, which he graciously gave me permission to use. You will probably be as impressed as I was on the meticulous care he took for every detail of the production, which is something worth modeling.

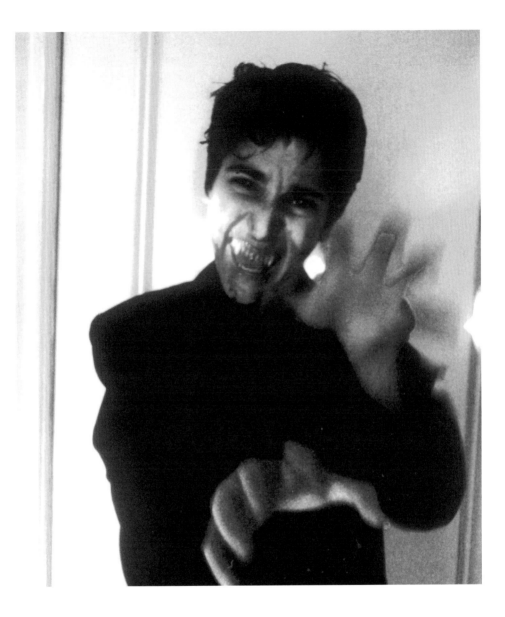

ORIGINS OF THE HABIT

Larry's first attempt at making *Habit* was in 1980 as an undergraduate film student at New York University.

"I gravitated to the video department at the time because the medium was so new," Larry shares. "There was no structure to the classes. And I figured out

you could make features for almost nothing. I wanted to tell a contemporary tale that would use the vampire as a metaphor to explore love and lust and friendships and addiction and to play out all the realistic confusion and feelings of being drained by loneliness or despair. And I wanted to say something about how violence and evil can creep into everyday life unnoticed and unexpected, and how we are all trapped in our own subjective world.

"When I was little, I loved old black-and-white horror films. I responded to the heavy life-and-death themes and the presence of the supernatural. But as I got older, I became frustrated with the predictability of genre, and I was drawn to the naturalistic movies of Marty Scorsese and Cassavetes. And so with *Habit*, I wanted to present a traditional horror story in a stark naturalistic style, because I love looking for new truths in old clichés. I wanted to make a movie that was about reality versus fiction. That's the essence of *Habit*.

"The original film played on our cable access TV show in 1982 in a shortened form, and that was all I could see doing with it. There was not the same infrastructure of festivals and indie distributors to find a home for a video feature. But I always threatened to make it again someday."

Fourteen years later, in 1994, Larry asked his colleague and friend Dayton Taylor to help produce a new version of the film for $60,000.

EFFECT-IVE FILMMAKING

"I've always appreciated low-tech special effects. Not campy effects, but ones where the illusion and impact is derived from the film technique. And I think Dayton [producer] and Frank [DeMarco, DP] and I were united by an interest in cinematic inventions. In some of our first camera tests for *Habit*, we were trying out 'in-camera' effects. We were inspired at the time by Coppola's *Dracula*, which celebrated early cinema tricks. And the final film has many in-camera effects like double exposure. And this kind of experimentation invites the unexpected into the editing room. We used hand-made rigs like the pole cam, which was a 16mm Bolex tied to the end of a pole. No viewfinder, just operating on faith. And Frank had an array of glass and plastics and other textures that we filmed through for effect. We were still shooting pick-up shots even after principal photography ended. And when I needed to enhance the wolf scene during editing, I scheduled an hour with Frank. And I'd built a set of jaws out of sculpy. I knew I'd only be using a few frames of the shots, so the prop was crude but lovingly photographed and color-timed and fits right into the scene. And sometimes bad effects have their own personality, like the

shark in *Jaws*. I think there are many ways to convey effects beside the photo-realism of the computer."

FILM OR DEATH

"We were a very small crew, anywhere from three to seven of us. We were assembled on a volunteer basis for deferred salaries. We shot for forty-five days over a period of three months, and every core crew member held a lot of responsibility. One thing about doing action sequences is when we're shooting, each shot may seem silly, but you really have to keep the faith that when it's all together it'll make some sense. When I did the last stunt at the end [Larry and Meredith tumble out a window], it was the last scene of the film in case there was an accident; the film could be finished and what a marketing coup. There was no net, just a rope tied around each of us to a radiator. When I was little, I was a big fan of Werner Herzog, who said quite seriously in Les Blank's documentary *Burden of Dreams*, 'film or death.' And however literally you take this statement, I have always followed that sentiment because it speaks of commitment and passion and potency of self-expression. And ultimately, the experience of making a film was about getting something grandiose through very limited means, mirroring my theme of finding the mythic every day."

FINISHING *HABIT*

"The first cut of *Habit* was two hours and forty-five minutes. And in cutting out almost an hour, I wanted to retain a day-in-the-life feeling in which the supernatural crept in unnoticed at first and at the same time deliver on the needs of a genre film. And I always knew the film couldn't be reduced to a simple vampire story, because we hadn't filmed the supernatural sequences with the potency they would need to make a straightforward horror film. One scheme I used to condense the film was to use the sound take from one scene over images from another, and this brought us into Sam's paranoid world, compulsively going through past encounters in his head."

Despite difficulties that followed with marketing and a lack of distribution, compensation came in a different form. Larry won the 1997 "Someone to Watch" award," a cash prize jointly given by the Independent Feature Project West and Swatch watches. The IFP/Swatch award is granted to "a filmmaker of exceptional talent and unique vision who hasn't yet received sufficient recognition for her or his work." While $20,000 would have gone a long way toward

Larry Fessenden

funding another project, Larry did not forget the support he received on *Habit* and instead used the money to pay his crew who had worked on deferment. With this ethic, I'm sure he has no problem finding dedicated crew for his current projects.

A Film of Custodial Proportions for $2,000

In the horror film world specifically, it is quite common to produce full-length films on budgets ranging from $1,000 to $10,000. But the old adage "you get what you pay for" certainly applies if you're looking to cut corners on essentials. But where there's a will there's a way, as Los Angeles filmmakers TJ Nordaker and Andy Signore provide with *The Janitor*. Unlike *Habit*, this film is a lighthearted gore-and-boob fest loaded with plausible special effects and produced on a budget of only $2,000.

The film was released in September of 2005 by Elite Entertainment and has received many positive reviews. The horror movie entertainment site *bloody-disgusting.com* described it as "a film that goes above and beyond what we've come to expect from a good low-budget independent horror film . . . *The Janitor* reveals some of the most clever filmmaking in independent cinema all year!" The *sexgoremutants.com* site lauded, "after a slightly rocky start, *The Janitor* (most welcomingly) manages to deliver exactly what fans of this sort of movie want . . . splatty gore, belly laughs, big bouncing boobies, and a great sense of the absurd."

So how did the filmmakers do it? And as importantly, how did they reach their audience once it was made?

Andy Signore, John Carreon (DP and talent), and TJ Nordaker on the set of *The Janitor*.

CONCEIVING *THE JANITOR*

The Janitor is a sadistically comical splatter flick, full of boobs, blood, and audacious humor. Campy in a self-effacing way, there are numerous scenes

like the one in which actor Lloyd Kaufman, whose long list of credits is mostly extreme genre fare, gets both arms chopped off and is more upset about the fact he can't hold his liquor bottle than the loss of his limbs.

"I think we just really wanted to make it as outrageous as we could," TJ explains. "We wanted to fill it up with as much blood, gore, and nudity as possible."

Self-described as "an epic of custodial proportions," the film focuses on a disgruntled and insanely violent janitor (played by co-director/writer Andy Signore) who takes out his frustration on arrogant, dimwitted, and sexually inclined office personnel. Despite a ridiculously large body count, hapless FBI agents are unable to solve blatantly obvious clues that point to the janitor and his associates.

The idea was conceived when the directing partners participated in a twenty-four-hour short film festival in Los Angeles. The short, titled *The Office Is Closed but Her Legs Are Open*, was so well received that the filmmaking partners decided to develop it into a feature-length script.

"Comedy is my first love," says TJ. "I love slapsticks like *Naked Gun* and *The Three Stooges*. *The Janitor* is in essence a comedy with excessive amounts of blood and tits."

PRE-PRODUCTION

"We spent a good four months finding locations and casting, and on my next movie it's going to be even longer," TJ says. "I think our biggest downfall was that we didn't storyboard anything, so it took longer to shoot. Especially with a lot of action, it's good to go in as prepared as possible even if you're never going to be 100 percent prepared."

Although there was no money in the budget for locations, Andy Signore was enrolled in film school, so the filmmakers were able to utilize locales at the college and scouted the city for other sites.

"We got a good part of the locations in the movie at the school," says TJ. "So that was a good side that we could use that location for anything we wanted. Just going in, you'd be surprised who would be willing to help. At some points, we'd just walk into bars and say, 'Hey, we're shooting this really low-budget horror film. Do you mind if we use your place for a couple hours in the morning sometime when you're closed?' We were pretty surprised at how supportive some people were. And we got costumes and props at garage sales and thrift stores."

The Janitor had fairly limited locations, a definite budget asset and something the filmmakers seriously considered in the scripting stage, as TJ explains:

"It's important when you're writing the movie to have some idea of what you have access to and don't write some kind of epic that you're not going to be able to get made."

CREW AND TALENT

While TJ doesn't think it necessary for independent filmmakers to live in Los Angeles, it did help him when selecting talent and crew for this project.

"There are just more resources out here and hungry people you can use to your advantage. It helps everybody out. Actors need to put something on their demo reel, so it helps them out. And it helps you out because you don't have to pay them. And for every facet of the filmmaking process there are people here just aching for work. So that is the major benefit of being in LA."

However, the process of finding suitable actors was long and tedious, with two rounds of three-day auditions and as many call backs.

"It's such a cattle call," says TJ. "So many people come out, and just going through it all you lose track of who is good and who is awful."

The crew played multiple roles, wearing all hats including talent caps in order to get the project shot under exceedingly tight deadlines. During auditions,

The Janitor **Cast and Crew.**

the filmmakers even asked talent if they would be willing to help out physically on set.

"We were directors, and we were boom operators as well," says TJ. "When you're doing movies on this budget you've got to wear many, many hats. You can't have an ego when you're directing a low-budget horror film. You try to give DPs enough time to get the shots the way they like it and get the lighting right, but sometimes you just kind of have to go, go, go, and you don't really have the leisure to get the lighting just right. And that's true for any movie, no matter what the budget is. Everybody will tell you that everything is high pressure, every schedule seems like you're not making your day, and you're always behind."

BLOOD AND GUTS

The $2,000 budget primarily covered two items—food for the crew and talent and an abundant supply and construction of special effects. *The Janitor* is loaded with buckets of blood, seven gallons to be precise, so plausible effects were essential in keeping some sense of credibility going throughout the film.

TJ Nordaker takes a break on the set of *The Janitor*.

"Special effects was very important but we pulled a lot of favors," explains TJ. "Somehow we got Lance Anderson (*Cat People*, *The Crow*, *The Grinch*) who is a huge effects guy. In LA you think everyone's out for themselves. But Lance Anderson is a guy who's retired. He has his own special effects shop, and his son is carrying it on. He donated special effects props—every prosthetic arm, fake limb, and head—for nothing. He just wanted to help out. I have no idea why he did it; just out of the kindness of his heart."

Even with the donations, TJ and Andy struggled for months to find the right special effects person to work on set. A particularly challenging scene during production was when a dummy had to be lit on fire in a baseball diamond close to major roads. The filmmakers did not have a permit so had to rush through shooting a la Ed Wood before the cops came. This made for some tense moments and plenty of cursing between TJ and Andy, who otherwise made it through the film with their friendship fairly intact.

"We were going have conflicts because we were basically roommates with writing, pre-production, and production, and if you've ever had roommates, you know how much they get on your nerves when they're around all the time, but overall we did pretty good."

A SORORITY PILLOW FIGHT TURNED MASSACRE

The final conflict in *The Janitor* occurs during a topless sorority pillow fight in which the main character battles with his nemesis, another janitor with whom he formerly worked who stole his dream custodial job. The documentary footage on making the scene is as vicariously fascinating as the final edited scene, with the girls getting prepped in skimpy panties, then being drenched in blood.

"The sorority scene was a big deal, because we had about twenty pages of script," says Andy. "We had to choreograph an entire fight scene, a pillow fight scene, and then a blood bath finale with about twenty deaths."

The scene was originally written as a mud-wrestling fight, but in lieu of the fact that the crew was filming in a virtual stranger's home with no insurance, permit, or real plan for damages, a compromise was made to keep the property somewhat intact. Regardless, there were amputations, gut-slicing, and bullet wounds, all accompanied by abundant blood. For the gunshot effects, the crew used an old-fashioned but inexpensive technique—latex gloves filled with fake blood and a string attached to it and taped to body parts under the garments. A pull of the string by the actor ripped the glove so the blood would effectively gush out, mimicking a piercing bullet wound.

"We had a small budget, so we had to work with what we had available and could afford," says TJ. "It's hard to guess what an effect will look like, so you just have to ride out the scene and hope it's doable."

POST-PRODUCTION

While the production went smoothly, problems arose in post-production, primarily with the critical music score. These problems were for the most part due to miscommunication and grandiose thinking that did not have the concomitant support of allocated funding to sustain use of the proposed scores. For more discussion about the problems that arose, see chapter 11.

Much of the dialogue also had to be re-recorded and mixed in during post due to sound problems on set, plus there was the addition of all the special sound effects. The sound team was creative, using celery sticks for the snapping of bones and squishing oranges for the sound of a hand wrestling in someone's gut. But it was a slow process that took almost a full year to complete.

THE JANITOR GOES PUBLIC

Despite setbacks in post-production, *The Janitor* premiered at the LA Film School to a packed house.

"It was very nerve-wracking wondering if they were going to laugh in the right places or be grossed out in the right places or even like the movie to begin with," TJ recalls.

Fortunately, the film was well-received, with an abundance of kudos from their horror fan base. TJ and Andy also developed a remarkably well-done, fun-packed Web

site, chock full of photos, merchandise, and other highly entertaining information about the making of the movie (*www.janitormovie.com*).

Whether or not TJ and Andy make it big, they do share those important qualities with other successful filmmakers—a passion for the craft and a willingness to take great risks. I'm confident *The Janitor* is just the beginning of two very prolific careers.

Notable Directors of Horror

The horror industry can credit much of its commercial success to a handful of directors who changed our ways of thinking about the genre. Some of the most influential directors still haunting us today with their inimitable vision include:

DARIO ARGENTO (BORN SEPTEMBER 7, 1940; ROME, ITALY)

Dario Argento is the son of famed Italian producer Salvatore Argento. He credits his upbringing, including folk tales told by his parents and other family members, for his filmmaking ideas. As a teen he wrote for various film journals and, rather than go to college, he took a job as a newspaper columnist. Inspired by the movies, Argento later found work as a screenwriter. He joined Bernardo Bertolucci in writing the screenplay for Sergio Leone's epic western *Once Upon A Time in the West* (1967). His directing debut came in 1970 with *The Bird with the Crystal Plumage*. Argento is probably best known for *Susperia*, a stylish tale about a young American dancer who travels to Europe to join a famous ballet school, only to discover that the school is merely a front for a much more sinister organization. He has directed fifteen films and various television series. His style is often described as "giallo," meaning yellow. This term is associated with the yellow covers of cheap horror paperbacks that were sold in Italy.

Directing credits include: *Il Cartaio* (*The Card Dealer*) (2004), *Non Ho Sonno* (*Sleepless*) (2001), *Il Fantasma dell' Opera* (*Phantom of the Opera*) (1998), *La Sindrome di Stendhal* (*Stendhal's Syndrome*) (1996), *Trauma* (1993), *Opera* (1987), *Phenomena* (*Creepers*) (1985), *Tenebre* (*Unsane*) (1982), *Inferno* (1980), *Susperia* (1977), *Profondo Rosso* (*Deep Red*)

(1975), *Le Cinque Giornate* (*The Five Days*) (1973), *4 Mosche di Velluto Grigio* (*Four Flies on Grey Velvet*) (1971), *Il Gatto a Nove Code* (*The Cat o' Nine Tails*) (1971), and *L'Uccello dale Piume di Cristalo* (*The Bird with the Crystal Plumage*) (1970).

JOHN CARPENTER (BORN JANUARY 16, 1958; CARTHAGE, NEW YORK, USA)

Touted as "the master of horror film," John Carpenter has worked as a writer, actor, composer, producer, and director on hundreds of projects since the 1970s, when his short student project, *The Resurrection of Bronco Billy*, won an Academy Award for Best Short Live Action Film. He is a graduate of the University of Southern California's School of Cinema. He has directed many worthy thrillers, such as *Escape from New York* and *Assault on Precinct 13*, but is best known for *Halloween*, one of the most commercially successful independent films, which broke him—and certainly helped push the genre—into mainstream Hollywood.

Directing credits include *Ghosts of Mars* (2001), *Vampires* (1998), *Escape from LA* (1996), *Village of the Damned* (1995), *In the Mouth of Madness* (1994), *Memoirs of an Invisible Man* (1992), *They Live* (1988), *Prince of Darkness* (1987), *Big Trouble in Little China* (1986), *Starman* (1984), *Christine* (1983), *The Thing* (1982), *Escape from New York* (1981), *The Fog* (1980), *Halloween* (1978), *Assault on Precinct 13* (1976), *Dark Star* (1974), *Gorgon, the Space Monster* (1969), *Gorgo Versus Godzilla* (1969), *Sorcerer from Outer Space* (1969), *Warrior and the Demon* (1969), *Terror from Space* (1963), and *Revenge of the Colossal Beasts* (1962).

ROGER CORMAN (BORN APRIL 5, 1926; DETROIT, MICHIGAN, USA)

Roger Corman is best known for fast-paced, low-budget film-making, shooting the original version of *The Little Shop of Horrors* on 35mm in only two days and a night. Originally he studied engineering but with a passion for film, he entered the Hollywood studio system working as a messenger for Twentieth Century Fox, later becoming a

story analyst. He began directing in 1955, churning out six or seven films a year utilizing leftover sets from other productions. Over time his budgets increased (though they were never large) and he made a series of adaptations of Edgar Allen Poe stories starring Vincent Price. Once he retired from directing in 1971, he put his energies into the production and distribution company Concorde (originally called New World), which concentrated on low-budget exploitation films and using those profits to distribute distinguished art films. Some well-known names who were employed by Corman early in their careers include Francis Ford Coppola, Martin Scorsese, Jonathan Demme, and James Cameron.

Some of Corman's immense collection of directing credits include *Frankenstein Unbound* (1990), *The Red Baron* (1971), *Bloody Mama* (1970), *Target Harry* (1969), *The St. Valentine's Day Massacre* (1967), *The Secret Invasion* (1964), *The Masque of the Red Death* (1964), *The Haunted Palace* (1963), *The Terror* (1963), *The Raven* (1963), *Tales of Terror* (1962), *The Intruder* (1962), *The Premature Burial* (1962), *Creature from the Haunted Sea* (1961), *Last Woman on Earth* (1960), *The Little Shop of Horrors* (1960), *House of Usher* (1960), *A Bucket of Blood* (1959), *She Gods of Shark Reef* (1958), *Machine-Gun Kelly* (1958), *The Undead* (1957), *Attack of the Crab Monsters* (1957), *Not of This Earth* (1957), *It Conquered the World* (1956), *Day the World Ended* (1956), *Apache Woman* (1955), and *Swamp Women* (1955).

WES CRAVEN (BORN AUGUST 2, 1939; CLEVELAND, OHIO, USA)

Wes Craven has been challenging audiences since the release of his controversial 1972 feature film debut *The Last House on the Left*. Since then, Craven has made a remarkable career with shockingly memorable fare including the *Scream* series and *A Nightmare on Elm Street*. He completed his undergraduate degree at Wheaton College and holds a Master's degree in writing and philosophy from Johns Hopkins University. His first job in the film industry was as a messenger. He advises people venturing into film to read a lot, as he believes storytelling comes as much out of literature as it does from filmmaking. He himself is an avid reader and birdwatcher.

Directing credits include *Red Eye* (2005), *Cursed* (2005), *Scream 3* (2000), *Music of the Heart* (1999), *Scream 2,* (1997), *Scream* (1996), *Vampire in Brooklyn* (1995), *New Nightmare* (1994), *The People Under the Stairs* (1991), *Shocker* (1989), *The Serpent and the Rainbow* (1988), *Deadly Friend* (1986), *The Hills Have Eyes Part II* (1985), *A Nightmare on Elm Street* (1984), *Swamp Thing* (1982), *Deadly Blessing* (1981), *The Evolution of Snuff* (1978), *The Hills Have Eyes* (1977), *The Last House on the Left* (1972), and *Together* (1971).

DAVID CRONENBERG (BORN MARCH 15, 1943; TORONTO, ONTARIO, CANADA)

David Cronenberg's early love of science fiction is evident in many of his films, notably in his early horror/sci-fi *Shivers* about parasites overtaking humans; *Scanners,* a darkly paranoid story of a homeless telepathic man who is enlisted into a program of "scanners" and becomes involved in a battle against nefarious forces; and *The Fly*, the horrific remake of the science fiction classic about a scientist who accidentally swaps body parts with a fly. Raised by a journalist and piano player, he showed an interest in literature and music at a young age. He graduated from the University of Toronto with a degree in literature (though starting as a science major).

Directing credits include *A History of Violence* (2005), *Spider* (2002), *Camera* (2001), *eXistenZ* (1999), *Crash* (1996), *M. Butterfly* (1993), *Naked Lunch* (1991), *Dead Ringers* (1988), *The Fly* (1986), *The Dead Zone* (1983), *Videodrome* (1983), *Scanners* (1981), *The Brood* (1979), *Fast Company* (1979), *Rabid* (1977), *Shivers* (1975), *The Victim* (1974), *Crimes of the Future* (1970), *Stereo* (1969), *From the Drain* (1967), and *Transfer* (1966).

TOBE HOOPER (BORN JANUARY 25, 1943; AUSTIN, TEXAS, USA)

Best known for his disturbingly gory debut *The Texas Chainsaw Massacre*, Tobe Hooper went on to direct other cult favorites such as *Salem's Lot* and *Poltergeist*. A native Texan, Hooper attended the University of Texas in Austin and gained experience directing industrial

films, documentaries, and commercials. He made *Egg Shells*, a little known film about Vietnam veterans returning home, which garnered little attention, then blew audiences away with *The Texas Chainsaw Massacre* (originally titled *Head Cheese*), which was loosely based on a variety of true crime sources. His success with the film pitched him into Hollywood where he has had a string of successful and not so successful projects as a director for film and television.

Directing credits include *Toolbox Murders* (2004), *Crocodile* (2001), *The Mangler* (1995), *Night Terrors* (1993), *Spontaneous Combustion* (1990), *The Texas Chainsaw Massacre 2* (1986), *Invaders from Mars* (1986), *Lifeforce* (1985), *Poltergeist* (1982), *The Funhouse* (1981), *Salem's Lot: The Movie* (1979), *Eaten Alive* (1977), and *The Texas Chainsaw Massacre* (1974).

SAM RAIMI (BORN OCTOBER 23, 1959; FRANKLIN, MICHIGAN, USA)

Sam Raimi got the film bug as a child, making 8mm films before the age of ten. He was a fan of *The Three Stooges*, and his childhood films tended to revolve around slapstick comedy. His first major independent film, *The Evil Dead*, received lukewarm response in America so he took it to Europe where reviews were much more favorable and encouraged renewed U.S. interest, bringing it home to theaters nationwide. Raimi is now best known for his Hollywood successes on the *Spider-Man* movies.

Directing credits include *Spider-Man 2* (2004), *Spider-Man* (2002), *The Gift* (2000), *For Love of the Game* (1999), *A Simple Plan* (1998), *The Quick and the Dead* (1995), *Army of Darkness* (1993), *Darkman* (1990), *Evil Dead II* (1987), *Crimewave* (1985), *The Evil Dead* (1981), *Clockwork* (1978), *Within the Woods* (1978), and *It's Murder!* (1977).

GEORGE ROMERO (BORN FEBRUARY 4, 1940; NEW YORK, NEW YORK, USA)

George Romero reignited an interest in horror with his graphically chilling zombie movie, *Night of the Living Dead*, which spawned further

directorial credits on *Dawn of the Dead*, *Day of the Dead*, and *Land of the Dead*. Like other directors on this list, Romero began making films in his teens with an 8mm camera. He then entered the industrial film business in Pittsburgh, where he garnered enough funds to produce his first *Dead* picture. *Reader's Digest* wrote an article on the movie, which led to a movement to ban it. Of course, this had the opposite effect and made the movie a popular must-see. The profits from this film allowed Romero to make a few other lesser known indies before breaking into the mainstream to continue the *Dead* series.

Directing credits include *Land of the Dead* (2005), *Bruisers* (2000), *The Dark Half* (1993), *Monkey Shines* (1988), *Day of the Dead* (1985), *Creepshow* (1982), *Knightriders* (1981), *Dawn of the Dead* (1978), *Martin* (1977), *Hungry Wives* (1973), *The Crazies* (1973), *There's Always Vanilla* (1971), and *Night of the Living Dead* (1968).

CHAPTER 7:

capturing fear on film

"We were working with maybe $75,000 to shoot
Atrocity Exhibition. That's like a tenth of the
catering budget for *Empire of the Sun*."

—*Bud Gardner, Cinematographer*

When we watch a horror film, the techniques used in cinematography, editing, and sound tap into our intuitive fear, and manipulate our emotions. These techniques create a mood, style, and pulse that have the power to make us smile, cry, cringe, laugh, and scream, yet we are barely aware of them in the moment. If utilized effectively, these techniques complement and enhance a story as it unfolds, tugging our emotive responses while not detracting from the story itself.

Cinematography, in a very simplistic, physical sense, is about capturing images with light and transferring them to some form of media. Production design, or art direction, provides the palette of locations, properties, costumes, and colors that are the basis for these images.

"In 1994, I invited Dayton Taylor to produce a new version of *Habit* to be shot for sixty grand, and we started by taking pictures and shooting test footage of the locations to begin mapping out the script," recalls Larry Fessenden. "I wanted to find in the contemporary streets of New York a look that was Baroque and ornamental, post-industrial and colored in a certain patina. And

that was our art direction. We had a strict palette of *Habit* colors—dark reds and greens. Even the subway cars had to be maroon."

The combined skills of the cinematographer and production designer affect the overall look of a movie. A good cinematographer can only do so much if the set pieces are inadequate or incongruous with the story. Again, this usually comes down to experience.

Creative Visualization: The DP's Job

As mentioned earlier, the cinematographer is usually the first crew member on board with the director, taking the script and visualizing the text, while keeping the director's vision at the forefront. Trust, a shared vision, and good communication are essential between the director and cinematographer.

"I'm usually hired for my experience," says Bud Gardner, who has been working as a professional DP for over twenty years with a slew of horror and other independent films under his belt. "I've logged thousands of hours in camera time and worked on thousands of sets. A lot of filmmakers will listen to reason about what they can do and what they can't do. Ultimately, my most important job is to give the director his vision. Even if I don't think it's right or he's making a mistake, I can certainly point that out but wouldn't do it in front of anybody. I'd say 'Hey, maybe we should grab this shot just to make things work.'"

Having attended college in London and traveled around the world for work, Bud has been heavily influenced by European cinema, with its looser, less formulaic structure, and brings those influences to his work.

"I have a tendency to like the European approach, and most of the movies I like are of that ilk rather than Hollywood," he says. "I like Italian horror films like those by Dario Argento, who is just a master of moving a camera and imagination and art direction. *Suspiria* is just a cool-looking movie. It's almost thirty years old, but it still holds up pretty well. There was a whole renaissance of filmmaking that came out of Europe, especially in the horror genre. Having gone to school in Europe, I've seen hundreds of movies that I wouldn't have seen over here. I guess this is because of the rating system and the fact that the films were too out there for the American public in the sixties and seventies. And now they're attaining a revival in cult status amongst horror movie aficionados."

THE DP/DIRECTOR RELATIONSHIP

With two minds trying to achieve a single vision, it's not surprising that tensions sometimes arise.

"I've worked with different DPs after stopping shooting my own stuff," says Larry Fessenden. "I always have problems with DPs, because I'm very controlling and I do see it a certain way, and naturally I also want them to not feel oppressed, so there's always this tension between my element of control and my encouraging them. I have a very specific style to bring up some sort of dichotomy between the indifferent camera on a tripod and the reactive hand-held one. I think you see that in my stuff. I like an array of moves, and I have feelings about how all these things play into the story."

The best way to avoid such tensions is to communicate well in pre-production when you are storyboarding and planning your shots, rather than going on set and beginning to direct without a clear plan between you and the cinematographer. Of course, things will change on set due to new ideas or unforeseen circumstances, but the more prepared and communicative you are, the less likely there will be differences of opinion during production when you need it the least.

Lights Up or Down

The "photo" in the word "photography" literally means "light," and, in cinema, lighting has a direct effect on mood.

"I try to mix up the lighting, but you can go more mysterious in horror films," says Bud. "And you don't have to go to motivated light sources [light that would come from a real source such as a window or lamp]. Things can get a little off-tangent especially now after MTV, as people are used to accepting jump cuts and strange lighting that isn't real. A comedy, which is broader, like an Adam Sandler movie, uses more high-key lighting. There isn't a whole lot of mood in them, and they don't have a lot of diversity in look, especially those generated out of Hollywood. They have the stars backlit, they all look beautiful, and they act in a comic situation. They're all homogenous in their look, but that's what works in that style of movie. On horror films, it works better being under-lit and eerie. But things can be scary in broad daylight. You can mix it up a little bit so it's not saturated with a constant look. Mixing it up helps make your statement seem more punctuated. If you have a really scary moment, you want to highlight it."

Many new filmmakers focus on story and effects without considering the tremendous potential of light or color in their films. As Bud mentioned, even broad daylight can be scary if it fits within the context of the story. Many zombie and vampire movies utilize daylight as a prelude to the horrors that will inevitably bombard at night—look at *The Blair Witch Project,* where the student-

protagonists were desperately trying to get out of the woods by day before they had to camp again. This prelude, or set-up, certainly increased our tension as the bright skies faded to dusk, then blackness, with creepy sounds and racing images lit only by flashlights.

While planning your shots in pre-production, discuss how light will be used with your cinematographer, as this will have an impact on your schedule if you are planning exteriors and, more importantly, have a direct visual effect on the final product.

Basic Lighting Situations and Techniques

How much light is thrown on an image, whether a person, object, or landscape, will affect our mood, as it does in daily life. Sunny, bright skies imply fun and happiness; dim lights, romance; dark shadows and skies, an unsettling feeling or fear; bright neon lights, an urban environment; and so forth. We are affected by color, as well as light, with blue tones denoting coldness or despair; red tones, danger or sexuality; yellow tones, warmth and familiarity; and green tones, a sense of energy and growth. Talented cinematographers use such palettes of light and color to rouse our emotions in subtle ways.

HIGH KEY VERSUS LOW KEY LIGHTING

In film and television, the standard way to light a subject is with three-point lighting. In this set-up, a key (main) light shines from one angle in front of the subject, a fill (secondary, less bright) light shines from the other angle in front to soften shadows on the face cast by the key light, and a back light is positioned behind the subject to create highlights on the hair and shoulders and help separate the subject from the background.

As Bud mentioned earlier, genres like comedy utilize "high key" lighting in which the characters and background are all brightly lit to literally lighten the mood. The horror genre tends to mimic the film noir style of "low key" lighting, with stark contrasts between light and dark to build tension as we wonder what lurks in the shadows.

In low key lighting, the fill light is minimized or eliminated in a three-point lighting set-up to achieve the stark effect on a subject while minimal lights are used in the backgrounds to keep them shadowy and dark. Orson Welles was a master of low key lighting, using distortion and high contrast black-and-white compositions in films such as *Touch of Evil* and *The Third Man*.

Psycho offers some good examples of low key lighting. In the parlor scene where Norman Bates and Marion (his shower victim) talk once she arrives at the motel, the only source of light is a Tiffany lamp, which is the key light in the scene. The characters are lit by this single source, though Marion sits closer to the lamp and is thus more brightly lit while Norman is in a corner and the light shines just on one side of his face, creating a harsh line between the shadow and light sides of his face. This, of course, helps emphasize his dual personality. There is barely any back or fill lighting in the scene, which results in sharp, angular, and rather ominous shadows on the walls.

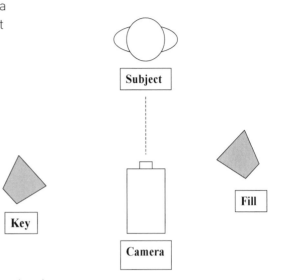

DIRECTION OF LIGHT

The way in which light is directed on a subject can affect the entire mood of a scene. The direction is usually based on a real light source, such as from a window or lamp. Consider a man standing at a doorway. Rather than lighting him from the front or side, he would look far more sinister if the light shone from below, perhaps from a candle (which would explain the light source), as it would cast spooky shadows on his face. Subtleties like this can make an emotional impact and should be considered when storyboarding your film.

LIGHTING WITH COLOR

If you are shooting in various locations, you need to be aware that lighting will not only change in intensity but also in color. Natural and artificial lights have different color temperatures that affect how an image will look on camera. Sunlight has bluer tones, artificial lights have more orange tones, and

fluorescent lights have greener tones. Therefore, you may need to use colored gels to balance the overall color scheme you want to achieve, whether that's cooler blue tones or warmer orange ones. Gels are colored plastic strips that are attached to the lights to cast a subtle hue.

Color is also important in a symbolic sense. Colors are often associated with specific emotions, and thus can be used to arouse or highlight these emotions. For example, red is often associated with danger and can be used as cue, warning viewers of danger to come. Color can help unravel plot, character, and underlying concepts. *In 28 Days Later*, for example, the predominant color is yellow, which was intended to exemplify sickness and sadness. In the scene where Jim, the main character, finds his parents dead in their home, the walls, staircase, bed sheets, and even his mother's nightgown are yellow.

Sleepy Hollow used highly stylized lighting and a very controlled color palette, which created an almost black and white monochromatic feel that was punctuated by color accents in the wardrobe to give it an unreal and rather fantastical atmosphere commonly associated with most Tim Burton films. Old fashioned painted backdrops were also used in a theatrical fashion.

Using a distinctive color palette is part of the art direction that is coordinated between the director, cinematographer, and art designer.

"Good art direction makes a picture because it is the basis for the environment and the atmosphere," says Katherine Bulovic. "You need a sense of the aesthetic of how things will look visually on the screen, and they will give it to you. A novice unfortunately may not comprehend that and think they don't need it or have money for it. But art direction adds a lot of depth to a film. It also helps in a subliminal way. We're all a part of the big visual picture. The cinematographer is very important and so is the production designer. Those to me are the two key departments, and when we're in synch and we've met with the director and he knows what we're doing, he is free to work with his actors, and we give him the space to do his magic."

OUTDOOR LIGHTING

Daylight naturally provides a source of light, but the degree of light shifts with the weather or time of day, so lighting issues still need to be considered. This is especially true at dusk or dawn, often referred to as the "magic hours," when colors change drastically and quickly. During the day, when the sun is high, shadows might become a concern or, if it is hazy, it might result in a flat, dull look.

A fundamental rule in photography is to shoot subjects with the sun behind the camera so they are well lit, unless you are going for a silhouette effect. However, as the light source is vast and not narrowly directed, the light on the

subject can easily look flat. To add dimension, outdoor lighting gear, such as bounce cards, reflective boards, umbrellas, and flags may be needed. Bounce cards and reflective boards or umbrellas are held at an angle to cast soft, additional light on one side of the face, while flags are used to create shadows and block sun flares. If the sunlight is very harsh, you may also need to use a diffusion panel, which is material that allows some light to penetrate, softenening its appearance on the subject.

When filming in daylight, additional lighting may be needed in the background. For example, if your subject walks in front of a brick wall but that wall is in shadow, you may need to cast a light parallel to the wall to illuminate your subject and create a sense of depth.

A majority of horror films have night scenes, which are an obvious challenge as you need to create light sources to make the scenes visible for the viewer. If you are lighting in a remote location without a power source, you will need a generator, which is something to consider in your budget. Night scenes do offer an opportunity to be creative with lighting. Where is the light source coming from? The moon, a candle, a lantern, a flashlight? How will you supplement the existing source, which would probably not offer enough light in itself, so that images appears bright enough to see on film?

All of these lighting needs should be considered when location scouting and discussed with your cinematographer.

EXISTING LIGHT

Existing or available light means the light that exists in a scene, whether that is daylight, a lamp-lit room, light cast by the moon, or neon lights on a city street. Using only existing light gives a raw, realistic quality and obviously provides freedom of movement for the camera. This might be suitable if you are going for a documentary feel but again, you should discuss any lowlight situations with your cinematographer as you will probably have to open the iris in those situations to allow more light into the camera. Scandinavian filmmaker Lars von Trier (*Dogville*, *Breaking the Waves*, *Epidemic*) is well known for his stylistic, distinctive use of light. *The Kingdom*, a Danish TV miniseries about a haunted hospital that became an international festival favorite, was shot in a Copenhagen hospital using mostly handheld cameras and available light.

The Right Angle

Camera angles have a subtle but influential effect on mood and style. Comedies and lighter films tend to use conventional angles with matching eye

lines between characters. This is done for the purpose of continuity so that the audience focuses on action and dialogue rather than stylistic devices. Horror and darker films tend to use low, high, and tilted angles to unsettle the viewer. In *Psycho*, seventy different angles were used to capture the famous shower scene, which were then edited into a forty-five second sequence, each cut as quick and jagged as the knife being thrust. When filming *Jaws*, cinematographer Bill Butler purposefully kept the camera barely above the water in the beach shots. This approach implies that the shark might be around and thus maintains suspense.

Filming from different points of view (POV) can increase the intensity of the viewer's emotions. For example, in *Jaws*, at times the camera was filming from the shark's POV, as the camera drifted up in the water toward a pair of dangling legs. This POV style of filmmaking is used frequently in horror, such as the little boy running through a maze while being chased by his deranged father in *The Shining*. This vicarious effect emphasizes the danger the boy is in as we, the audience, seem to physically close in on him along with his father.

The POV effect was particularly powerful in *Halloween* when we literally viewed the victim's horror through Michael Myers' mask. In this case, the audience is forced to see the scene from the killer's POV, and therefore, however reluctantly, identifies with the villain's power, while at the same time experiencing the victim's dread.

POV angles can also be used to trick us; they can make us believe we are witnessing a scene from the killer's perspective to build suspense, but then it turns out to be someone harmless. In a scene of *I Know What You Did Last Summer*, Helen (Sarah Michelle Gellar) is in her bedroom and we know the killer is in the house. The camera approaches her from what appears to be the killer's POV, but when she is tapped on the shoulder and spins around, it is in fact her sister whose POV we've been sharing.

POV shots are also used when the villain is kept a mystery until the final conflict, as in movies like *I Know What You Did Last Summer* and *Scream*. A number of the characters were set up as potential villains, so the only way to see acts of murder without giving away the villain's identity was by using the POV device.

Tilted angles, known as canted or Dutch tilts, are also very common in horror. Tilted angles make us feel off balance and give an impression of danger. This slanted angle is achieved by lowering one leg of the tripod. Low- and high-angle shots have an equal but opposite psychological effects on the viewer. A low angle, which has the camera positioned below the subject and looking up, gives the subject a sense of authority or a menacing aura. This was the type of angle used on Norman Bates in the parlor room scene.

The opposite is true for the high angle shot, which has the camera positioned above the subject and looking down on him or her. It has the effect of minimizing the subject's importance and emphasizing the subject's vulnerability. In *Jaws* when the three main characters—the principled police chief, the bespectacled marine biologist, and the grizzly veteran fisherman—go out in a boat to destroy the shark, their hierarchy is set up with the camera angles, especially between the biologist who, shot from above, is seen as inferior and literally a "fish out of water" when out of the lab and in the ocean, and the experienced fisherman, who, shown from a low angle, is given a sense of importance and authority in this arena.

Diverse angles should not be overused, or they will lose their effect. But in moments where danger is looming, these techniques will add plenty of tension to your film.

CAMERA MOVEMENT

The movement of a shot is also important. Camera shots can be static, shot on a tripod without shifting the camera, or moving, such as panning (moving the camera from left to right or right to left), tilting (moving the camera up and down), handheld, and tracking, meaning following the action on a dolly, Steadicam, or other device. A Steadicam is a camera stabilization device that combines image steadiness with the freedom of movement of a hand-held shot.

The choice will probably depend on the momentum you want to achieve in a scene. Static shots can be effective as tension builders like the calm before the storm and are useful for extreme close-ups when you want the audience to hone in on a particular item. Moving shots can add tension, like the scene where the boy is being chased through the maze in *The Shining*. That particular scene was shot when Steadicam technology was in its infancy and it looked very impressive for the day. Moving shots can also reveal information, perhaps panning or zooming to the discovery of a dead friend in films like *Halloween* or *Scream*; in a handheld fashion, they can provide a sense of raw tension, such as when the main characters are being chased by the rabid zombies in *28 Days Later*.

Beyond the Lens

There is substantially more to the cinematographer's role than the knowledge of how to technically use film or video and lighting equipment. We assimilate knowledge visually as well as from the written word. Screen images have the power to transport us into unknown realms of the imagination, the eye of the

camera becoming our eye and allowing us to journey from the microscopic world of microbes to planetary systems in the universe. The ways in which these visuals are captured by the cinematographer have a direct effect on our thoughts and emotions. The cinematographer influences us, not just through the use of light and color to establish mood or atmosphere, but also in other ways, such as through the use of visual motifs or themes that recur throughout story.

"I did *The Shore* with Ben Gazzara and Leslie Anne Warren, and that was more motivated light sources, although we did a lot of stuff with water, which was one of the underlying themes of the movie," Bud recalls. "So we did a lot of water reflections in the patterns on walls and the tides of the ocean. We worked that in, in a sort of European style throughout the movie, so it became a sub-theme of the movie."

Using symbolic imagery as Bud mentioned has the power to subconsciously emphasize underlying themes. In the parlor scene of *Psycho*, which was discussed in the lighting section, the stuffed birds positioned high in the room often seem like dark angels over Norman's shoulder. These birds presage the shocking revelation near the end of the movie: Norman's mother has lain dead in the fruit cellar for years, like one of his taxidermy projects. Birds are a motif repeated throughout the movie, both visually and in dialogue.

Motifs—details within a story that gain significance through repetition—can be objects, colors, locations, sounds, or even behavior. *The Others* is a story about a rather unstable woman and her infirm children living in a creepy house that appears to be haunted. The children can't be exposed to sunlight or they will die, so every curtain must be drawn and doors are kept locked at all times so that the children don't inadvertently enter a sunny room. Keys, locks, gas lamps, heavy fabric, and barred gates are all motifs that are repeated to emphasize the feeling of being trapped in the dark. To use fabric as an example of a visual motif: in one scene, the mother enters a room where all the furniture is covered with dust cloths. Believing someone is hiding there, she rips down the cloths to try to expose the culprit, as if trying to bring "light" to the situation. Soon after, all the curtains are missing, which puts her children's lives at risk. The mother goes into a fury, fires all the house staff, and finds other means to shutter the windows. There is also a scene where the daughter is trying on her communion dress, a lacy affair with a long veil. Under these garments, the mother discovers an old woman instead of her child. The frightened mother tries to rip off the garments to find her daughter. The metaphors of "unveiling" layers of material have much to do with the thematic elements of her need to unveil the truth, past and present, and come to terms with those events.

Considering ways to include motifs will help add dimension and underscore important themes in your story.

Professional versus Shoot It Yourself

The landscape of the film industry has dramatically changed as a result of the explosion of the digital world, and this world has opened up a different model of raw, eclectic, in-your-face visual storytelling, as films like *28 Days Later* and *The Blair Witch Project* have demonstrated. Digital cameras have simplified the process, but as explained in chapter 4, simplification should not mean a neglect of the craft.

In the world of low-budget horror filmmaking, the luxury of time and money rarely exists, and sacrifices need to be made, one of which may be to forego the expense of an experienced cinematographer. Consequently, cinematographers are often hired by virtue of their equipment possessions over talent, or filmmakers decide to take this role on themselves. But media like film or video, and the camera itself, are just tools with which to visualize story. An experienced cinematographer brings to the table not only an understanding of the technology, but also a creative and perceptive ability to use these tools and all the options they offer in order to translate your vision from text to screen. A good cinematographer thus offers skills and knowledge lacking in a less experienced camera person or a director.

That's not to say you should ignore "new blood" or not shoot your own film if you have the skills, creativity, and desire. Less experienced cinematographers have their own merits. Experienced cinematographers can sometimes be trapped by conventions, while a less experienced but enthusiastic one may offer radically different ideas of how to make your project more dynamic and fresh. You may *want* to shoot your own project, experienced or not, as you have that story visually in your head already and know it better than anyone else. That was the case with *Red Cockroaches*, an intensely sensorial film almost entirely made by Miguel Coyula from Havana, Cuba. The film has garnered rave reviews and festival awards. Represented by Heretic Films, the film may be that company's most successful product, predicts Alex Afterman:

"I think this film is going to get a lot of notice and a lot of sales, mostly because it has cross-over appeal. It's a science fiction/horror film that was made by a first-time filmmaker from Cuba who came here on a one-year acting scholarship, borrowed a digital camera, and made a film for $2,000. He edited the entire thing himself on his computer, and he has a certain artistic style and editing style that is very, very unique. Everybody who has seen this film, from critics to industry professionals, is absolutely blown away by it on a technical

level. We're working in a straight-to-video genre, but I do believe this film has a chance to get noticed by more than just genre fairs. I do think this has the potential to attract mainstream interests, because a) it's got an incredible hook to it, which is a filmmaker making a film for $2,000 and doing it all himself, and b) he produced this incredible work of art and I think anyone, whether they like the story or not, will like the filmmaking and will appreciate the film itself."

While the director as cameraman *might* keep the budget down and vision unified, having an experienced cinematographer could also be an asset because he plans and coordinates the shots, surveys locations, and makes decisions on lighting, equipment, focus, angles, and so forth.

"I try to make it as methodical as I can and as neat as I can," says Bud of his production style. "I try to run a tight ship and a tight set and keep things very organized."

Running a tight ship is essential on low-budget films, and one of the easiest ways to lose time is through attempting to frame the shot in the viewfinder while simultaneously trying to work with the actors to find the most effective way to block a shot. It takes time and effort to come up with creative solutions on the spot while trying to maintain continuity, a particularly difficult task for one who does not have experience as a cinematographer.

Tips for Hiring a Cinematographer

The cinematographer is one of the most important roles in a film production as the visual interpreter of your vision, so it is important to make careful decisions in your selection process. Important qualities to look for include:

1. Strong knowledge and understanding of the technical and creative aspects of the craft
2. Sample reel with clips in a similar genre/style as your intended project
3. Referrals from directors on past film projects
4. Own equipment or inexpensive access to equipment
5. Contacts in the industry for additional equipment needs at discount prices
6. Experience in shooting low-budget horror films
7. Experience in shooting special effects
8. Track record of staying within budget
9. Communicative and open to suggestions
10. "Team player" attitude

CHAPTER 8:

How to Make a Monster

"I've grossed out a lot of people over the years."

—Anthony Pepe,
Special Makeup Effects Artist,
New York

Special effects existed long before the advent of cinema, astounding and shocking audiences in stage plays, magic shows, and carnivals, creating optical illusions with devices such as magic lanterns and two-way mirrors. Some illusionists were even jailed for their seemingly satanic acts of resurrecting the dead.

Cinema in a sense became a special effect itself, a spectacle of photographs in motion. It was easy to dupe audiences inexperienced in this format with techniques such as stopping and starting the camera to make discontinuous motion appear continuous. The first known film to use this illusion was *The Conjurer*, shot in 1899 by French magician George Méliès. This one-minute gem shows Méliès disappearing, then his assistant turns into confetti and vanishes, an effect Méliès discovered by accident when his camera jammed on the streets of Paris, and the images he captured "jumped" in time. He transformed this stop-start notion into "trick photography," as it used to be called. Not only could illusions be created in real life, but the camera itself could also be the manipulating force.

Today's technology has allowed whole cities and planets to vanish. Since the stop-motion animation of the King Kong and Godzilla battles, the blue-screen days of our local weatherman, and split-screen effects like those on *Woodstock*, nothing has revolutionized special effects as has the digital age. Imagine an audience in 1899 witnessing CGI (computer generated imagery). It boggles the mind to surmise what audiences a hundred years from now will think of today's effects, considering how fast the technology is changing. Will CGI in films like *Jurassic Park* look as dated as Pac Man, stop motion, or the simple magic-lantern trick?

Types of Special Effects Techniques

There are two main types of special effects:

- Mechanical (Physical) Effects—effects that are physically-made constructs or devices to create an illusion
- Visual Effects—anything added to a shot that was not originally there to create an optical illusion

Mechanical Effects

Mechanical effects include explosions, car crashes, gun battles, falls, fire scenes, mechanically controlled weather illusions (such as rain, wind, or snow), and even physically manipulated fake creatures, known as animatronics.

Mechanical effects are usually cheaper and more realistic looking than visual effects.

"The least expensive way is to try to make these gags as simple as possible," recommends Randy Cabral, special effects coordinator for the *Charmed* television series. "When I first started on *Charmed*, they wanted a rose petal to catch on fire in somebody's hand. The visual effects people said that's a hard effect to do and it's going to cost $100. At a production meeting I knew the rose petal was going to come up and I'd already rigged a little battery and a little cotton wick and treated black powder on a rose petal and I pulled it right out in the middle of the meeting, lit it up in front of everybody and said, 'You mean something like that?' And it was like, 'Yeah, just like that!' That gag cost about fifty cents."

With mechanical effects, such as pyrotechnics, stunt people are typically used in instead of actors as safety is a primary concern. Stunts are shot from a distance, with the stunt person made to look as much as possible like the actor, and then close-ups of the actor's face are taken and inserted in editing.

In the low-budget world of horror, filmmakers have taken extreme chances with disregard to safety when budgets don't permit stunts or special effects artists, in much part due to naiveté of the real and inherent dangers.

"A lot of guys will take unnecessary chances," says Randy Cabral. "You'll see these young guys take horrible chances just to get things on film. It's really not worth it for anybody to be hurt. If you break an arm or a finger or lose your actor or actress for a day's shooting because they fell down and hurt a wrist, that's not only costly but inexcusable. You have to bite the bullet and pay for the experience of having at least one person who can oversee everything and make sure it's safe. The only people really thinking about safety on the set are your effects coordinator or your stunt coordinator. Everybody else walks around the set like they're at Disneyland. They'll have people working above their heads or stand under guys changing lights because they don't have set savvy. And people are so concentrated on what their specific job is that they're not stepping back to look at the overall picture. Like wow, if this thing caught on fire, where would our exits be? Oh, they're blocked by equipment and that type of thing."

Car or other explosions are common mechanical effects that are exceedingly complicated and dangerous and should never be attempted without an experienced professional's help.

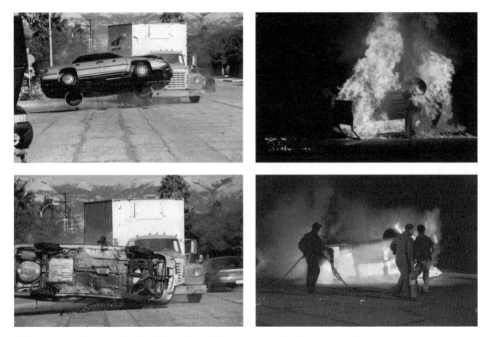

"Doing a car crash is an art in itself," says Randy Cabral, who created these car explosions.

"You can get into a lot of trouble if you don't know what you're doing," Randy continues. "I put in roll cages and huge bumpers, beef things up, and let the air out of the tires so when the tires get so hot, they won't blow. And you have oil and gas shocks and gas tanks that have to be removed. Those are all things you have to think about, especially if you're filming close to a burning car, as the wind could shift."

Animatronics have been around for decades. In 1961's *Voyage to the Bottom of the Sea*, a giant squid was created with rubber and latex for the film and the same footage was later used in the television series. Animatronics have greatly improved since those rubbery tentacles. A horse Tom Cruise rode during battle scenes in *The Last Samurai* was animatronic, controlled by three computers and a number of puppeteers, and you would be hard pressed to tell it was fake.

Miniature effects, or scaled-down models, have been used since the early days of cinema for settings that would be impossible or impractical to create or use in real size. In addition to many other effects, Fritz Lang's *Metropolis* (1927) made use of one of the first miniatures. Lang's effects artist, Eugene Shuftan, also invented the Shuftan process, which optically allowed actors to appear in miniature sets. While CGI is now utilized for many scenes that previously would have been done with miniatures, it still comes down to money, practicality, and realism. If pyrotechnics are being used, for example, blowing up miniatures will appear more realistic than a computer effect generated in a 3D landscape. Similarly, a small-scale submarine will be more practical and cost effective than the real thing or a CGI model.

Today, most miniature sets are combined with CGI effects, such as a miniature spaceship whizzing through a CGI galaxy. In one of the final shots in *Ghost Ship* where the ghosts are "released" from the ship, the effects crew used a myriad of techniques, including a ten-meter miniature ship that was digitally combined with real ocean shots and about 300 computer generated people.

High speed cinematography is utilized to shoot miniatures to make the scene look more natural. Shot at a normal frame rate (the rate per second at which a single frame of film runs through the camera), a raindrop would be a blur even if played in slow motion as only a few frames would have captured the high-speed image. By increasing the frame rate, more actual images are captured on film, providing that intense clarity when run at a normal speed. Giving this clarity to miniatures makes them appear to have more depth and substance.

Visual Effects

Visual effects can be done in-camera, such as double exposure or stop motion, or they can be created by optical or digital processes, such as blue screens or CGI.

Computers are used widely for visual effects. Compositing allows one shot to be superimposed over another to create a new combined image. Blue (or green) screens are used to layer subjects and backgrounds, much like the weatherperson on the news. The subject or object is filmed in front of a blue screen and an image (moving or still) is added but appears in the blue area only, so that the original subject appears to be in front of the added image

These days, almost every Hollywood film that requires effects utilizes CGI. CGI offers the ability to create otherwise impossible action, like a herd of dinosaurs running across a field or tidal waves cascading through the streets of New York. The technology has evolved tremendously over the years and will continue to do so exponentially, producing results that could never have been achieved until recently. The first film to use 2D digital image processing was *Westworld* in 1973, a story about a futuristic amusement park in which androids and computer systems begin to murderously run amok. Digitally processed, pixilated versions of motion photography were used to show scenes from the android's point of view. The sequel, *Futureworld* (1976), was the first to use 3D imagery for a computer generated hand and face. Soon after a few films made large investments in CGI, such as *Tron* and *The Last Starfighter*, but as these were commercial flops, CGI became relegated to images made to look like they were created by a computer. In 1985, the first CGI character made its appearance in *Young Sherlock Holmes*, and then started gaining popularity in films like *The Abyss* and *Terminator 2.* The first fully computer-generated feature film was *Toy Story,* which was a huge commercial success. With improved image quality, increased processing power, and other technological advances, CGI is now the dominant special effects form.

These days, mechanical and visual effects are often combined. In *Spider-Man 2* there is a scene where a car flies through a deli window at a high speed. This scene is composed of three layers of effects: the actors were shot in front of a blue screen reacting to the crash; computer-generated glass and debris was created; and an actual car was launched through a window by an air cannon. The car launch was a mechanical effect as it was physically achieved, while the blue screen and computer-generated glass and debris added to the scene created the overall visual effect. Once all three images were combined in editing, the illusion made us believe that the event was a single action.

"Once you learn what you can do in post by blending the two mediums, you can come up with a really nice effect," says Randy. "Even to this day they haven't perfected fire, and the rain doesn't look so good with CGI. But if you work with a really good visual effects coordinator, they will also say that if you

mix the two mediums you can come up with something really good. Otherwise your show looks like a computer game."

THE PROBLEMS WITH CGI

Although its merits can't be denied, CGI is becoming rapidly overused, and the often unconvincing animated look can destroy credibility for the audience.

"I go to the movies often, and I'm taken out of the moment completely when you see something and it's so unreal, so unbelievable and it just screams CGI that it completely ruins the film for me," says Randy. "What I like to see is when you can actually pull something off using the two mediums and you don't think twice; it doesn't trick your mind. I can look at things and say oh, I know that was just a little bit of CGI added but it doesn't ruin the story for me."

Heavily touted CGI vehicle films, like *Ghost Ship*, have also received harsh criticism for their predictability and lack of original story. Special effects artist Anthony Pepe agrees the technology is being overused these days.

"In all honesty, the way I see it, CGI is a good tool, but it shouldn't be a replacement. The human eye can totally tell when CGI is on the screen so it might save money but it's not as convincing, especially in humans. You can't really replicate a soul inside the eyeball of a character. I think the only time CGI should be used is when it aids the effect, not replaces it."

Makeup and Props

In addition to working with mechanical and visual special effects techniques, special effects artists also create props and specialized makeup. They can manipulate an actor's appearance through the use of facial makeup, artificial teeth or hair, masks, latex suits, scars, and prosthetics. They can defy reality with specialized props, such as dummies, body parts, fake blood, or a knife that can be attached to an actor as though it has penetrated him. Creating these effects requires specialized skills and it can take significant time to construct the items as well as apply them on set, as discussed in more detail in the sections "Learning the Trade" and "Effects Take Time." Special effects do not stand apart from the rest of your production—they need to be considered in the planning process and coordinated with a number of other personnel, including the director, cinematographer, costume designer, and others who are affected in some way by the process.

A BLOODY MESS

 Blood is a common makeup component in horror films. Stage blood works well enough, but independent filmmakers usually prefer to make their own concoctions, not only to save money, but also for the fun of it. To look real, blood needs good color and consistency. If it is too light or runny, it won't pass for the real thing. In the days of black and white film, a much larger array of substances was available, as the color of the blood was inconsequential. Hitchcock, for example, used Bosco chocolate syrup for blood in *Psycho*. These days, some red dye or other form of red coloring is essential, and the darker and gloppier the better. Homemade concoctions aiding color and texture have included ingredients like corn syrup, chocolate mixes, peanut butter, flour, laundry detergent, condensed milk, arrowroot, coffee granules, Kool-Aid mix, strawberry jelly, gelatin ... and the list goes on. Larry Fessenden has his own unique concoction:

 "Every director has a preferred blood formula. Roman Polanski's is a secret. My own feeling is there has to be some sort of food substance in the mix. For the blood in *Habit* I added a dash of soy sauce for color and consistency."

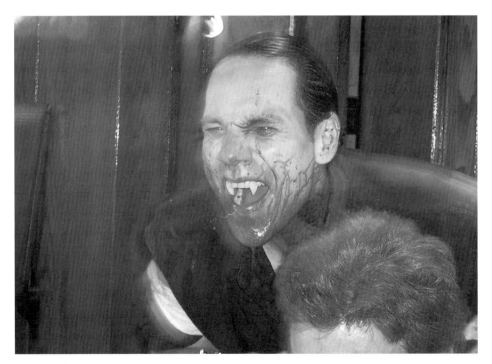

Actor Marcus Perez in *Dead Serious*.

If you make your own blood, you do need to consider safety issues. If it gurgles out of the actor's mouth, is it safe for her to swallow?

"Everybody's so concerned about what's going to hurt them or what's in things," warns Randy. "Anymore, I just purchase my blood from one of the local makeup houses so I can have my MSDS (Materials Safety Data Sheet) on it. So when the actor asks, 'What am I putting in my mouth? What if I swallow this?' I've always got my insurance card, which is my MSDS and I go 'See, this is what's in it.' You've got to protect yourself more and more in this industry, so you need to make sure you're covered if something does go awry, be it blood or smoke or anything that someone could get hurt with."

Another important consideration in the type of blood recipe you use is the ability to clean it up after the effect, especially if you are shooting in someone's private property.

"We had one scene where we had some blood, so I communicated with the makeup people and found out that the blood they were using was water-based, so we were able to wash it off the set and reshoot again," Katherine Bulovic recalls. "But if you're at someone's home, which happens a lot, it's different. On one scene I worked on, where one character whacks another with a vase and blood comes out of his head when he hits the wall, it was a one-time shot because we didn't have the means or the actual paint to re-paint the wall."

Learning the Trade

The range of skills that falls under the rubric "special effects" is probably broader than any one person can encompass: puppetry, makeup, mask making, sculpture, computer animation, pyrotechnics, to name a few. Special effects artists need a broad-based knowledge, areas of specialization, and contact numbers for those who have expertise in other areas. The effects guy who works with firearms, fog, pyrotechnics, rain, etc., obviously needs to be trained in how to employ these effects safely. Skilled makeup artists need to have knowledge of anatomy, physiology, and the filmmaking process, not to mention a host of other skills. Visual effects artists need vast studio and computer training and knowledge about how to use CGI and other optical illusions.

Anthony Pepe, the owner of Demonic Pumpkins in New York City, a company that provides prosthetics, as well as character makeup and glamour services, originally wanted to be a Disney animator. However, although he had spent years drawing and copying Disney characters, when it was time to choose a profession, Anthony settled on special effects. He went to a makeup

school in Orlando, Florida. While the experience was valuable for learning basic skills, he considers the craft an ongoing learning process:

"It's a learning process constantly. I'm not just a makeup artist—construction, engineering, physics, chemistry—all are part of a special effects artist's skills. It's not just going to a makeup school and specifically learning special effects makeup. I don't just shop at a makeup store; I shop at a hardware store, pet store, toy store, things like that."

Anthony continues, "A lot of it is hands-on. I learned most from my experiences on set. Going to school, they just give you a diploma and say, 'okay, now you're licensed,' but what they don't really teach you is how to do it fast or how to deal with different actors and be on location and how to present yourself on a film set. You learn that as you go along."

"Only by doing a lot of these gags and doing them practically for years and years do you come up with ways of doing them a lot cheaper," agrees Randy. "It's just through experience of doing it and actually knowing the camera angles you'll need."

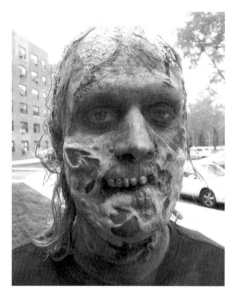
Zombie by special effects artist Anthony Pepe.

The SFX Process

Low-budget horror films don't usually have funds for high-cost special effects, such as exploding cars or buildings; instead, they tend to use cheaper effects like masks, latex suits, scars and boils, knives through the chest, gunshot wounds, heads blowing off, and simpler pyrotechnics such as gun blasts. If you plan to film many effects, you should bring the special effects person into the process early on to allow adequate time for designing, creating, and testing. Special effects artists can also provide a lot of creative input and offer suggestions from their years of experience on how to affordably make the effects look realistic.

"The special effects artist is so important to have on set, to have involved on a horror script, as he elevates the film beyond what the director or the writer

originally envisioned," says Anthony. "I've worked closely with writers, producers, and directors where they have the script and they have ideas and I come in with more suggestions. Since I've worked mostly in the horror industry, I've experienced different ideas and different aspects that most first-time horror filmmakers have never seen. And I know enough about camera angles and stuff like that that you can actually almost direct the shots for them and make sure that it's going to come out beautiful."

Usually the effects person works alone during the actual creation of the costumes, masks, props, or devices, although the director approves the progress at various stages for input.

"Once in a while they'll have their own opinions of what should be in the design, but it's very rare that they'll be over my shoulder watching me," says Anthony. "They generally just trust me and let me go with it. But if I'm sculpting a prosthetic mask for someone, I give the director what's called final sculpt approval. So I'll actually sculpt the idea and then show him pictures of that before I make the copies or the actual pieces. So the director can say I like this but want to change that."

Special effects people need to coordinate with the cinematographer when there is an effect in a shot to ensure they'll be able to pull it off on camera as intended.

"I've been fortunate enough with some of the DPs I've worked with, they have effects experience, they work on other horror movies, so they understand when it's the effect I'm doing on camera that I'm pretty much calling the shots," Anthony explains.

"Basically, I see what the special effects person has prepared and how they want to do it and then I have to build a sequence of images that will lead up to it and finish it," adds Bud Gardner. "Let's say I need a wide shot to sell the idea that this action is going to somebody's head. Obviously, we're going to cut to a dummy or something like that, and it will probably have to be done close because in a low-budget movie, you can't do full torsos or lose heads, so we have to plan what shots we need to build up to the effect, and what we're going to need for the aftermath of it."

Blood Money

Anthony has had his share of working on low-budget productions with minuscule effects dollars. He works with the filmmaker to explore what is realistic within monetary parameters.

"When presented with a low budget, I usually try to finagle with the director. Now obviously there are certain effects that can be done cheaply, and the less you pay for it, the cheaper it's going to look on camera. A lot of people I've dealt with have tried to cut down on the effects to practically nothing and then expect Hollywood magic. So, unfortunately, this is one of the careers where money does actually decide how your art is going to look. Artists can paint with any kinds of supplies and create something amazing. As an effects person, I can only do so much with certain supplies if the budget is limited. I have to manipulate the effects to the cheapest way possible yet know they will still look good on camera through the editing, camera angles, lighting, as well as through how the actors are going to correlate with the effects.

"For one project I made seven different severed heads, and those usually cost around $300 to $400, depending on how much detail is going into it. So I had to use the bare minimum materials to keep the budget down. I can easily go and charge $2,000 for one head with silicone and perfect eyelashes and everything like that, but by the same token, this head is going to be on camera for less than a second. So you have to do the best you can for the amount of money you have, and you have to think about it. Obviously, you can't spend $5,000 on one head when it's on camera for two seconds. Hollywood can afford to do that. Independents, most of them would just balk at it. You take a company like Troma; they use watermelons and cantaloupes for heads, yet you'd never really notice because it's so quick. So you've just got to basically work with the director, and you may have to start cutting effects and say, 'Listen, I really like this chainsaw gag and this machete gag, but the exploding head's just got to go. We just can't do it unless you can find an extra $300 to $400.'"

TJ Nordaker had a difficult time finding an effects person who could work with the budget limitations on *The Janitor*, which was approximately $1,500 for a feature-length shoot.

"We didn't get our effects person until pretty close to shooting," TJ recalls. "It got pretty down to the wire. We'd try out all these effects artists, and it seemed like they were more interested in doing these extravagant effects. Even though we would tell them it was really low budget, they couldn't think in that mindset. We had one scene where a guy gets cut down his stomach and his guts are torn out. One guy wanted to build an entire life cast. And Lance Anderson (effects specialist) said no, all you need is a piece of latex and stick in chicken gizzards. They just couldn't think that low. As far as the effects, one thing I wish we could have done is test them all beforehand, but once we started shooting, it was fly by the seat of your pants."

The directors ended up selecting Scott Dawson, who managed to go through all seven gallons of blood making effects for a body count of close to fifty. Working with Lance Anderson, he used oatmeal, red dye, and the recommended chicken gizzards during the big "gut buster" scene starring Chris Hall. In the scene, Chris is tied to a chair while his girlfriend eggs on the janitor to torture and kill him. The scene was visually effective in a literal gut-churning way, but not the easiest of times for crew and talent.

"Filming the scene was horrible," Andy recalls in the behind-the-scenes documentary. "The smell was ridiculously bad with Chris's sweat, fake blood, chicken gizzards. It was horrendous. Guts were dripping down Chris's underwear."

In the first season of *Charmed,* Randy Cabral was challenged with creating a war scene for minimal dollars. The scene would include both mechanical and visual effects.

"When we first started this show we had a huge parking area in Canoga Park and we would actually push the cameras outside. Talk about low-budget film; these were 'push-tos.' Back then we didn't have load trucks to go to a location. One area of the parking lot had these dirt mounds and we did a war scene for an episode called "Saving Private Ryan" there.

"Talk about a blending of effects. They wanted some strafing airplanes coming in, so the visual effects people put in those. I had a forty-foot yacht that had been damaged in the marina. I bought it for about $3,000, dragged it to the parking lot, tore the trailer out from under it and set it in the ground. We painted it gray and turned it into a PP boat. Then I had a bunch of sand and palm trees brought in, and from the low angles looking up at it, it worked. We painted some regular cardboard drums and turned them on their side. I took some film cans and turned a little steel sculpture into a 50-caliber machine gun. It was like the cheapest low-budget thing you could ever imagine, but when you looked at it you could swear, oh my God, well that's a naval vessel. We painted some numbers on the side of this old boat and literally lit it up on fire. Right there in the parking lot at Canoga Park we did one of the greatest war scenes that's ever been done for nothing. We had the Sheraton Hotel and a shopping mall to the right, but by cheating the angles and using a long lens and having explosions in the foreground and a lot of smoke, you didn't know where we were."

Effects Take Time

Although many effects are planned and created in advance, on-location costumes must still be fitted, makeup applied, and effects rigged. Prior to

shooting, scheduling should be coordinated with the effects person to allow realistic set-up times.

"On production, usually I've told the directors how long it will take to apply something or how long it'll take to do the effect," says Anthony. "I've gotten quite a reputation as a pretty fast makeup artist. I can usually get things done in less than an hour, even faster. The director will say I need a bullet hole right here, and we'll get it done in a few minutes. One of the things you learn about being on set is that you have to be lightning fast. You have to be able to do a beauty makeup in fifteen minutes, that kind of thing."

Applying heavy makeup and prosthetics can be very challenging when you are pressed for time, another reason an experienced makeup effects artist with quick turnaround times is a definite plus.

"On one film, there were about twenty ensemble characters, and eight of them wore prosthetic masks," Anthony recalls. "And upon average they're in the chair an hour, an hour and a half at the most. Hollywood standards to put on a prosthetic is about five hours, but only because they're getting paid by the hour and Hollywood can afford to do that kind of thing. On independent films, you're lucky if you have an hour.

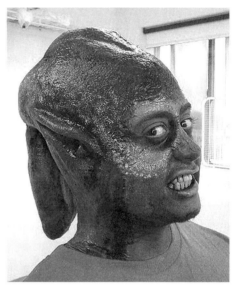

Prosthetic makeup by special effects artist Anthony Pepe.

"For the most part I'm very sociable. The actors have a good time. Most of them are into it because they're independent, starting out, or just in the local scene in New York, and most of them haven't had a chance to do a horror movie. They especially like it when they get to be a creature or something else with a mask. Most actors welcome external costumes like that because it really brings them into character. If I just do some white makeup on them and some dark circles under their eyes, they dig it but it can be kind of a letdown. I feel like I have to uphold their images of what the special effects should be. But I've had claustrophobic people who can't handle it and we'll just change it around or, unfortunately, they need to be re-cast."

Sometimes there simply isn't the luxury of time. On the *Charmed* series, Randy is challenged with quick turnaround times on top of limited budgets.

"I get the scripts a week before we start shooting, so that would give me seven days ahead of the first day of shooting and then once we start shooting of course I'll still be prepping the show we're on and prepping the next episode. So I've got two scripts going at once. Communication skills have to be right there. You have to know exactly what the director's vision is and then try to sell to the producers because they're the ones forking out the money. It's a challenge. You just have to pull a rabbit out of the hat every day."

Whatever your budget, an experienced special effects person will be a valuable addition to your crew. Be sure to allow adequate time and dollars for effects, as minimal as that might be. The reward in this investment will be when your audiences scream and cringe at the realism of the effects. For special effects artists like Anthony, the reward is more instantaneous:

"Almost every major special effect I've ever done, no matter what movie it's on, I think the best reward is the ovation I get after the effect goes off. On *Dead Serious* a vampire gets a grenade shoved in his mouth, and we light up the head and explode it. And when I blew up the head the entire cast and crew stood up and applauded, and you get that whole 'wow.' I think the reward on a movie for any effects artist is the fact that people actually get grossed or freaked out by some paint and some latex."

Special Effects Suppliers

BONE YARD EFFECTS www.boneyardfx.com
Suppliers of FX faces (foam latex), makeup products, makeup supplies, and other accessories and equipment.

AVES STUDIOS www.avesstudio.com
Manufacturers of self-hardening clays and maches that are non-toxic, odorless, and non-shrinking.

BOLAND PRODUCTION SUPPLY www.bolands.net
Manufacturer of motion picture special effects supplies, including weapons and blanks, pyro, and breakaway glass.

CHAVANT www.chavant.com
Chavant produces oil and wax-based modeling clays and tools that are helpful in creating makeup effects.

FRIGHT CATALOG
www.frightcatalog.com/Special-Effects-Supplies.htm

Fright catalog is an online store for special effects supplies and equipment, makeup, prosthetics, Hollywood items, and more.

FRIGHT IDEAS
www.frightideas.com

Manufacturers of easy-to-use controllers for props and scenes. All include sound and amplifiers and are programmed in real-time.

GM FOAM
www.gmfoam.com

GM Foam is a four-part professional "hot" foam latex system sold by the kit.

MONSTER MAKERS
www.monstermakers.com

The Monster Makers is a complete one-stop shop for do-it-yourself monster makers ranging from amateur hobbyists to professional special effects artists. They carry a full line of supplies for use in film, TV, and haunted house productions.

NIMBA CREATIONS
www.nimbacreations.com

Nimba Creations is a UK-based special effects company supplying animatronics, costumes, models, prosthetics props, and creatures to international films, TV, and attractions. The site includes an online store.

LUNA TECH
www.pyropak.com

Luna Tech offers pyropak pyrotechnic special effects, firing systems, accessories, and supplies.

SMOOTH-ON
www.rubbermoldcompounds.com

Suppliers of rubber mold compounds and plastics. Smooth-On has provided special effects supplies to movie creators for years.

SPECIAL EFFECTS SUPPLY CORPORATION
www.fxsupply.com

Provides hard-to-find information and materials to special effects artists and other crafts persons throughout the world.

CHAPTER 9:

A Talent for Terror

"I'm six-foot-one and worth the climb.
You can stop for a rest half way up."

—*Julie Strain, Scream Queen*

The actors you select for your film must bring your characters from script to life in a credible, distinctive way. Your main cast, the villains and heroes, can literally make or break your film depending on their performance. At the same time, the director needs to provide guidance and inspiration to help the actors draw out the characters. Acting and directing are both very personal processes, and each individual will have his own style, but a collaborative and communicative approach is essential for bringing out the best in both roles. Brandon Johnson, the lead male actor in *Malevolence,* speaks of his working experience with director Stevan Mena:

"It was definitely a 50/50 on the molding of Julian, which I think is great. Stevan was gracious enough where I could approach him and say I think Julian might do this or can I try this. And he let me do it. On independent films, you have limited time, limited budget, limited everything and to allow an actor to step up and say 'I want to try this' was a real gift, as you're in crunch time 90 percent to 100 percent of the time.

"It can be a tug of war sometimes, especially if you're really specific about a choice you made that feels really good. In the end that's why the director's

there, to direct his vision and it's my job to show up, and in the end try to find a compromise that we're both happy with. In the end if the director says that 'this is what I want,' I'll comply with that. I'm not there to bicker and argue. Some directors are hyper directors. You're not allowed to deviate from anything. You show up, do your lines, hit your marks and it's done. Then there are some directors that don't talk to you at all and just let you go and that seems to be where I shine the most, when they let me just be an actor."

If you are inexperienced at directing talent, you might want to consider taking an acting class to better understand the process actors go through. Likewise, it benefits actors to be familiar with the filmmaking process.

"I was in an acting class where there were writers, directors, just to see what it was like and what we went through," says Brandon Johnson. "The more experience one has in all the various facets of acting, especially film acting, the more advantageous their experience is going to be. When I was in college I was a comprehensive theater major and not only had to go through the acting process but I directed, I did scenic and lighting design, stage craft, costuming, makeup, theater management. I did all these different things and it really helps give you a well-rounded perspective. To a certain degree I understand the amount of responsibility that falls on the shoulders of directors."

Most films involve special directing challenges, such as directing fight scenes, special effects scenes, emotional scenes, sex scenes, and so forth. All of these special situations require significant rehearsal time, from reading off the page to physically blocking shots and action, as discussed later in this chapter.

Main Cast

Film and audience reviews focus as much on talent as on story and direction, so your main talent will be critical to the success of your film. As great acting can't hide a bad script, bad acting can't bring a great script to life. Your job as a director will be to select the most appropriate actors for the roles and collaborate with them to ensure the characters are engaging, credible, and memorable.

VILLAINS AND MONSTERS

You may have one villain or monster, such as Frankenstein, or a villainous group, such as zombies or vampires. Your villain may be completely evil and devoid of emotions, like Michael Myers, or have an extremely complex personality like Hannibal Lector. Regardless, your villain undoubtedly has super-human or supernatural power and possibly extreme intelligence that makes

him threatening and incredibly challenging to outwit or outstrengthen. The villain is the cause of the conflict in your movie and, as such, probably the most important character. This is not just true for audience appeal but also for marketing purposes as the villain will probably appear in one form or another on all promotional materials.

The actor you choose to portray the villain not only needs to meet the physical demands but also give the character a depth of persona. Even if completely evil or inhuman, there will still be distinctive facets and a personal history. For example, how did the villain become evil or inhuman? Is his motivation revenge, madness, or something else? When did the character become sinister? How specifically does the villain exact pain or death? Does he go after a particular type of victim or commit random murder? What are the villain's strengths and weaknesses? Stevan Mena gave his villain in *Malevolence* a strong, complex back story. We learn that the villain was kidnapped as a child, severely abused, and forced to witness fatal atrocities, which explain how environmental factors made him a killer.

"All characters worth knowing have a back story," says Stevan. "Even the most vile people have a history. The original script for *Malevolence* was 500 pages long, so it was all back story. This film only contains a tiny portion of the whole story, which, when you break it down, is more of a tragedy than a slasher."

Giving an actor a character's back story helps him understand and portray the character more credibly and meaningfully.

THE HEROES

Like the villain, you may have only one hero, such as Clarice Starling in *Silence of the Lambs*, or you may have a partnership, such as the detectives in *Seven*, or you may have an ensemble of heroes working together to survive, as in *Aliens*. Similarly, you need to inform your actors of the characters' strengths and weaknesses, unique histories, and so forth.

The heroes do have to be appealing in some way so that we care if they live or die. *I Know What You Did Last Summer* was sharply criticized as a majority of the main characters were unlikable, bratty teens so it didn't matter to audiences if they were knocked off. In contrast, audiences did care about Clarice Starling in *Silence of the Lambs*. Her character had complexity and depth, as revealed to us through her conversations with Hannibal Lector. She had defined weaknesses, motivations, intelligence, and compassion. Similarly, Detectives Mills and Somerset were very contrasting, convincing, and complex individuals

we came to understand and care about in *Seven*. We could feel Mills's pain at the end of the film with the shocking discovery about his wife sent from the killer via messenger service. In both these cases, it was not just an intelligent, well-written script that endeared us to the heroes, but also the actors' sensitive portrayals, embodied through their own talents and the guidance of the directors.

In *Malevolence*, Brandon Johnson's character is an antihero, an unwitting bank robber who must eventually protect others from the serial killer's wrath.

"He's kind of a weak character in the beginning but certainly takes more control as the movie progresses," says Brandon. "In auditions there are a lot of directors who will say, can you send me an actor who can act? What they mean by that is send me an actor who has an imagination and can give me different choices. So the more I can work on my choice-making muscle, that, I think, in turn will help a director see something he didn't see before and then we can start to work on that. When they let me go, I'll keep going until the director says no, or bring it down a little bit, or I did or didn't like that. I constantly try to bring choices. I try to stay within the realm of circumstances but push it up a little bit every so often."

THE SCREAM QUEEN

As mentioned earlier, an advantage of making low-budget horror films is that they do not require a high-powered Hollywood star to find a market. However, horror films do have a star brand of their own that legions of fans appreciate—the "scream queen." This term has been used for decades to describe the heroine in a horror film who screams at the monster or evil she is trying to evade. In the past, scream queens like Fay Wray in the original *King Kong* were typically portrayed as victims who needed rescuing by strong male leads. Although endowed with the same set of lungs, the scream queen of today is strong, clever, and independently rescues herself. Audiences are drawn to her vulnerability but also to her strength and resourcefulness. What has not changed over time is the fan base that considers the scream queen as important as any other component of the film. Fans will follow talented scream queens from film to film, and even from convention to convention. Having a recognizable scream queen is an obvious benefit for any horror filmmaker, especially as it won't break the bank.

One of the most popular and recognizable scream queens in recent decades is Julie Strain.

"I didn't get a chance to come here [to Hollywood] until I was about twenty-eight years old, and at that time I wasn't really looking as good as I thought I

was," Julie recalls. "I was really too skinny, and I had these poodle bangs, and my eyebrows were plucked too thin. I just came here, and some people gave me a couple pointers like straighten your bangs out, grow out your eyebrows. So, little by little, I realized it was kind of a formula, and I added to it. How about a hairpiece that'll make my hair bigger so I'll look like Brigitte Bardot? And I thought if I had black boots, they would make me look vixeny and match my costumes. My trademark became those black leather boots."

As with the majority of actresses who venture into Hollywood, Julie's early days were a rollercoaster of ups and downs with career experiences that reflect the changes of technology.

"When I started, they were shooting on 35mm, so you

Scream Queen Julie Strain is out of this world.

had the real movie set feel," Julie remembers. "You had the craft tables and a couple times here and there you had a big trailer, though not too often. And the directors had all the team members, and they still have all that there, but it was something different to see that big camera going, with 35mm film, which is so expensive. And you'd get more breaks, so you could go rehearse your lines, and now they try to cram a month's worth of movie in five days, and they're keeping the camera running 24/7 so you never get a break. It's very tiring. I've probably been in around 120 to 150 films. Maybe only eighty of them made it to the market. Others have been floating in a vault that young producers are buying and trying to fix and get out there. But I had to keep myself alive. I wasn't prostituting at night, so the only income I had was the money I made in the enter-

tainment industry. Then Kevin Eastman [husband, publisher, producer, and co-creator of the *Teenage Mutant Ninja Turtles*] came along and financially rescued me. I'd never turned down a job until I met him. Never, no matter how cheesy it was, I had to do it. It's a relief now to be at a point where I can kind of pick and choose."

Eric Dagust 2005

Scream Queen Isabelle Stephens.

Isabelle Stephens, a French-speaking Canadian actress from Montreal and up-and-coming scream queen herself, is a big fan of Julie Strain. She had an opportunity to work on the same film with her idol on Troma's *Tales From the Crapper*. Julie and Isabelle know that there is more to being a successful scream queen than shrieking copiously at the sight of blood.

"You have to be a real business-woman, you have to be professional," Julie advises wannabe scream queens. "I'm sure you can get to a certain point on the casting couch, but you have to study acting these days, because people don't want to see a blank look on someone's face. They really want to see somebody who has some history behind her character. Even if it's a small movie and shot on small cameras, the viewer deserves the best entertainment he can get. And if you invest in yourself as a product and give a better product out, you're going to have more people who want to see more of you and directors who want to hire you more often. If you show up on time, if you bring some of your own wardrobe, that's great. If you don't complain, that's awesome. And if can do your own hair and makeup—and if you can be really proficient at that—it helps save a couple hours of shooting every day. Those are things I bring to the table as well."

Although the fan base for low-budget horror films has always existed, the Internet has expanded that base through Web site promotions, chat rooms, blogs, and other means. The lure of the scream queen is certainly part of this phenomenon, especially now that online pics and Web sites of these alluring women can be easily found. Having a talented and known scream queen in a film project is an obvious asset.

"I think if a director works with somebody who already has a fan following, more people talk about you," Isabelle agrees. "There are fans who follow your movies and want to see more of your pictures. I try to answer every single person who writes to me. I think it's very important to tell them I appreciate them."

SUPPORTING CAST

If you are making a low-budget film, chances are you won't have a cast of thousands or massive crowd scenes, rather a handful of characters who are pitted against the villain. Supporting characters are very important in several ways. If your script includes a small role that is particularly interesting, it may be appealing enough for a name talent to agree to a cameo. The supporting actors can also be the most interesting either as character types or by being a fundamental part of a memorable scene. In horror, they often suffer those memorable, excruciating deaths we never forget, such as the brutal death of Casey (Drew Barrymore) at the beginning of *Scream*.

Stevan Mena strongly believes that the supporting cast is as essential as all other on-camera members:

"One weak link breaks the chain. So even the smallest characters, if not pulled off believably, can take an audience out of a film."

If playing victims, the supporting cast needs to be convincing in portraying raw, unbridled fear. This is not as easy as it looks, especially if there are multiple takes needed for a highly emotive scene, as described in the "Directing Emotion" section.

The Importance of Rehearsals

Rehearsals are an important part of the pre-production process. They help actors develop their characters and help establish the actor/director relationship that will be all-important on set. Rehearsals will help allow you to physically see and hear whether the actors share chemistry and if the dialogue is working naturally "out loud" versus on paper. Throwing actors on set without having taken time to block scenes, run through lines, and identify character histories and personalities makes things far more challenging on set for those on both sides of the camera.

"I realize now that it's very important to rehearse and very important to bond with the people you're going to work with," says Julie. "The director has to be like a parent you trust who guides you along the way. At first they didn't really

tell me what to do other than 'drop the dynamite and the guns and run three steps and your top falls off.' It was about the action, it wasn't about the acting. So early on no one would ever say anything, then finally when I got on bigger films or with directors who had a few things to say, or now that I'm in acting school, I realize wow, there's so much more you can do with it, and someone can guide you along the way and say, 'Think about this. Use your old horse that died for the cat that just died in the scene if you don't have a cat.' Little stuff like that makes a big difference."

"One time a filmmaker gave me only fifteen minutes to rehearse before the shoot," Isabelle recalls. "I think you should rehearse until you're comfortable with your lines and know how you'll move or how you'll react. You have to explain the characters to the actors—the backgrounds of the characters, how they feel in the different situations, how the character reacts. I think most people don't do this. They just let the actors improvise, but I think they should have a good talk with every actor so they can really work on the character in some more interesting ways. When you just let the actors go, they tend to repeat the same type of character. And if they are uncomfortable, they will repeat themselves a lot more, I think."

In low-budget filmmaking, rehearsals can be tricky to coordinate, as most people on the crew and cast are working "real" jobs to make a living, so time is precious. But as TJ Nordaker mentioned in the making of *The Janitor*, the process also helps filter out those who are seriously committed to the project. If an actor can't make a rehearsal, think about the consequences if he or she doesn't make it to the set. It is time worth investing in the long run.

SCRIPT READING

Rehearsals typically begin with a script reading. This is where the actors and filmmakers are assembled and the actors literally read their lines out loud to get an understanding of the character and story and get to know their fellow actors' styles. It helps to have someone read the action sequences around the dialogue so the actors comprehend how the whole story flows together. While the actors have probably received and read a copy of the script in advance, the initial script reading will help you hear how well lines are working as well as how the actors interact with each other.

"Listening and reacting to what's coming at you helps keep one in the moment and makes all those moments authentic," says Brandon Johnson. "If you can get somebody that is willing to do the same and you really trust that

other person, you can have a real intense moment on screen. As an actor I can't act in a bubble, I can't act in a vacuum. That becomes self-indulgent and uncaring. There are times when you learn how to be in the driver's seat and times when you learn how to be a passenger. Sometimes you can see it where an actor completely dominates a scene. Finding a balance is where the rehearsal can really be beneficial."

As Brandon mentioned, acting is as much about listening and reacting as it is about delivery, so the way in which your actors interact is highly important. What is not said but implied through emotive actions or the particular way a line is delivered to suggest something other than the words themselves is often used as a form of subtext. For example, Hannibal Lector's "I'm having an old friend for dinner" would have a very different underlying meaning if delivered by a housewife to her husband.

As filmmaking is a collaborative process, script readings are also an opportunity for actors to share their ideas for improving dialogue or action to better fit the characters they are portraying or to make dialogue sound more natural.

"There were definitely script changes [on *Malevolence*] and there were moments where maybe we could ad-lib a little bit," says Brandon. "There was also stuff that was cut where there was a little bit too much dialogue."

If actors offer interesting, legitimate suggestions, it helps to take script notes so you can adapt changes in a final draft before shooting.

Improvisation

Improvisation, the act of making something up as it is performed, is not very common in horror, *The Blair Witch Project* being a major exception. You may still opt to use this approach for a more spontaneous and natural result. You may want to improvise the whole story, certain scenes, or even scripted lines. Improvisation, or improv, helps actors free up their creativity as they discover fresh approaches to a scene through spontaneity.

"I think improv and learning how to move on your feet is one of the greatest gifts an actor can have," says Brandon. "It forces one to listen and it forces one to totally tune into the other person, to their partner, and that is really the essence of acting. Improv is not an easy thing to do, especially live improv in theater groups. People are shouting out things to you and they just make things happen. If you feel comfortable with doing improv then you can do anything. It just makes you feels so much more comfortable in your body and that's important because as an actor our bodies are our instruments. When I fully connect

with my body and I feel confident, vibes are good, I'm willing to take every risk possible. So I love improv. I love when people throw me stuff. It keeps me present."

Even though the actors may not be reading from a script, rehearsals are still beneficial. The approach, of course, will be different but the actors still need an understanding of their characters, the locations, and staging issues such as camera positioning, use of props, and so forth.

"On low-budget things you don't always have a continuity person on set so if you're improvising or doing something new, you don't want to deviate too much from take to take; if you do something out of the ordinary on a low-budget film, maybe you'll have a happy accident happen on film, but maybe it won't work," explains Brandon. "When you're limited to only a couple of takes everyone wants to know what the heck you're doing."

Getting Into Character

Trained actors will have their own techniques for getting into character. Method actors try to replicate the emotional and often physical conditions under which the character operates in real life, drawing on their own personal emotions, memories, and experiences to influence the portrayal. Your actors' knowledge and experience may be invaluable in helping shape the characters if you are not very familiar with different acting techniques.

"My process, after I've read the script a couple times, is I start to make certain choices and that's what I'll bring in to a rehearsal," says Brandon. "I also will experiment if there's any kind of dialect or other nuances. Do they wipe their nose or have quirky tics? I love getting lost in them. Sometimes I really push it because it's easy to tone down a character but really hard to tone up, so I'll push it a little too far in the beginning and then we'll mold it. I'll do my best to be a piece of clay."

Collaborating with your actors and listening to their advice, versus telling them how to specifically play a role, will nourish fresh ideas that might improve the characterization.

"Flexibility is always helpful and allowing an actor to make bold choices," Brandon reinforces.

The actors also need an understanding of the character arc if there is one. "Character arc" refers to how the character changes or grows from the beginning to the end of a story and comes to some new understanding as a result. For instance, the lead character in *The Sixth Sense* learns to accept his mistakes and let go of the past. The heroine in *The Ring* comes to an understanding that she hadn't been listening to her son's cries for help.

Some highly successful film characters never change, such as James Bond or Michael Myers, but within the story their resolve increases with the conflict, whether or not they ultimately win. If a role doesn't have a character arc, you should still give the actor an understanding of how the character develops and is affected throughout the story, especially at major points of conflict or crisis.

In every scene, a character has an objective. This may be anything from trying to seduce a girl to finding an escape route to get away from the villain. Experienced actors know how to pinpoint their characters' objectives and focus on the scene's intent.

"When I go to a scene we concentrate on our objective—what do I want and what am I going to do to get it?" explains Brandon. "It becomes my through line and makes my intention stronger. I try to look for verbs, meaning am I trying to convince or manipulate? I stick on that verb. It'll change through a scene, but I don't like to get too heavy. I don't go through the script and make a billion notes or it can become sterile and static. I like to work in a more organic, improvised way, with a loose blueprint and then letting go. But there's got to be a need. If I don't know what I want, then what the hell am I even doing there?"

Getting into character is a complex, personal process and one that should not be neglected in the rehearsal stage if you want your characters to be credible, dimensional, and multifaceted.

Blocking (Stage Direction)

Blocking is the process of deciding where the camera and lights will be set up and what the actors' positions and movements will be for each shot. Blocking the actors' positions in a general sense usually begins in pre-production, then on site ahead of each shot during production. Stevan Mena videotaped all of his rehearsals for *Malevolence*, which helped in multiple ways.

"I rented a studio in Manhattan and we went there two or three times a week," Stevan explains. "I videotaped them, and even discovered angles of the actors I liked for those scenes. It's great practice, especially for a novice. I also always rehearsed a scene with the actors on location before cameras rolled. That also allowed for spontaneous ideas to come about before we shot so that perhaps they could be implemented into the scene instead of later saying, 'Oh shit, yeah we should have tried that.'"

"I can't believe some rehearsal footage ended up on the DVD," adds Brandon. "That was like, retch! At the same time it's a beginning and you can only begin at the beginning and it's an organic process. I don't think in rehearsals the end product should be there. I don't think it should be spectacular. That's the point of having a rehearsal, to see what works and what doesn't."

Ideally, your actors will have training or experience in film or video, which differs significantly from theatrical experience. While theater performers may be wonderfully talented, it will benefit you if the actors have an understanding of blocking, continuity of action for being able to match shots together in editing, the intimacy of the lens, and other filmic aspects, or otherwise the process may get bogged down.

"Actors with film experience know that less is more and the camera doesn't lie," explains Brandon. "It picks up everything. It's a whole different way of learning to act and learning how to act inside a little box, so to speak. The size of the lens—is it a close-up, is it a master shot—all these different things come into play."

Your storyboards will help a lot during the blocking process.

"Planning and storyboarding are really important so the director knows where he's going—he has to show everyone how he's going to do it," says Isabelle. "When you don't know exactly what to do, you have to think about it, and that affects your performance. I like to know what to do, or how he wants me to pick up the bottle of water, and when I should put it back."

"Thankfully we did have rehearsals for *Malevolence* so that we were prepared on set," adds Brandon. "If anything, we had to do different takes because of lighting or camera movement. As actors, we were at least able to do our part and there was just some minor tweaking on other people's parts."

Many filmmakers also draw floor plans to indicate placement of equipment and the movement of the actors and camera within the shot. These visual aids can really help communication between the director, actors, and crew, thus saving you time on set.

In rehearsals, share the storyboards and/or floor plans with your actors and then let them demonstrate how they would act out the scene. Once you have physically seen their performances, you can make adaptations as necessary.

How you block a scene should be motivated by what your characters are doing rather than saying. If you have a scene heavy in dialogue, it would be boring to just cut back and forth between the actors standing next to each other. The more you have them move and do things that complement the events, the more interesting the scene will be. In *Malevolence,* for example, two bank robbers, male and female, don't find their partner at the meet up location and most of the money is missing. They discuss the problem at opposite ends of a parked car, then the man goes to open a trunk and discovers that the woman's brother, a partner who died at the robbery, had planned to kill them. They pace around the car as they argue over the discovery and then lean back

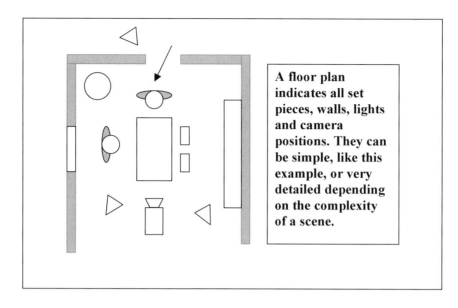

A floor plan indicates all set pieces, walls, lights and camera positions. They can be simple, like this example, or very detailed depending on the complexity of a scene.

on the car next to each other as the woman concedes that her brother must have intended them harm. The pacing back and forth creates a strong tension between the characters as they quarrel and show their distrust to one another. When they lean back on the car, this calmer action complements the resolution to the argument.

Continuity is crucially important, and the more you rehearse, the more your actors will move in the same way so that shots can easily be matched in editing.

"It is important to learn how to repeat the same thing over and over again," says Brandon. "With film you need blocking for camera and lighting. If I'm going to do something extreme, I should let the director know and I should let the camera guys know because if they don't catch it or they're not prepared for this sudden thing, that's going to waste more time and money."

Rehearsing for Special Effects

Although rehearsals for special effects were discussed in the previous chapter, there are a few other considerations related to the perspective of the actor. Mechanical effects are inherently dangerous without the oversight of a practiced professional, and actors without much experience in the effects arena can be understandably nervous.

"I'll talk to my actresses and let them know this is what's going to happen, this is what it's going to feel like, this is how big it's going to sound," says Randy

Cabral, special effects coordinator of the *Charmed* television series. "When we started this show the girls were so reluctant to do anything pyrotechnic-wise; they were scared to death of fire. It took the first whole season of doing all these little practical gags but then you earn their respect. They'll let me do anything around them today. You need to earn that trust; it's not something they'll just give you off the bat."

If you have a tight budget and only one shot at the effect, rehearsals are crucial for your actors. "I worked on a scene where the bad guys and the good guys were in a store and had to crash through a glass door," Katherine Bulovic recalls. "We knew because of the price of the door we could only shoot it once. So the producers got some extra cameras, and we shot it from three different angles, one from inside and two from outside. It was well-rehearsed before we shot it, and, of course, when we put it up, we had to explain to everyone that it's fragile, so when you guys are rehearsing, don't get near it, don't touch it, because once it's broken, it's done. It's a one-shot take."

Directing Fight Scenes

Fight scenes are moments of raw physical and emotional tension. They require choreography, as the actors must appear to be hurting each other while playing it safe. If your fight scenes are complex and you have little or no experience in this area, consider hiring a stunt coordinator or specialized fight coordinator. They have the knowledge and experience to make punches, head bashes, stabs, kicks, and falls look realistic while keeping the actors safe. The stunt coordinator spends rehearsal time with the actors to train them on the various tactics needed to the point they are comfortable and confident with the moves. In low budget filmmaking, funds are rarely available for specialized scenes and directors fly by the seat of their pants.

Director Stevan Mena glances back while directing a murder scene.

"We winged our fight scenes," admits Stevan. "In fact, we really broke a chair over Richard Glover's back, twice. We put a piece of wood and a towel on his back and hoped for the best. It didn't work, and he got hurt. But he was a real tough guy."

The DP will have unique challenges in shooting and lighting a fight scene, as to keep the energy level up, there will probably be shots from many different angles, moving shots, hand-held shots, lens changes, and so forth. Even with choreography and rehearsals, it may still be difficult for the actors to replicate the same physical action. For a complex scene, it's wise to use two or more cameras to cover the sequence so that it is easy to match shots in the editing room. If you're lucky enough to be shooting on film, changing frame rates will give you high or slow speed motion shots which can add a lot visually (these effects can also be done with video in post). In *Raging Bull* when Robert De Niro was in the ring facing his opponent, the frame rate was physically changed as the camera was rolling, so that the speed changed within the shot itself, a highly unique and effective technique in a fight sequence.

For more insight on how fight scenes are coordinated, check out *Fight Scenes for Motion Pictures*, distributed by Kirby Brothers Productions on DVD. This thirty-minute instructional video gives advice on preplanning for fights and demonstrates a host of techniques on making physical impacts and falls look real. It also shows how to make use of cameras, editing, and sound effects to give fights added impact.

Directing Emotion

Film actors must be able to achieve and repeat highly charged, emotional moments time and again to capture the scene with a variety of shots and to offer options in editing. Fear, anticipation, dread, and loss are just part of the horror film actor's emotional palette.

"It's hard to bring these things out," says Stevan. "Either an actor can act, or they can't. Overacting is a sign of bad acting. It's my job to spot bad acting or unbelievable acting and try to correct it. I can make suggestions, but it's up to the actor to interpret the character's emotions during that scene and bring his personality and character to it. I can say whatever I want, but at the end of the day, hopefully I did my job during auditions."

Emotional scenes can be very trying and exhausting for an actor as they require so much energy. Try making yourself cry or scream at the top of your lungs for ten seconds to get a sense of this. Actors often draw on personal experience as closely related to the scripted event as possible.

"I try to help actors come up with feelings and emotions by using analogies to the material," says Stevan Mena. "Like when I needed a better scream from Samantha (Dark), I told her to imagine there was a tarantula crawling up her leg. That worked so well that we looped that scream twice in the film for other scenes. Also, the location really helped them to get into character, since there were real meat hooks and bloody smocks and rats. We shot on location in a real abandoned slaughterhouse. I'm not sure exactly how the actors get into character, but I can tell you that Heather Magee used to do the River Dance before each take. That was interesting."

Every actor is unique and will have individual techniques for managing emotionally charged scenes. Brandon finds that the more relaxed he is, the better he can draw out his emotions.

"One thing that helps when it comes to emotion is breathing. The more I breathe and the more I relax, the easier it is for me to access the authenticity of that moment. I've spent time working with yoga and meditation to help me relax. I can't work when I'm not with my body—I lock up. I have to do things on my end to be relaxed and flexible, and that helps with emotions. It can be helpful sometimes to be physical to get into the moment, but I find the stiller I am, the more that emotion comes from the inside. It seeps out as opposed to screaming and yelling and running. Stillness can be very powerful."

Directing Sex Scenes

With increasing frequency, in low-budget horror films, horror is paired with erotica, regardless of the heroine's inner or outer strengths.

"Horror is something that's selling these days," says Julie Strain. "They either want a lesbian movie or a monster on the box. So movies that I started doing, like the action adventure ones with the guns where you go to Hawaii, and you're on a yacht, and your bikini top comes off—those movies are gone. Because it's all the small cameras now and they're either making horror movies or writing scripts that have six lesbian lovers in it. I've done a few of those and I'm so over it, so the only thing left to do is horror, which I get offered quite often."

More and more, "boobs and blood" are the bill of fare, often to the point of overkill. It has become a recipe of sorts and an expectation of many distributors and fans. There is nothing wrong with including sex scenes in horror films, but it helps to ponder their purpose. Sex thrown in for the sake of sale value but which does not serve the story easily becomes clichéd. Like violence, sex can be numbing when thrown in our face at random like cream pies. One too many pies, and that whipped cream starts to lose its fun and flavor.

For a sex scene to be an integral, and thus legitimate, part of a film, the scene must have a purpose for being in the film and must move the story forward. And if you haven't planned and rehearsed these scenes, chances are that the characters will appear to feel as awkward as the actors feel in the moment, resulting in scenes that seem overdone or devoid of any emotional connection and that appear to have little or no purpose.

Sex scenes are intimate, and actresses can be timid about revealing this highly personal side of themselves. If the scene is obviously gratuitous they may feel that much more awkward and inhibited. Isabelle is comfortable with nudity but agrees that there has to be a sense of purpose to the scene:

"I don't have any problem with nudity for movies or pictures, because I'm a model as well, and I do a lot of artistic nudes. I play a character, and if the character has to get naked, it's okay. But the nudity and the sexy scenes should be part of the story. If it's just there, like a shower scene that has nothing to do with the story so that if you take it away, the movie will be the same—it doesn't make sense. It has to mean something and add something to the film and not just be exploitation."

Filmmakers like Larry Fessenden, who does make sex scenes an integral part of his stories, has an artistic yet honest view of the discomforts that exist:

"Actors will tell you that sex scenes are embarrassing and highly technical and no fun, but that's just what they have to say so their job doesn't seem too fun. The truth is, after you get through laughing, you have to admit there's some sort of edgy thrill, because it is naughty and you're being filmed. I love nudity in movies. I remember all the racy scenes I saw in my youth. They made a big impression, and I spent a lot of time involved with performance artists in the eighties where people get naked as a way to shock and expose and get real, so that's my orientation. Art is most exciting to me when there's a risk; not necessarily a physical risk, but the risk of exposure, of embarrassment; an offering of vulnerability from the artist. But we did laugh a lot [in the making of *Habit*], and I became known as the 'naked director.'"

A filmmaker must be very careful to hire people who share Larry's point of view, or else he needs to work with the boundaries of the people he hires. "If it's a newcomer that's been tricked into it, and doesn't want to do it and is only going to show one nipple from the side, that's really not the person for that scene," says Julie. "There's nothing worse than being on a set and just hearing the torture back and forth between the director and the actor on the phone with her agent saying she doesn't want to do the scene, and they're set up where they have to do it, and they're forcing her, and she's crying. I mean, it's happened in almost half the films I've been on."

Larry Fessenden and Maredith Snaider get erotic in *Habit*.

When you work on a low-budget production you'll probably not be working with union or highly experienced talent. The actors may have done few sex scenes, if any. In order to make them comfortable from the outset, any nudity requirements should be explicitly explained upfront so that there are no surprises or misunderstandings when the camera is ready to roll. TJ Nordaker had such a plan when auditioning *The Janitor.*

"That's something that was brought up in the first audition," he says. "'This role requires nudity, are you comfortable with that?' We were straightforward with all our actors. There would only be about three people in our crew, and of course we didn't just have people standing around. We tried to make it as comfortable for them as possible. That's why it's a good idea to shoot those scenes

first, because if you get in a situation where you've shot half their scenes and you have a nude scene and the actor decides not to do it, then it doesn't completely screw you over. Then you're at the actor's mercy, and she'll probably realize that, too. 'You shot half of me already. What are you going to do, reshoot?' If you shoot those scenes first, you can easily replace them instead of having over half the other scenes done."

Some steps that filmmakers can take to make talent more comfortable during sex scenes include:

- Be upfront in auditions about nudity or sex scene requirements and gauge comfort zones
- Find actors who are comfortable and experienced with nudity
- Make sets closed with minimal crew in the room
- Rehearse sex scenes so actors are more comfortable and knowledgeable about what is required during actual filming
- Shoot sex scenes early on in case an actor bails out
- Use appropriate humor to lighten feelings of embarrassment— chances are you're equally embarrassed behind the camera
- Keep things professional in the same manner you would when filming any scene of your project

Sexual appeal comes from the connection between the characters; this connection comes in part through the character development that takes place in scripting and spending time developing dimensional people we care about so that the sex is meaningful. Similar to violence, less is sometimes more. Showing reactions, such as the girl's face during orgasm, can be much more powerful than witnessing the act itself. Effective erotica teases us, so that our imaginations are left to fill in the blanks, versus having it thrust in our faces. Remember the scene at the pottery wheel in *Ghost?* There was no nudity yet the wet hands and clay helped to provide a very provocative and sensual moment.

Character, Costume, and Location

Costume and makeup tell us a lot about a character, such as age, socioeconomic position, and occupation. It is a method of communicating information about your characters to an audience. The wardrobe and makeup you choose for your characters is a reflection of their personalities, which in turn helps the actors get into character.

"That's what costume designing is, it's to help everybody get what the character is all about," says costume designer Lynn McQuown. "It also helps the audience understand them. There are two approaches; one way is to hide what the character is through his clothing intentionally and the other way is to help explain the character through his clothing or explain what's going on in the film itself. Clothing also shows class, economic status, whether the person is conservative or wild, and so on. Modern dress is a bit different, as it doesn't show status as much as time periods where dress was more rigid, but it still applies. The psychology of dress is one of the really interesting things about costume design—how a character is visually portrayed based on his or her personality."

The actor who played the villain in *Malevolence* found that his simple costume, a raggedy white cloth mask, helped him get into character in a big way.

"The person who played the killer would hide behind craft services and jump out, or in the bathroom," says Stevan. "He was constantly jumping out and scaring people. And since there were no lights around for miles, we would have to escort the ladies to and from set because they were terrified he would jump out and 'get' them."

Malevolence **killer in costume.**

Brandon also believes wardrobe aids immensely for getting into character:

"Costuming is a big thing. Certain clothing I put on does something to me. It changes me. I put on a business suit and walk around differently, my demeanor and the way I hold myself is more confident. Some people are big with the shoes but they haven't done it for me."

Locations are equally important for helping an actor get into character. The slaughterhouse used in *Malevolence* was in fact a real, decaying old slaughterhouse.

"That slaughterhouse was a find," Brandon recalls. "Our art director, Andy Pan, was incredible at transforming and adding to what already existed in that environment. When you're in an early rehearsal stage you're in a white room trying to imagine it. A lot of times I won't go to the set until we actually start shooting and let it affect me that way. I got a chance to walk around the slaughterhouse before we'd shoot and there was such a vibe and energy. It just permeates you as an actor. At night it was pitch black and we're out in the middle of nowhere. You'd hear something move and wouldn't know if it was the wind or an animal. You felt on edge all the time and couple that with long hours of shooting, a little sleep depravation and night fading into day, all those factors would really get under your skin. Stevan would do stuff to screw with us, too, to keep us on edge, like banging on windows."

Production designer Katherine Bulovic concurs with the importance of location:

"I have done sets where the actors will walk in, and they're like, 'Oh my god, I love this. I *feel* this.' Actors think in character, and when you give them the space to be that character, they stretch even more."

PART III:
POST-PRODUCTION, MARKETING, AND DISTRIBUTION

Post-production is usually the longest and most time-consuming part of the filmmaking process as it takes considerable time and effort to select shots, edit sequences, add sound, and, once the film is actually complete, find an audience through marketing and distribution. In independent filmmaking it is not unusual for one or two years to pass before this is all accomplished, given financial and time constraints.

Each phase of the post-production process requires specific skills. You may hire experts or have the knowledge to do this on your own. Building suspense and creating moments of shock is a challenging task achieved through a careful fusion of imagery and sound—ergo the editing, sound mix, and music score. Editors will help the pacing and rhythm of a project, heighten moments of tension, and objectively see ways in which to creatively and logically cut scenes with the footage available. Music is often described as 50 percent of a movie so must be approached with the same steadfastness and vision as the actual film production. Music greatly contributes to the mood, underlying themes, and characterizations.

As creative types, most filmmakers dread the business aspects of marketing and distribution. But if treated in the same practical and imaginative way as making the film itself, the process can actually be fun and less daunting. However, it is important to understand what marketing opportunities are available and how to negotiate distribution deals.

If you manage to get through the post-production process, you deserve a medal just for completing what so many others simply talk about doing. The reviews may or may not be favorable, but your labor of love has been birthed and you're ready to move on to the next project armed with priceless experience and know-how.

CHAPTER 10:

cut to the chase—editing chills and sounding Thrills

"You guys get beat up in the process, and some of you don't survive and never want to do another flick again. I definitely don't want to see that happen."

—*Ross Byron, Editor*

A few decades ago when editing linear ¾-inch or one-inch tape, I truly valued the role of the editor. Every cut mattered, as to make a change could mean starting over or losing image quality. Today, with digital technology eliminating those technical hazards, many filmmakers opt to edit their own film projects, especially those with a "one man band" philosophy or exceedingly limited funds. However, the professional editor not only brings unique talents to the process, he also brings a fresh perspective to the material, a point of view that is more objective than that of anyone who has been involved since the conception of the film. If you can't afford professional sound design, your editor will most likely manage all the sound for your film as well, including the dialogue, music, and special effects. All the sounds will need to be "equalized" so they match in volume and are added at just the right moments to make your audience fearful, startled, or horrified.

The Collaborative Process

"I believe that anybody who thinks they can do it all themselves is making a mistake," advises Michael Hein. "It's one thing to have a vision of your film or to say this is what my film is going to be, and nobody's going to change any of that. But I believe that achieving success in anything in life, and part of being a good director or producer, involves putting good people around you. People who you trust; you trust their talent, you trust their opinions. So when it comes to the post, you can take or leave the advice of your editor, your sound designer, even people who are doing your title credits; but if you're working with good, talented people that you trust, they're going to come up with ideas that you may not have thought of. Allow them the opportunity to show you what they mean. 'Hey, I got an idea for this; instead of having him run, then jump, then shoot, let's have him shoot while he's jumping'—things like that. And you may hear an idea from an editor and wonder how realistic it's going to look, but allow the editor the time to show you. Anybody that thinks they're going to do it all will basically find that they may have missed out on a lot of opportunities to get some stuff that they would never have thought of that would have made the film better."

If the collaborative process works well, director/editor partnerships often develop from the first experience into many other projects. Since *Close Encounters of the Third Kind*, Steven Spielberg worked with editor Michael Kahn for over thirty years on films including *The Color Purple*, *Indiana Jones and the Last Crusade*, *Jurassic Park*, *Schindler's List*, *The Lost World: Jurassic Park*, and *Saving Private Ryan*. When Michael Kahn once spoke at an ACE

Editor Ross Byron.

(American Cinema Editors) honorary society seminar, he described the collaborative process this way:

"Before a picture starts I always ask Steven to give me the opportunity to make mistakes. Give me the chance to be wrong. So in that way I can try different things and experiment, be innovative. I think an editor needs that because to try to bring about the director's vision you may have to take some circuitous routes editorially."

As an editor, producer, camera, and sound person in the New York City area, Ross Byron has experience in all facets of production.

"Filmmakers are different animals," Ross observes. "Some people have taken a film as far as they can and are ready for input. They've cut a first draft on Final Cut—'I've done what I can, can you help me out?' And I've done things like tell them about how reaction shots can tell more about the story than necessarily someone saying their line into the camera. That's for a basic filmmaker just starting out. Then other times further up the food chain, it's about getting the Foley to work and getting shots that are a lot tighter. If the principal is walking over to a certain part of the room, we need to show that shot of what he's looking at.

"There are some filmmakers that definitely know exactly what they want to do, and there are some that need their hand held and almost need the process explained to them, because they're learning at the same time. As a matter of fact, I'm always learning. We're learning together. When they come in, they rarely say, 'Here's a bunch of tapes, cut it together and I'll check back in with you.' I really don't work too well like that. I like to sit side by side and solve the problems together, and then they know I've done the best I can, and we did it at the same time, so I don't have to go back and revisit scenes. But that still happens all the time. I'm glad it helps them to a degree. Sometimes you have to be a little firm with them, but I've been pretty lucky. Most of my clients, partners, and friends have been as patient with me as I have with them."

As Ross stated, the editing process is when you might discover you don't have all the shots you need to make a scene as complete or fluid as it could be. The editor is extremely helpful in this situation as he can envision what shots are required for a viable solution, assuming you have the money and time available for reshoots.

Ross also mentioned that a lot of the directors he works with don't really understand how much editing can bring to a project, and that he has to help educate them about things, like the fact that a reaction shot can tell more about a story than a person just saying his line to the camera. Those are the kinds of things you need to think of before you even begin shooting your movie, when you are storyboarding it. How are we going to get the coverage that is going to allow us to put this together so that it tells the story we want to tell? If you went to film school, you probably already have a basic education in film editing. If you did not, you've picked up a few pointers in the discussion included in this book (angles, POVs, inserts, etc.).

You can school yourself through trial and error—we all learn from our mistakes—but you can also learn a lot by watching films—even commercials on TV—and analyzing how they are put together. What do you learn about story,

when you see a closeup of a child's frightened face, in bed at night, followed by a shot of a dark, partially open closet? How about a picture of a chainsaw, followed by a shot of a man's haunting, unwavering eyes? Without a word being said, you realize the filmmaker has managed to convey character and a piece of the story. This kind of "close reading" of the films of others will help you think like an editor, even before you shoot your film.

What an Editor Can Bring to Your Project

An experienced editor will bring an objective, fresh perspective to your project with new ideas on how to cut shots together to maintain continuity or stylize scenes if intended.

"I offer filmmakers a chance not to paint themselves into a corner," says Ross. "When you're dealing with a feature, you have an awful lot of media, and when you start, you need to organize your bins so that you know where your shots are. We bring a sense of organization to it that a first-time filmmaker might not be able to get a grip on. I've had people that took it as far as they could, and I had to untangle it. There's also intuition and instinct. I'm happy about that, because of going on a sense of criteria, now I have some feelings to go on, a mood, and that's because of all the homework and all the years of experience. I did have to learn all that stuff and put in my time, but it's a joy to get to this point where it just comes naturally and you can make it look easy. Now all of a sudden it's instinct and intuition, and it feels good, and you can sense a little pride in my voice."

In horror films, an editor will help arrange shots in a way that helps build suspense and shock.

"It can be tricky," admits Ross. "Horror is almost as hard as comedy. I go on instinct, and once again, it's me and the director. There's always somebody else in the room, and we're like, is this working? I don't know; let's see it the other way. There's trial and error, and you don't know until you see it, and once you see it, you know that's almost it, but not quite, but now I know the direction to go in. We need some more time on that door before she actually puts her hand on it."

PLANNING FOR POST

There are many planning considerations necessary for editing before the tapes arrive in the editor's hands. The work you do in pre-production and on set

will have a profound impact on the editing process. Rushing into production and shooting masses of footage without having taken the time to polish the script, create storyboards, and stay organized on set can haunt you in the final stages.

"From the editor's point of view, save a little money for post, because I know you guys are broke by the time you get to us, and that's okay," Ross advises. "Try to consult with us before you shoot. Ask questions as much as possible, get those POV shots, get those tight shots. Make sure you have a master shot, and get those singles. Please get those cutaways in the room. Treat your DP right so you can end up directing instead of DPing."

During production, you hopefully had funds for a script supervisor to log every take of every shot and indicate whether or not they were good. Logging is essentially writing down the scene number, shot number, take (if a shot is repeated, each time it is given a "take" number), and the timecode numbers, which are the hour, minute, second, and frame on the original tape at which the shot begins and ends. Once the editor downloads the footage, he will be able to immediately access the shot you are looking for by utilizing those numbers.

If shots have not been logged on site, you will need to get window dubs made by the editor or at a tape duplication facility. Window dubs are copies of the original footage but with a visible window that indicates the timecode number. With those tapes, you can review your footage and write down the timecode numbers for the shots you want to use. If you have three or four takes of one shot that you like, select them all so that you can try out different options in editing.

Once you have selected all of your shots, the editor will download the original footage, create a folder for your project on the edit system, capture the scenes you want, and store the clips in "bins." A bin is essentially a subfolder in your main project folder, much like drawers of a filing cabinet. Bins allow you to sort your media clips in a logical way. For example, you could have a bin for raw footage, a bin for edited scenes, a bin for sound, and a bin for graphics or special effects sequences.

DURING POST

In post, the editor will be concerned with continuity (the flow of action) from one shot to the next so that each scene appears seamless and fluid. The choice of shots will have a direct meaning on an audience's perception of the story. Consider the following three shots:

1. Close up of a young woman running out of a barn door
2. Medium shot of the barn on fire
3. Wide shot of the barn exploding

In the above order, it appears that the woman has left a burning barn and the fire has caused something to explode. If the first shot appeared last, we would think she had been in the barn during the explosion and had somehow survived and managed to run away. If the second shot was last, we would assume the fire happened as a result of the explosion. This is a simple example, but you can imagine the possibilities when it comes to nuances about character and theme. How one person looks at or reacts to another can speak volumes and change our perception of a scene. A skilled editor understands how to best sequence shots in a way that will match your vision and the scene's intent.

The editor will also be concerned about rhythm and pacing. Like musical beats, the number of cuts, or edit points, will affect the mood of a film. In an action sequence, such as a high-speed car chase, using more frequent and shorter shots will create a sense of urgency. In contrast, holding on shots for a long period will evoke a sense of suspense. In *Trauma,* a psychological thriller about a widower who starts to doubt his own sanity, there is a scene where he sees his dead wife at a crowded market. The pacing of the scene is frenetic, with cuts every three seconds, then even more frequently as he loses sight of her, creating a sense of extreme urgency and chaos that matches his psychological confusion.

The rhythm and pacing also affect time perception. Who hasn't witnessed a scene with a massive explosion that took about five times as long as it would in real life to go off as the heroes escape—typically in slow motion—in the nick of time? For this type of scene, the editor uses frequent, short shots to build up the energy until the actual explosion. The pacing slows down at the moment of impact so we can fully enjoy and digest the scene's climax.

This effect also works in reverse to build suspense. In *Night of the Living Dead*, the opening shots in the graveyard are slowly paced as the brother and sister talk while noticing the creepy looking old man in the area. Once the old man attacks the brother, the pacing, or frequency of shots, intensifies dramatically. Opposite to the previous example, the pacing increases at the moment of impact so we feel the woman's panic and urgency to escape.

How one edits film is highly subjective and different editors have their own unique ways of cutting a scene together. Ultimately, it is an audience you want to please. Filmmakers get so close to their material that sometimes it is diffi-

cult to see the forest for the trees. It is highly recommended that you have a screening of the rough cut (first assembly of the film which may still need additions such as music, effects, sound mixing, etc.). Invite some of your talent or crew as they can share suggestions based on that knowledge, and others who were uninvolved so they can give you a fresh perspective. Notice their response during the film—did they get scared, scream at shock moments, or laugh when they were supposed to? After the film, ask your screening group specific questions. Did you understand what was going on? Did you guess the ending? What scenes scared you or could have been scarier? Their feedback may require you to make some changes as you complete the final edit, but at least you will have valid justification for why they should happen.

Sound

In low-budget filmmaking, there aren't usually funds for a professional sound mix, in which case the editor typically manages the sound. Sound in film consists of three elements that are mixed together: dialogue, music, and sound effects. As the musical score is such an important and integral part of any film, the next chapter is fully devoted to the topic.

Like cinematography, sound should complement rather than distract from the story. Attention should be paid to capture sound well during filming, as it can be a challenge to try to fix it in post.

"Please make sure your sound is good," pleads Ross. "Sound is the bastard stepchild on set that gets overlooked. Production days are always hectic, and everybody's got blinders on focusing on their lone jobs. You really need a person who's there dedicated to sound, listening to that pair of headphones with a mini jack plugged into the camcorder, making sure you're actually getting the dialogue. I can't tell you how many times and on how many jobs that have paid me pretty well there was a refrigerator or air conditioner humming or too much background noise or the sound was too low, and I had to bring it up, and at that point, the filmmaker had to pay some money. And I know you guys don't have a lot of money, so in post, when you get stuck with stuff like that, you might have to find a specialist. I'd hate to see you have to do that when your money could be spent on promotional materials so you could make your package look good to get a distribution deal so that you can live to make another film.

"If you really want to make a film, I don't want you to come out so discouraged that you don't jump back into it. Proper planning prevents poor performance.

Talk to an editor prior to filming and then ask him what he needs to make his job easier, which will make your flick that much better and possibly distributable. My ability to work with sound, having produced several CDs and home recordings, gives me an edge. So I've become the Fix-It Dude and can usually help people out with their sound on their features or their shorts."

RECORDING SOUND IN POST

Whether there are problems with original sound or additional recordings are needed, most films require sound recording of dialogue and/or effects in post. The term for adding recorded sound, whether dialogue, music, or effects, to an existing image is commonly referred to as dubbing, also known as looping. The technical term is automated dialogue replacement, or ADR.

If dialogue has to be replaced, the actors need to be brought in to a studio for an ADR session. The studio should have a playback system so that the actor can view the scene as his lines are rerecorded to match lip movement as much as possible. The actors will probably have to do a number of takes to match action and to sound natural in a rather unnatural environment. If you are unable to bring an actor back for rerecording, you will have to rely on your editor to be creative. You may be able to cut the line out by changing the structure of the scene or use dialogue from another scene that has a similar meaning.

SOUND EFFECTS

Sound effects play a crucial role in horror films, as they can startle us out of our seats. Sound effects can be *synchronous*, meaning the sound matches the image, such as a door slam. They can also be *asynchronous*, meaning they do not match a specific action in an image but create mood or ambience, like the sound of birds twittering in an outdoor scene or heavy traffic through an urban-dweller's window.

Asynchronous sounds are often neglected by the novice filmmaker, yet they add dimension to the soundtrack. For example, natural sounds that peak in intensity, like the buzzing of mosquitoes or the chattering of birds, can create feelings of stress and anxiety. In horror we often hear natural sounds exaggerated, like heavy breathing or a heart beating when danger is looming. In *The Jacket,* Jack Stark's breathing is extra loud every time he is put in the morgue drawer for "treatment" and, combined with the clanking in his metal prison and synthesized sound effects as he flashes into the future; this helps emphasize his fear and anxiety.

"The sound tends to make up for the other senses of touch and smell that you're not getting," says Ross. "A squishy sound or screech. Sound can make up for some of those other things. It's the feel, the smell of the room, the tension in the air."

Loud, sudden sounds are the most startling and can be used well for effect, such as a sudden clap of thunder, a cat's meow as the cat pounces out of a closet, or shutters banging on a gusty night. Of course, nothing is creepier than the slow turn of a doorknob or the sound of footsteps on creaky stairs. The opening of *Boogeyman* begins at night showing a pair of swings, hinges squeaking in the gathering storm, then the camera moves to a Victorian house and up the stairs toward a creaking bedroom door. The squeaks and creaks certainly help us realize this film has the potential to be very scary from the get-go.

Sound effects can be purchased cheaply, or you can create many of them yourself. The filmmakers of *The Janitor* snapped crunchy vegetables for the breaking of bones. With a little imagination, you'd be surprised how much sound you can capture in inventive ways.

At the same time, there is something to be said for silence when used effectively. Virtual silence in an empty house, perhaps with just the ticking of a clock, has an ominous quality. Being lost in the woods and not hearing birds chirp can give a disturbing sense that something is wrong. When the three student filmmakers are in the tent at night in *The Blair Witch Project*, the eerie silence that precedes the ensuing crunching, rustling, tent flapping, and distant screams serves to intensify the suspense and our anticipation of terror.

As discussed in the next chapter, most filmmakers agree that music is as important as imagery in a film. Combined with great sound effects, your film has the potential to take on new levels of horror.

Too Many Cooks?

Ross has seen his share of contentious arguments between directors and producers in his edit suite. It is hardly surprising that creative and business minds would collide over the selection and sequencing of shots, perhaps defending the artistry versus the commercialism of a project. The editor easily becomes the go-between, caught in the crossfire.

"The producer and the director do have their usual tug-of-war process," says Ross. "Things can get heated, but as long as the child itself is better for it, people walk away from the table going 'yeah, the film is better.' That's necessary because you have to get people to see your point of view, and sometimes

you have to press to be firm, but if the look, the sound, and the movie is better, after you go home, lick your wounds and sleep on it. Some people, on the other hand, don't fight for their stuff and then later on they'll be passively aggressive and blow. So my advice to you guys is to go ahead and let it out in editing, even if you're afraid of what somebody might say. Most people tend to come to decisions out of fear, like they're afraid what might happen or what might not happen. Try not to let that thing creep into your process. Try to go positively to that person's face and say, 'I really want this. We're all still learning.'"

Planning how to effectively use sound in your film is as important as planning the visuals. Sound has the ability to make us feel present in a film, subconsciously teasing and tapping into our emotions. The next chapter explores the role of the composer and how music can effectively enhance the mood of your film.

CHAPTER 11:

scoring suspense

"If the director is not crazy about the film, then it's hard work,
because the communication won't be great.
If a director doesn't know what he wants to achieve,
how am I supposed to write the music?"

—Vincent Gillioz, Composer

It is hard to think of films like *Halloween* without the haunting, repetitive melody that warns us that some poor wretch will soon be sliced in two by Michael Myers's knife. John Carpenter's high-pitched, dissonant score, with its unusual and frantic pulses, is as powerful today as when it resonated on screen in 1978. Similarly, the wrenched string notes in *Psycho* are a musical imitation of Norman Bates's action with the knife, making the music seem to literally cut into the flesh.

Whether Wagner or heavy metal, music has the ability to affect the entire range of human emotions, none perhaps more powerful than fear. It has such a tremendous impact that our gut reaction during a scary scene is to cover our ears. Doing so reminds us that there is a camera recording the images; it's not real, so we can stop being afraid if we don't hear what's going on. At the same time, music, like cinematography and editing, should complement the story rather than distract from it. It is something that enhances the mood and tension, often barely noticed except in moments of excruciating terror.

As a filmmaker, how do you find a composer who will be able to create the type of emotional, suspenseful, or brooding score that fulfills your expectations,

and how will you collaborate together? What ideas of his own will the composer bring to the project? And what are the steps that a composer must take in order to create the type of music you have envisioned?

Musical Identity

In horror films, music is often used as a warning cue for danger, and as such, enhances feelings of suspense and dread. Composers in this field tend to divert from conventional scoring by utilizing irregular rhythms or incessant repetitions, dissonant harmonies, unusual choices of instrumental sonorities, and mystifying music such as that provided by liturgical choruses.

Composer Vincent Gillioz was born in Geneva, Switzerland and moved to Los Angeles in 2001 with the goal of scoring movie soundtracks. While not specifically pursuing horror movie scores for a career, Vincent enjoys the freedom the genre offers:

"It's a music where you can use contemporary techniques with classical music, because it has to be scary and over the top as far as emotion. It's nice to be able to use different styles of music in the same score. You can experiment also, because you need to be extravagant and take emotion to the extreme. You will try to play with the extremities and make those sounds that are not usually heard by the instruments; like just half of the flute or oboe or make the violinists bow behind the bridge, and that is a genre where you can do it unlike a drama. Comedy is the same as horror. In comedy, you have to push to the extreme and have weird sounds coming out of the instrument to get the laugh."

As movies like *Halloween* and *Jaws* have demonstrated, music can leave an everlasting impression, even after the film itself looks visually dated. In these examples, the music is a fundamental part of the identity of the film.

LEITMOTIF

Music is used in many ways in film with various effects on the viewer. A common device used by composers is the leitmotif—an identifiable musical theme or other musical cue that accompanies, and thus is associated with, a particular character, emotion, symbol, or other element in a drama. Wagner is famous for his use of this device in his operas. It is common in horror films, for example, for a leitmotif to be used to clue us in that the evil being is present. Audiences have become so conditioned to this type of musical cue that we can anticipate danger before it arrives. In *Jaws*, the leitmotif associated with the shark let us know it was approaching before we actually saw it on camera.

While this technique was very effective in earlier films, its use today can result in hackneyed and unconvincing clichés. Earlier films adhered to generic expectations much more dogmatically than is the case today, and arguably films of the 1930s and 1940s were more consciously "stylized" than "realist." As such, it was less of a problem if the music followed suit and drew upon stock cinematic clichés. As films tended to diverge from generic expectations more and more, the music had to do likewise. The leitmotif, particularly one that mimics a previously successful leitmotif, is not sufficient *per se* to tap into our emotions, and other techniques have been developed to supplement or replace the leitmotif. Vincent cautions against copycat motifs and suggests endeavoring to give your soundtrack a unique identity of its own.

AMBIENT MUSIC

"Now it's very, very common in movies to have a leitmotif or a theme for a character," adds Vincent. "But there are different ways to score a movie. You can go to a leitmotif for a character, but you can also do something totally different, as Steven Soderbergh does. He doesn't want any melody, just an atmosphere. It's unlike more commercial films, but, for example, in *Traffic,* you would not hear a melody. He tells the composer no melody. You can go with no themes, no motifs, just music to be a second character, like a layer that is not in the movie but is there as something else."

Atmosphere is often created with ambient music. Ambient music is a term first coined by Brian Eno in the1970s to refer to music that would envelop the listener without drawing attention to itself. Unlike a leitmotif, which calls our attention to the music, ambient music affects our mood yet we are not necessarily aware of it as it is complementing the action, which has our primary attention. In horror, ambient music can change rapidly in tone from one moment to the next along with the action. In the psychological thriller *Trauma*, ambient music is used sparingly but effectively in moments of intensity. The tone is extremely melancholy as the main character copes with the supposed death of his wife and very chaotic and foreboding in moments when he doubts his sanity. In the film, the tones switch rapidly as moments of sadness quickly turn to fearful visions and memories. As in this example, ambient music in horror tends to build slowly during the suspense, then crashes loudly in the act of terror. It is during the build-up that we typically cover our ears as we know what's coming. The theme in *Jaws*, for example, is composed of ascending semitones, which get progressively faster and faster to suggest the shark's getting nearer.

THEME AND VARIATIONS

Another technique is developing variations on a single theme by changing the instrumentation or intensity of the piece. For example, there are a number of variations on the *Halloween* theme music, scored by John Carpenter, not just in the original but in most of the sequels as well. In an early scene of *Halloween II* when Laurie is pounding on the hospital doors as Michael Myers stalks toward her, a stripped-down variation on the main theme plays, highlighting the fact that danger is fast approaching. Like leitmotifs, themes can help identify characters, places, or situations. In *The Jacket*, variations on a tender, melodic theme is used every time the main character shares close moments with the woman he loves. This theme is in sharp contrast to the more ominous music used in the rest of the film, paralleling his state of mind.

MINIMALISM

Bare (or minimal) scoring can be particularly effective in moments of building tension, while more expansive music is very powerful in highly dramatic or climactic moments. Knowing when, and when not, to use various musical techniques is part of a composer's talent. In *North by Northwest*, composer Bernard Herrmann made a decision not to use music in the famous seven-minute crop-duster attack on Cary Grant. Instead, the quiet sounds of the country and the buzz of an approaching plane give an eerily quiet atmosphere that intensifies our fears. Avoiding use of music until the actual moment of terror is also effective, because it adds to the shock value. In a flashback scene in *The Ring*, when the mother finds her daughter, the music starts and crescendos after she opens the closet door and sees her daughter's horrific appearance, rather than building up to that climactic point.

Films with more of documentary flavor, such as *Henry: Portrait of a Serial Killer*, *28 Days Later*, or *The Blair Witch Project* tend to minimize scores to avoid breaking the raw sense of reality, while Hollywood horror, such as *Aliens* or the remake of *House of Wax*, is far more expansive and orchestrated (and often marketed separately as movie soundtracks).

Original Score versus Royalty Free Music

It may be tempting for those working on a low-budget independent feature to consider royalty free music in order to obtain significant cost savings. Royalty free music has evolved over the years and has grown increasingly cheaper,

compared to $100 needle-drop fees of the past. (The term needle-drop comes from the days of record players when filmmakers were charged for each piece of music used in a production, i.e., each time the needle was dropped on the record.) These days, you can own a whole library of music, royalty free, through many companies easily Googled on the Internet, for less than that. Nevertheless, what you are purchasing will not necessarily match your visuals, and unless you find a number of selections with the same style, your sound-track may seem disjointed.

"As far as library music is concerned, it's seductive, and sounds like a solu-tion at first, because of its very low price. Now they even put in the editing soft-ware music loops you can assemble to build your own soundtrack as a director," says Vincent. "I think it is a good idea that directors try to build their own soundtrack once in their careers, because they will see how much work and creativity are involved in scoring a movie, and that a real composer is needed to have a cohesive score that fits their visions. Library music is generic—even if you find a track that provides the right mood on a scene, it is more likely that the track will not follow the structure of your scene. Even worse, it will re-shape your scene the wrong way. Now, let's say you find a second track in a library that conveys the right mood for a scene. It is most likely that this second track will not be consistent in style, instrumentation, thematic idea, etc., with the first track. Going for library music for a soundtrack will sound like a patchwork of impersonal music, and eventually it will reflect on the movie and will lower its artistic and production value. This is like trying to assemble a cohesive movie out of different scenes from different movies."

Many newer composers are anxious for credits and will often score a fea-ture for the same price as, or less than, library music would cost, if not for free. The Internet makes it easy to receive links to music samples, whereas previ-ously tons of CDs or tapes would be sent by mail. When I look for a composer, I put an ad out on a production job Web site and, in one day, I typically receive over 100 submissions. Vincent is well aware of this type of competition.

"Now it's crazy—the second movie I scored here, the director received about 500 CDs from all over the world," Vincent recalls. "People writing from all over the world saying, 'If you take me, I'll move to LA,' although there was no money involved in the score. It was a deferred payment. So you can have 500 people sending their CDs, and you're going to lose a lot of time listening to them, but you can find a good composer because there are always good beginners. As a composer, you have to do the best job for every movie you work on, because this movie might take you to the next level. If the movie gets awards, that looks

good on the résumé you will send for the next project, and the director might make a second movie and take you with him or her to the next film because they're happy. And before anything else, you need to pay your dues and build a résumé."

Today, for obvious economic reasons, most scores are produced entirely on electronic equipment, compared to the days of live instrumentation. So, on low-budget movies, the composer has to compose the original musical score, and generate the various instrumental sounds. He must also arrange the different instrumental tracks to be able to mix them together at the desired volumes and record them onto a master disk or file. That implies owning a home studio equipped with the best samples and being able to master the latest technology in the field.

Bringing a Composer on Board

Since music isn't incorporated until post-production, many directors wait until a film has been entirely shot before bringing a composer on board. But like a special effects artist constructing a prosthetic head, a composer needs time to build music for those crucial moments in a film.

"Directors play a lot with deadlines, like they need a score in three weeks when they really have eight weeks," Vincent points out. "Then give the composer eight weeks, because the quality is going to be better. I understand they want some leeway to correct the music if they don't like it, but as much time as possible is the best. It's tough for low-budget filmmakers, because they have to work around other people's schedules, so it's pushed back easily. On low-budget movies, if the directors expect you to be flexible with their schedules, then they should be flexible with yours."

Like any segment of the filmmaking world, there are many aspiring composers, easily found on a host of Web sites, who will work for free in exchange for a credit. At the same time, composers must go through a tremendous amount of work to provide the results a filmmaker is looking for, and if the director has no clear idea of what type of music he or she requires, confusion and conflict between director and composer can easily arise. To assuage this possibility, Vincent suggests offering at least a bread crumb or two.

"A director should always reward the composer, even if it is as little as $20 or a CD coupon. First, it becomes a different relation, for the better, and second, it shows that the director respects and understands the composer's work and that he or she tries as much as he or she can to reward it," suggests Vincent. "And for a first-timer, it's great. Wow, you respect me in some way and

I see you trying. Filmmakers often say the same things, like that they're going to go to festivals, you're going to get exposure and get a copy, and a credit. Directors shouldn't say they give, as a reward, things that belong to a composer anyway, such as copy, credit, or music royalties. We know what we are supposed to get."

As with any other crew member, an agreement needs to be drawn up between the filmmaker and composer. There are many sample forms that can be Googled online if you can't afford an attorney. Some important issues that need to be addressed in the agreement include:

- Services—a description of the services that the composer will provide for the specific project, with the title of the project and production company or filmmaker's name given.
- Terms—the dates on which the composer will begin and end his services.
- Compensation—the amount the composer will be paid and when he will receive payments based on the completion of certain tasks.
- Expenses—the reimbursement of any reasonable, out-of-pocket expenses the composer will assume.
- Publicity—the filmmaker's right to use the composer's name, approved likeness (e.g., photos or video clips), and biography for the film's publicity.
- Rights—the owner's right to copyright the music and obtain copyright renewals, which may be the filmmaker or the composer, depending on their agreement. This also includes the right to change or use the music and reproduce, record, transmit, telecast it, etc.
- Screen Credit—how the composer will be credited in the film.
- Royalties—whether royalties will be paid for the music in addition to other payment, and if so, what percentage and how the funds will be dispensed to the composer.

The Collaborative Process

As discussed in earlier chapters, the making of any film is a collaborative process, one in which all those involved must coordinate their efforts with the director's vision in mind. When selecting a composer, it pays to consider how

the collaborative process will work for both of you, and thus try to find someone who is personable as well as skilled at his work. The greater the mutual compatibility in terms of personality and stylistic preferences, the more likely it is that the collaboration will be successful.

"Listen to the best music, then meet and talk with the people," Vincent suggests. "I think human relations are very important. You have to feel humanly very connected. On my second movie, I asked the director why he had chosen me, because I wanted to know how to do my marketing. What did I do wrong or say wrong or what did I do right? The first thing was, it was cheap. They selected seven composers and did an interview with the seven of them, and then they gave them five-minute cues to score. And before I went to the first interview, I had already downloaded the trailer that they had on the Web site, and I scored it anyway, and they were very impressed.

"I had just arrived in LA, and I was naïve and full of energy and really willing to score whatever; 'Wow, I'm scoring a movie.' So I had a very positive attitude and a lot of energy, and I was very funny. I'm lucky I was born like that. Some people have good energy, and some people are more business-oriented about money, money, money. For the filmmaker and composer, I say, don't speak about money until they choose you. The idea is to get the gig. Then afterwards, if you both want to work, you will find the solution. What's important is to know the person. If a director works with me, sometimes it's not just because of my music, it's because he knew me. I met him at a party, and we talked together, and he liked my CD and chose me because he knew me even though he probably received twenty CDs as good as mine, maybe hundreds.

"Try to know and talk to composers as humans. To choose, there's no recipe there. It's the right balance of everything. You don't have a recipe for the actor or anything and might make a mistake all the way through. For every project, do as much research as you can on the person that you hire. When you speak to the composer, try to see how he is in life and how the previous movie went, and what he did or didn't like about the process. I always ask the director what movies he prefers, to see if we're on the same page with movies I like, because at the end, it's about sensibility."

Filmmaker Michael Hein concurs:

"It's very, very important that you feel the composer is someone you can work with and direct and not get hassled if you say this piece of music is brilliant but it's not working for the sequence, it needs to be rewritten. Usually you're not paying them much money, if anything at all, especially if you're a

first-time filmmaker. You want someone you know you can work with and will take the time to really, really score a nice piece for you."

Logistically, the filmmaker needs to provide the composer with a timecoded copy of the final edited film. This way, the filmmaker can give specific timecode numbers of where he wants to include music and the composer can lay the music down over those scenes to test its effectiveness. The composer will then provide an initial demo of the music laid in over the timecoded version. Once reviewed, the filmmaker can request revisions as necessary. These days, media files make it easy to send demos back and forth via Internet, saving time and money. Once the filmmaker is happy with the score, the composer delivers the final music mix recordings on a format specified by the filmmaker. Within this process, discussion has to take place so that the composer has an understanding of the filmmaker's vision and musical preferences. Many times filmmakers will provide samples of music they think would work for particular scenes or the overall mood to give the composer a starting point. This can have an adverse effect if your expectations are too high, as TJ Nordaker points out:

"We gave our composer a bunch of temp tracks and an idea of the feel we were going for. We had themes from *Gladiator* and all these huge orchestra pieces. Once you get that in your head, when you're working with a composer you're not paying who is working with pro tools at home, the composer feels pressured to produce a score just as grandiose."

As a filmmaker, it is important to show appreciation for the time a composer has put into your soundtrack and recognize that the composer's independent ideas can enhance the total work, showing possibilities that a director may not have considered. Watching diverse films and television programs and paying attention to scores and musical techniques will make you that much wiser about options that are available.

CHAPTER 12:

Distribution Dread

"The expenses do mount up, and there is a lot more risk on the distributor's part than intuitively one would think."

—Alex Afterman, Heretic Films,
San Francisco

Most filmmakers, especially those just starting out, are intimidated by the marketing and distribution process, because it has nothing to do with film-making itself. Many wait until the film is finished even to think about how they will reach an audience or recoup expenses. To get their work seen, filmmakers need distributors who take a vested interest in their projects, and the sooner, the better, as the more "buzz" you can generate during the making of the film, the more people will be excited to see the project once it is done. Once you actually find a distributor who is interested, should you sign immediately in case a better deal doesn't come along? What types of distribution deals are available? Will the distributor effectively get your project out there? Will you ever see a dime from sales?

To understand the distribution process, it helps first to understand the marketplace.

What Is Your Market?

With the advent of so many ancillary markets, we hear all the time about the wonderful opportunities that are now available for independent films. But what specifically are these markets, and will your film find a place in them?

Ancillary markets are markets for feature films that have emerged as a result of new television technologies. These markets include:

- Home video (cassette or DVD rental)
- Pay cable (e.g., HBO, Showtime, and Cinemax)
- Network television
- Cable television
- Television syndication

Of the 450 to 500 feature films made every year, fewer than half receive a theatrical release, and the majority of those that do are major studio pictures. Therefore, independent films are dependent primarily on ancillary markets to get seen at all. Fortunately, ancillary markets are growing rapidly. According to the U.S. Bureau of Census, there are over 22,000 businesses in the United States that rent or sell home videos and DVDs, and this statistic does not include other outlets such as convenience stores, gas stations, and so forth.

Similarly, the number of films shown on pay TV has grown rapidly. The major pay channels, like HBO and Cinemax, run approximately 200 to 400 features a year, which compares to big screen theatrical releases of around 450 films per year.

A new ancillary market that hasn't quite been realized yet is the delivery of films via the Internet, a process that would enable customers to order films on demand.

In addition to ancillary markets, there are also territorial markets, both foreign and domestic. From a U.S. perspective, the domestic market includes the United States and Canada, while foreign markets include Europe, Australia and Asia, Latin America, Eastern Europe, and others (e.g., the Middle East [particularly Israel], South Africa, and Turkey). The specific foreign markets that purchase the most English-language films are Japan, Germany, Italy, the United Kingdom, Spain, France, Korea, Australia and New Zealand, Brazil, and Mexico.

Reaching ancillary markets and domestic and foreign markets is what a good distributor can do for you, as discussed more fully below.

Heretic Films

Heretic Films is a small DVD distribution company in San Francisco specializing in horror, cult, and exploitation films. The company was formed in 2003 to represent films that push the boundaries of their genres. They look for cutting-edge films that are scary, violent, gory, and sexy. Vice President Alex Afterman and his partners created Heretic Films because they believed there was a strong audience to support their business.

"If you're doing a documentary or romantic comedy, it's a lot harder to find the right people to get your film in front of," Alex explains. "With genre, they find you. There are conventions, there are Web sites, and there are absolute fanatics. So we discovered a need, and we discovered an easy way to find the people that were looking for the type of product we could make available.

"Initially, we pounded the pavement, going to horror conventions. We're actually going to go to less horror conventions in the future, just because we have a more established brand now. People have found us, and we've made a bunch of connections through these conventions that we can maintain with phone and e-mail. But when we were starting out, actually getting out there in front of fans and filmmakers was a tremendous advantage to us. We picked up on the types of films people really wanted to see, that they really liked or really didn't like. And these conventions are also hugely attended by filmmakers—filmmakers either looking for distribution for their films or aspiring filmmakers who haven't started making a film yet but want to. And we made a ton of connections that way. We got a lot of recognition, and we were in people's minds.

"There are a few labels that do go and set up tables at these conventions, but not a ton, so we differentiated ourselves in a major way by being there and showing the effort and showing the interest and in many ways being able to "talk the talk" with these people because we're fans. We could sit there and be geeks and then turn around and have a business sense of how the industry works. Frankly, the conventions are really fun. Horror fans are fun people. I used to go to science fiction conventions when I was a kid. They mostly appear in the day and go back to their rooms at night, while horror people like to go back to the bar."

What Does a Distributor Look For?

While "name talent" is not a prerequisite for selling a horror film (as discussed in chapter 9), many distributors like to see recognizable faces in order to boost sales.

"Frankly, it gives people a sense of legitimacy about your film if there's somebody in it that they've heard of in one way or another," explains Alex. "A horror movie that I recently bid and lost out on features Ron Jeremy, the porn star, as a psycho killer. And because Jeremy's in the movie, even though he doesn't have a lot of lines or screen time, it attracted a lot of attention."

"It's not necessary to gain the distribution deal, but name talent in the film immediately puts you at a bigger buy-out rate," agrees Michael Hein. "You can demand much more for your film if you've got Robert Englund (Freddy Krueger) starring in it."

In addition to high production values, creativity, and a fresh story, festival awards are a big plus for any distributor. How many times have you wandered the video store and seen titles you never heard of, but the credited awards on the cover made you curious enough to find out more about them? As discussed in the next chapter, film festivals are an excellent way to promote your film, not just to audiences but also for negotiating a better distribution deal.

Distributors also like to see filmmakers actively involved in marketing their own films. A distributor handles many products and thus has limited time to focus on yours. The more you collaborate to promote your film, the better for the both of you.

Finding the Right Distributor

There are plenty of Internet and print resources that list distributors and the genres they specialize in, such as Hollywood Distributors (available through the Hollywood Creative Directory online store at *www.hcdonline.com*). As Alex mentioned, distributors also attend film festivals and conventions to search for projects suited to their companies' mixes of offerings. However, filmmakers need to do their research and be savvy enough not to accept a bad offer, however tempting it may seem. Distributors know that filmmakers are anxious for a deal, and some are unscrupulous about ripping them off. Other distributors offer good exposure but no cash advance and minimal opportunity to make money after marketing expenses.

A distributor incurs many expenses to market a film, from designing and printing box cover art and DVD duplication costs to promoting a project to potential buyers. However, if there is no control over these costs, the filmmaker will never see a penny back on sales. Alex Afterman suggests looking to see if there is a cap on expenses in the contract, something Heretic Films includes in theirs.

"The expenses have to be receipted, and we have a set cap in our contract," explains Alex. "It differs a little from contract to contract, depending on the scope of the film and what we feel we need to do to market it. But our expense cap usually ranges from $20,000 to $40,000. We won't go over that without the filmmaker's permission, or if we do, we can't expense it back. And that is one area where filmmakers do tend to get exploited.

"Distributors will find expenses until they have enough not to hand over anything. Some distributors will try to expense back their overhead, which is somewhat of an industry no-no. There are all sorts of little tricks to get around expense caps. For instance, if you're running a print ad that costs $4,000 and features three films, some distributors will expense the entire $4,000 of the ad to each of the three films, so essentially they come out expensing $12,000 when they only spent $4,000. We don't do that. We would split that money in thirds and expense out to the three films evenly.

"So there are a lot of things distributors can do. I know of one label that is actually very frank in their pitch to filmmakers. They tell them, 'We're not going to pay you any money but you will get exposure, your film will get on the shelves, and people will hear about you when you're making a second film.' And for some filmmakers that's an attractive deal."

That type of deal was attractive to TJ Nordaker when looking for distribution for *The Janitor*.

"You hear horror stories all the time, but on your first feature, I think you kind of have to bite the bullet," says TJ. "Exposure, that's the main thing that we were looking for. It wasn't about the money, we just wanted to make sure it was available to everybody and you could go into stores and buy it. That was very important to us. The stores go through a trade magazine and look at what's coming out and pick what they want, so the distributor can only do so much, unless you're Paramount or something where they'll buy all of your product. It's trying to make a package deal and make it marketable so the distributor can do their job. I'm so new to the business side of things that I have no idea what to expect in sales, and I don't want to expect anything really, because I don't want to be let down."

"Something that I've learned through the process of producing and handling all the distribution for *Biohazardous* was that, regardless of the size of the company that distributes the film, regardless of their reputation, these types of films are usually licensing deals," says Michael Hein. "It's very rare these films get picked up for a complete buy-out. As long as on your first feature you only spent a few thousand dollars, if somebody wants to buy it out, sign that deal

immediately, because the reality of licensing a feature of any budget is that it's usually a 50/50 split of the take, and then, if you're lucky enough to get a cash advance, a lot of filmmakers forget that a cash advance is exactly that—an advance; it has to be paid back to the company. So if you're lucky enough to get $5,000 or $10,000 on a cash advance, you can pretty well be sure that's just about all the money you're going to see.

"Once the film goes into distribution on the back end and it's out, you start getting all these fees back to you. Not only does that money have to be paid back to the distributor, they'll start hitting you with half the cost of promotion. You usually have to pick up half the costs of any ads they take out and the manufacturing of the DVDs. So you get a $5,000 cash advance that has to be paid back to them. Then say you're spending $3.00 per copy for manufacturing, $1.50 per copy sold has to be paid back to them. And a lot of first-time low-budget filmmakers get into the situation where, although you never have to repay any actual money, you could wind up getting monthly sales forms back that show you actually owe them money still. The homework that a producer needs to do when deciding who to distribute with, really should be done by talking to filmmakers that have done business with these people. So do your research, see what that company's library is, then Google some filmmakers' names, see if you can find a contact, and try to contact the producers and directors of the films the distributors have done business with."

Before signing any deal, it is important to take time to review the distributor's strengths and weaknesses:

- Does your project fit well within the distributor's major offerings?
- What type of audience is the distributor trying to reach?
- How long has the company been in business?
- Is it willing to provide a cash advance?
- Does the distributor partake in conventions, exhibitions, and other promotional events?
- Are its products and marketing materials of high quality?
- Is there a cap on expenses?
- What is the length of the contract?
- What are the percentage breakdowns between the distributor and filmmaker?
- What experiences have other filmmakers on their label had?

The Distributor's Role

Distributors, like filmmakers, need to make a living, and, similar to agents or managers, they represent numerous clients. Distributors make a profit by distributing films or videos as sales or rentals, taking around 25 percent to 75 percent of gross profits. This percentage range often depends on the marketing effort and expenses the distributor plans to invest in the project, as well as the type of agreement.

"When I first got involved in the business and looked at sample contracts, trying to get my arms around how the business works, I had more of a filmmaker perspective—a filmmaker puts all their love and time and energy into making their film, and I thought, at that time, all the distributor was doing was putting it in stores and taking half the money," Alex recalls. "And after I became a distributor, obviously I started to see things differently. A distributor takes a lot of financial risk. We tend to take up all the production costs for the manufacturing of the DVDs and create the artwork. Another way that we try to differentiate ourselves as a company is that we try to pack our DVDs with extras and special features. In the process of courting a film or filmmaker, one of the first questions I ask is, what kind of footage do you have? Are there deleted scenes out there? Do you have commentary track? Did you make a small featurette? We really feel a DVD is a collector's item, and you really make your DVDs attractive to collectors when you pack them with extras, especially genre DVDs. Independent or B horror films—again, it comes back to the audiences there, wanting to be found, and they're collectors. And it makes it very attractive when they're packaged with extras."

The Janitor DVD also features a behind-the-scenes documentary, which is worth watching, especially scenes depicting special effects and topless sorority girl pillow fights in which the actresses are discussing the rationale behind their choice of lingerie.

"We have a feature-long documentary that chronicles the whole process," says TJ. "It's really nice for people who are getting into filmmaking, as it's a little training ground on what it's like to shoot on such a low budget. We covered everything. When I edited the documentary there were about fifty hours of footage. I think people will enjoy it as much as the movie. We added all the deleted scenes and everything that we could possibly throw in there."

"However, packaging with extras creates additional production costs," adds Alex. "Usually we have to edit down the extras, and we have to use larger DVDs or multiple DVD packs. So you pick up a lot of expenses in the production process. You pick up a lot of marketing expenses. When we first started putting

together contracts with $20,000 to $25,000 expense caps, I thought naively to myself, 'Oh, this gives us plenty of room to work, we'll never even get near this cap.' But marketing films takes money. Print advertising, screeners, mailings, manpower to do mailings. There is a lot of money that goes into marketing a film, and I think that I didn't have an appreciation for it, and I think a lot of film-makers don't have an appreciation for it.

"One of the things I did when I started was to read a book about how to self-distribute, so I'd know the steps that a filmmaker takes if they're going to do this on their own. And it's a lot of work and a lot of money. And in many cases with these types of movies, the marketing and DVD production effort can actu-ally cost as much or more than the film did."

This is true in many circumstances. The estimated production budget of *The Blair Witch Project* was between $25,000 and $60,000 while the marketing costs were around $25 million—about ten times the production cost. The movie grossed over $248 million worldwide, making it the most profitable movie of all time as far as the ratio of production costs to box office proceeds.

"And finally there is the risk of putting money in, and you don't know if it will sell and whether you'll recoup this money," Alex continues. "Another element is returns. The video business is a very retail-oriented business. If you make a sale with a retail store, they order however many DVDs they're going to order, and they're allowed to return them for a full refund if they don't sell. And stores, especially the mass merchandisers, are getting better and better at allocating every square inch of store space to the maximum potential. And the result of that is that the window they allow a DVD to sit on the shelf before they give up on it is shrinking. In fact, Best Buy has one of the smallest windows around. They tend to stick a film on a shelf, and if it doesn't sell in a week or ten days, they ship it back.

"Now, as a small label, you can get severely crippled by something like that. Thankfully this hasn't happened to us yet, but if Best Buy orders 18,000 DVDs, we produce 18,000 DVDs at the cost of about $1.25 per DVD, and if ten days later they return 17,000 of them, that's just a loss we have to absorb."

Specifically, a media distributor's role and expenses on top of general busi-ness operations include:

- Acquiring rights to distribute a product
- Packaging, including menu authoring, box art, labels, and any other inserts
- Mass duplication of the product for distribution

- Marketing and sales
- Publicity, including on Web sites, posters, press releases, and/or other forms
- Networking at festivals and conventions
- Inventory and shipping
- Tracking sales
- Returns and refunds if requested

The Filmmaker's Role in Distribution

Filmmakers also have a role in the distribution of their films. Although someone is now marketing your project, you and the distributor will both benefit if you stay involved in the process.

"We have gone to several major horror conventions in our year-and-a-half of existence, and when the filmmaker comes with us, that helps tremendously," says Alex. "Again, it's a fan-based business, and fans love to mingle with filmmakers. And when you're operating in the straight-to-video level, there's a real bond between the filmmakers and the audience, and fans love to meet and greet, chat with the filmmakers, and hear their stories. So we do expect our filmmakers to join us on things like that. We expect them to be ready to do interviews at any time. But we don't expect a ton out of our filmmakers. A lot of them want to hand off their last project and start working on their next one. So part of the allure of going with a distributor like us instead of self-distributing is the ability to move on to other projects. We don't expect our filmmakers to consider promoting the film to be the full-time job that we have, but we do expect them to be ready to promote, to give us a weekend or two at a convention, to be able to take telephone interviews. Things like that."

What to Look Out for in a Distribution Deal

Distribution agreements vary considerably, and it is obviously wise to have an attorney review one before adding your John Hancock. Following are the main components to consider in an agreement:

EXCLUSIVE/NON-EXCLUSIVE

A distributor may offer an exclusive or non-exclusive arrangement. An "exclusive" arrangement is one whereby the distributor has the exclusive rights to distribute the project so that the filmmaker is not permitted to sell

the project through any other distributor. Exclusives can be worldwide or limited to specific markets, meaning the filmmaker may use other distributors for the remaining markets. Typical limited arrangements include domestic exclusivity (limited to North America), international exclusivity (limited to countries outside North America), and territorial exclusivity (limited to specific countries).

A distributor is expected to provide royalty statements (usually semi-annually) that state the number of product sales and other details. Ideally, a third-party auditing company is verifying the numbers. At the very least, the agreement should state that the filmmaker has the option of requesting an audit at any time at his or her expense.

LENGTH OF A CONTRACT

Another consideration is the length of time during which a distributor may market your project before renewing or ending the contract. This period typically ranges from three to five years. A long-term contract can be beneficial with a solid distributor but a headache if the arrangement is not working. Both parties should have the right to terminate the agreement if responsibilities aren't met. The agreement should provide that if the distributor defaults on its obligations, the filmmaker has the right to terminate the contract and regain rights to license the film and possibly regain money damages for the default, depending on the circumstances. The distributor also has the right to terminate if the filmmaker is not meeting his or her obligations. In most cases, the request to terminate needs to be put in writing and there is a period, usually a few weeks to a month, before it becomes effective.

OUT-OF-POCKET EXPENSES

In order to market your film effectively, a distributor needs to spend money on box and poster art, mailings, catalogues, attending conventions and film festivals, print and Web site advertising, and other types of promotion. These "hidden" costs should be carefully delineated in the contracts and appear as expenses paid on royalty statements. A distributor may cover all the costs, especially if your percentage-share of profits is lower, or split the costs and deduct your share of expenses from the royalties. As Alex Afterman mentioned, it is wise to look for a cap in expenses and have expenses carefully delineated.

Self-Distribution

Some filmmakers choose to self-distribute, and some find themselves in that position when no distributors have expressed interest in their project. Despite its positive reviews, awards, and accolades, Larry Fessenden's *Habit* could not find a home. He shares his experiences of self-distribution:

"Despite good notices from our world premiere at the Chicago Film Festival, we were turned down by the festivals that can break out a film, and no distribution company would put out *Habit*. After a year of rejections, I cut six minutes, enhanced the sound, and blew up the 16mm negative to 35mm, bringing up the total cost of the film to two hundred grand. And I released the film theatrically myself through Glass Eye Pix with my partner Michael Ellenbogen. *Habit* opened in about thirty cities, and, as a point of pride, we never four-walled, which is to say, rented a theater. We went into partnership with each individual theater based on a commitment to advertise and the hope for good reviews. And the best part of self-distribution for me was designing the marketing campaign.

"When I was growing up, the print material associated with a film was an extension of the world of the film. I think this is why Kubrick was so involved in the publicity for his projects. We paid to have posters put up in New York and LA, and we made *Habit* trading cards—collect all eight.

"We never could decide if we should market *Habit* as a vampire tale or not, and ever since the first version came into my mind, I wanted to make a film in which the audience would make the discovery along with Sam (the main character). And this is the best way to experience *Habit*. But how do you market such a film? The marketing and distribution experience made me more sympathetic to exhibitors who can't risk playing an obscure film for long. It does come down to what an audience is going to pay to see. And if Hollywood entertainments are going to erode our expectations of what a film experience can be, then all of us, like Sam and *Habit*, will willingly be seduced into numbness."

As Alex and Larry remark, self-distribution can be an overwhelming challenge and expense for a filmmaker, though the filmmaker is able to retain all rights and returns. Sometimes, as in Larry's case, self-distribution is not a choice but a necessity. To self-distribute, the filmmaker needs to generate ads, negotiate with exhibitors, create and send press releases to newspapers and industry magazines and Web sites, contact potential buyers, create the box cover art, cover duplication and shipping fees, and create or find platforms through which customers can order the film, such as a self-produced Web site or via markets like amazon.com. This is not only very expensive, but also very labor-intensive.

At the same time, the digital age has drastically improved the ways in which to self-distribute. Many filmmakers are implementing the same strategies used by distributors. They are creating Web sites about their film with streaming video trailers and linking with other pertinent sites for publicity. Mass distribution companies like amazon.com also accept independent films on their sites for a percentage of profit, which is a fair exchange, considering they have great name recognition, your project is searchable, and they manage the orders in a professional way. Amazon.com has become a popular venue for self-distribution. They take 55 percent of the price you originally determine but their traffic is far higher than a personal Web site meaning that your project gets much more publicity plus they manage customer shipping.

Whether by choice or necessity, there are many issues to consider with self-distribution. Reading about or talking to others who have been through the process at networking events or through the Internet will certainly enhance your understanding of what is entailed.

Cinematographer Bud Gardner offers these words of encouragement on the distribution potential of horror films in today's market:

"I realize a lot of my things aren't mainstream movies and go straight to video, because it's hard to get movies into movie theaters in this day and age. It's the hardest thing, but it shouldn't be disheartening to young filmmakers, because there are other areas to sell your movie, like HBO and direct to video, and that's really where the market is, for Hollywood films as well. *Van Helsing* can be a bomb after putting so much money into a domestic release, but it'll make its money back in the after market. Horror films have a big following, and there's a good market for them in video chains and even in video stores."

CHAPTER 13:

A Market for Mayhem

"It's very important to be able to promote yourself, and that's
not something everybody can do. You've got to be able to stick
your neck out for the product you make in order to get it
noticed, because nobody else is going to promote it like you are."

—TJ Nordaker, Festival Director, Filmmaker

Whether you decide to self-distribute or find a distributor, you will still need to promote and market your film. Many filmmakers are creative sorts who despise the business side of the industry, but without making a concerted effort in this area, it will be difficult for your film to find an audience.

"It's very important to be able to promote yourself, and that's not something everybody can do," says TJ Nordaker. "I happen to love doing it myself. It's quite necessary to do that. You've got to be able to stick your neck out for the product you make in order to get it noticed, because nobody else is going to promote it like you are. We're still promoting *The Janitor*, even though we have a distributor. We're going to networking Web sites and stuff like that. *The Blair Witch Project* filmmakers massively hyped themselves on the Internet, and that's how they did so well at the box office. I thought that movie was real when I went. It was brilliant marketing, and that movie made a lot of money."

Effective marketing does not mean you have to spend a fortune on advertising. Publicity opportunities exist through the Internet, press releases, film

screenings, and at film festivals, conventions, and networking events. Ideally, money will have been set aside in the film budget to cover these costs, though of course that is much easier said than done. However small your budget, you can still find creative and effective ways to market your project. If you feel daunted by the process, think of it like making a film. You will have to go through pre-production, production, and post-production in a similar way, though instead of making a movie, you will be creating and implementing a campaign.

Pre-production includes the planning of your marketing strategy. This is much like writing a business plan as you have a product you want to sell. You need to think about your potential customers, whether that's a distributor or your potential audience, and the ways in which you can best reach them. How specifically will you reach them? What tools and strategies will you use to promote your film? The production stage entails the creation of the tools, such as Web sites, posters, press releases, screenings, and so forth. Post-production requires the delivery and execution of your tools and strategies, such as attending film festivals, sending DVDs and promotional materials to distribution companies, and so forth.

Your Marketing Campaign

What should be included in a marketing campaign for a film project? A film is essentially a product that a customer must be able to find, access, and make a purchasing decision about. Customers often make decisions based on recommendations or the look or sound of a product. How many times have you selected a film at the video store based on the box cover art and descriptions, knowing little about the movie itself?

A loyal customer base is built from a combination of product quality, reliability, and promotional effort expended on tapping into the customers' needs and desires. Each one of these components is required for a product to be successful. The failure of generic products in the 1980s demonstrated that customers are loyal to brands, and this loyalty is in part a result of promotion of the product. Also, the greatest marketing campaign will do you no good if you have a lousy product (or film). However, with all these elements effectively combined, there is a good chance for success.

THE TAGLINE

Products and services of a particular brand are often promoted with the use of images, slogans, or logos, so that the image, slogan, or logo becomes asso-

ciated in a consumer's mind with the brand. For example, when we think of Nike, we think of the slogan, "Just Do It." Companies consistently repeat their slogans, logos, and imagery to reinforce the association in our memories and tap into our emotions so we will immediately associate such identifiers with the brand. Similarly, images, slogans, and logos can be an effective tool for filmmakers and can form the foundation for the design of the rest of the campaign.

Most movies have taglines or slogans, which are catchy short phrases that capture the tone of the film and peak our interest. The tagline is repeated in posters, on Web sites, and in other promotional materials, so that, as with an image or slogan for a company, we start associating it with the film.

MEMORABLE TAGLINES

Psycho (1960)	"Check in. Relax. Take a shower."
Jaws (1975)	"Don't go in the water."
Halloween (1978)	"The night HE came home."
Alien (1979)	"In space no one can hear you scream."
Poltergeist (1982)	"They're *here* . . ."
Poltergeist II:	
The Other Side (1986)	"They're *back* . . ."
Seven (1985)	"Seven deadly sins. Seven ways to die."
The Cable Guy (1996)	"There's no such thing as free cable."
The Blair Witch Project (1999)	"Everything you've heard is true."
The Amityville Horror (2005)	"Based on a True Story"

Imagery also plays an important role. Films that have consistent imagery, color, and style across all their materials have a much more cohesive sense of identity than those using diverse or generic imagery. This consistent imagery repeats itself in various ways on all promotional efforts, again helping to brand the film. *The Blair Witch Project,* with its distinctive stick figure icon, is an excellent example of consistent imagery across all promotional items. In a sense, the icon has become the film's logo. Likewise, we associate a knife-wielding pumpkin with *Halloween* and the red-toned moth with *Silence of the Lambs* as these images have been visually repeated across all forms of promotion.

WEB SITES

Only fifteen years ago, few filmmakers knew or understood how to use the Internet. Today, utilizing the Internet is virtually a necessity. Web sites allow you

to showcase movie clips, posters, production stills, credit lists, and whatever your imagination conceives, whereas in the "old days," bulky, expensive press packages had to be individually prepared and mailed.

"I love the Internet," says Larry Fessenden, who promotes his films and company, Glass Eye Pix, on the Web. "I was lucky enough to have a Web site almost right away when it became available. I always like minutiae, the tchotckes and the posters, and all the things associated with a film. When I was a little kid, I was always aware of the posters that went along with the movies. I loved how things were presented and the way you can tease an audience. So I find the Web to be a great place. It's really like an attic. If you looked at my site, you would see, all crammed in there, all the types of things I've been involved with. Part of that is not to boast but to say, look at all this, and there's this little trinket. It's fun to be able to have an online attic on the Internet, and then you can rant a little. You feel like you have a voice, because we all feel voiceless in this crazy environment of the 21st century."

"The Web site obviously is one of the best tools you have," advises special effects artist Anthony Pepe. "And whether it's an amazing Web site or lackluster Web site, even if you're just starting out, it's all about the image you project. I get a lot of people calling me up who want to become interns at my company. They think I own like a giant glass building in Manhattan running this company. In all honesty, it's just me and a little space I have, but when you present it in a larger way, people are going to think, 'Oh my God, this is like a real studio type situation.' It's all how you project yourself."

OTHER INTERNET PUBLICITY

Until *The Blair Witch Project* was released, most films were marketed on the Web through Flash games, trailers, and on-set photos and diaries.

Viral marketing, an Internet-based commercial advertising technique that encourages users of a specific product or site to tell a friend to create a "buzz," is gaining popularity in the film world. According to SearchCRM.com, viral marketing is "any marketing technique that induces Web sites or users to pass on a marketing message to other sites or users, creating a potentially exponential growth in the message's visibility and effect." Like a physical virus, this marketing virus is transmitted via Internet to various Web hosts or people. Virals can be film clips, games, or links that are strategically placed on Web sites, blogs, and mailing lists. Once an Internet user forwards the link or clip to a friend, it's "gone viral" and will continue to spread, potentially reaching millions

of other users. This network-enhanced word-of-mouth tactic has been successfully used to create a buzz on films such as *Serenity*, a movie inspired by the cancelled science fiction television series *Firefly*. Five creepy "unofficial" video clips of scenes that don't actually appear in the film but help explain the behavior of a main character emerged on the Internet and soon went viral.

Independent filmmakers are taking advantage of the Internet in other ways, such as garnering online interviews, posting links on Web sites, and making use of chat rooms.

"Since we had very little money for distribution, the Web became our only way of promoting the film to a large group of people," says Stevan Mena. "Posters and fliers are great to hand out if your movie is playing that night within walking distance, but otherwise I found them absolutely useless. We got our best promotion through doing interviews and talking it up online. When Fangoria posted on their site that we had won the Long Island Film Festival, our Web site received over 10,000 hits within a day. Suddenly, people from Indiana were emailing us wanting to see the film. That was amazing, and we got calls from festivals and distributors, too. It legitimized the film."

ART APPEAL

Art is an important part of your film's identity, whether you are self-distributing or going through a professional distributor, as it is a critical part of your Web site, posters, box covers, post cards, email announcements, press kits, and so forth. The quality and creativeness of your artwork is also a reflection of your film's potential.

"If I see a site that is extremely well-done, it shows me a sense of creativity and gives me some confidence that the film will show that same kind of creativity," says Alex Afterman.

In the same way a distributor creates an appealing box cover for a film, you should think in terms of what will appeal to your audience when building your Web site or making promotional pieces. Much of the imagery will come from the film, though these days with "behind-the-scenes" selections expected on DVDs, production stills or documentary footage will enhance your package. This is one reason it's a good idea to have a still photographer on set during production.

"Have a really good still photographer on set and take high quality stills on the production," Alex advises. "If you include stills in your press kit, it will help attract distributors. It's amazing how much easier it is to get editorial

coverage if you have good stills that a magazine or Web site or newspaper can run alongside the review. It's one of the best things you can do for the success of your film."

FILM FESTIVALS

While Web sites and online promotions count for a lot, there is nothing like face-to-face communication. Often labeled as a "who-you-know" business, the film industry is very much about relationships in every sense of the word, from the people you trust for your project to those who can help push it through the final gate. While stories and myths about nepotism in the industry abound, it is more a world where jobs are rarely advertised but are more often referred, and communities are very tightly knit. Thus, building relationships in more than a perfunctory way is invaluable.

Film festivals, conventions, and other relevant networking functions are an ideal way to build these relationships. "I don't go to all the festivals all over the country, but I do go to a fair share, and I sure keep track of every film that is showing in every festival, because festivals have Web sites too," says Alex. "And that's how I hear about a lot of films, and if I start to see the same film pop up at several festivals, that's a sign to me that a lot of people are interested in it."

"They provide the ability to generate excitement. Since festivals are also a market now, at least the big ones, that's how you get exposed, especially in foreign markets," adds Larry Fessenden. "With DVD, there's hope to get distribution, especially genre fare. I've been very fortunate with these things called scare flicks which are very small low-budget movies."

Film festival submission prices can be a bit steep, not to mention the cost to attend, but at least the ability to participate is changing with the technology as now DVD copies are readily accepted instead of the expensive film prints required in the past. If your film is accepted into a festival, it is worth attending. In addition to the possibility of receiving an award, film festivals are a great networking opportunity and a chance for you to see how audiences react to your film on the big screen.

It is important to strategize the best festival opportunities to make the trip worth it. It helps to promote, publicize, and advertise your project ahead of the festival. In other words, create a buzz by building hype in publications and through word of mouth so that audiences, and distributors, will have a desire to see your film. There will be countless other filmmakers attending, so you need to be aggressive about your intentions and research who will be attending

and who you want to approach. You can even try to contact these folks ahead of time to set up meetings at the festival.

INSIDE THE NEW YORK CITY HORROR FILM FESTIVAL

Michael Hein and Anthony Pepe are the creators of the New York City Horror Film Festival, which they claim is the largest of its kind in the country. They came up with the concept after attending a film festival in Los Angeles for a screening of Michael's film *Biohazardous*.

"From producing *Biohazardous* and trying to get into these film festivals, I thought, where are all the horror festivals?" says Michael, the festival director. "At the time there were only two of them in the states, and they were both in LA. First of all, I couldn't believe the capital of the world, New York City, didn't have a horror film festival. So right off the bat, I said I'd love to do something in New York City that's never been done before. And if it's successful, wow, wouldn't that be great. So *Biohazardous* was in a screen festival in LA. I'd hired Anthony for the film, and a fast friendship grew out of that. At the time we were in pre-production with another film. I said, 'When I get back to New York, we're going to start this festival.' I said, 'Anthony, there's going to be a lot of work. What do you think?' He said, 'Let's do it.' We got back to New York and immediately started calling people that I knew about sponsorships, about venues, about what my bank account could handle. And it just kind of blossomed from there."

"So in the first year, we just put our funds together, we got a couple of quick sponsors, and we opened in October at the Tribeca Film Center in downtown Manhattan," adds Anthony, the festival's programming director. "The reason we chose downtown Manhattan was because of 9/11. We wanted to bring some business back down. We're both native New Yorkers, and it was a big issue for everybody. And it took off beyond our wildest dreams. We never expected to make it through, and now we're in our fourth year. We didn't think we were going to make it through the first year. But the fan base grew, the celebrities started coming in, the movies started coming in, sponsors started coming in—to the point where it's become the number-one horror film festival in the country. Totally amazing, and it just blows our minds, as we're only in our fourth year now. We were so nervous in the first and second years about how we were going to start and how we were going to get everything ready, and now we just breeze right through it, no problem. The first year, we gave George Romero a lifetime achievement award. The second year it was Tom Savini, the third year it was Tobe Hooper."

New York City Horror Film Festival Poster.

For Michael and Anthony, the festival is about much more than showing off exciting films.

"A big thank you has got to go out to the Independent Film Channel (IFC), who supported us from day one," says Michael. "It added a lot of juice to the festival, as horror festivals really just don't seem to get the serious sponsorship, and for what reason I don't know. But if you don't have serious sponsorship that gives you dollars to let the entire country or world know that you're having this festival, none of the distribution companies or acquisition people are going to care. At a lot of smaller film festivals, they don't seem to understand that a film festival should be about the filmmakers. A film festival shouldn't be about having some screenings, you had a great time, and that's it. A film festival is about gaining distribution, about gaining good word of mouth, about gaining press for features that help with distribution. And that's a major focus of the NYC Horror Film Festival, but also one of the reasons I think it's grown so quickly. Because we work very hard with distribution companies to let them know not just about us in general, but also about the films that are going to be there and about the fact that we put them in contact with the filmmakers. One of the films from a previous year called *The Great American Snuff Film* was not screened at any other major festival that I know of. And I had put the filmmaker in touch with Barred Holes Entertainment and said, 'You've got to see this film,' and they wound up loving it, repped the film, and it has just gotten picked up by Lions Gate."

The festival is competitive, with awards given in eight categories that are judged by a panel of professionals in the industry. They evaluate the entries on a number of criteria, including acting and production values.

"There are films that we can't program, if their skills just aren't up to it yet," says Michael. "We get films from high school kids that may be shot on the weekend with their friends all the way up to studio projects. Even though I'm the festival founder and director, I don't handle it like Hitler. I'm not a dictator

and say this is in or this is out. And even though Anthony is the programming director, he doesn't have the final say either. We have a selection committee. We get different filmmakers and producers to watch these films with us. Then, we have a second round of screenings. If the film makes it to the final round, then we make our final decision. Getting into a festival, you should think about it like going into the production itself. Good acting. Take the time to cast your film. Don't just put your cousin in there because she wants to be an actor. So we like good, solid acting and production values. Regardless of what your budget is or what format you had to shoot on, you can still bring high production values if you take the time to do it right. And an original story. I think if you submit the film specifically to our festival, I can't speak for the others, but the more original, the better, because generic horror films usually just come off as that."

Film festival award criteria are similar to what many distributors are looking for in a potential product, such as production values, creativity, and audience appeal. In the NYC Horror Film Festival, categories include Best Feature Film, Best Short Film, Best Cinematography, Best Special Effects, Best Actor/Actress, Best Screenplay, and Audience Choice. The judging panel includes filmmakers and representatives of *Fangoria* magazine and *Hacker's Source* magazine.

As mentioned earlier, receiving an award is also a big attraction for a distributor and many of the NYC Horror Film Festival winners have found distribution, as announced on the festival Web site.

Worldwide Horror Film Festivals

ANOTHER HOLE IN THE HEAD, SAN FRANCISCO, CA
www.sfindie.com

Presented by the San Francisco Independent Film Festival, this fest offers a week's worth of vampires, werewolves, ghosts, zombies, monsters, madness, and mayhem.

CREEPFEST, LOS ANGELES, CA *www.creepfest.com*

A celebration of darkness in films, animation, music, art, and cyber-creation. Showcasing and awarding new and up-coming filmmakers, writers, musicians, and cyber-creeps, in the areas of horror, mystery, Goth, sci-fi, erotic animation, and all things dark and delirious.

DEAD BY DAWN, EDINBURGH, UNITED KINGDOM
www.deadbydawn.co.uk
Established in 1993 and a member of the European Fantasy Film Festivals Federation, Dead by Dawn provides horror fans in the UK an unrivalled opportunity to enjoy the very best the genre has to offer. The festival accepts features and shorts.

EERIE HORROR FILM FESTIVAL, ERIE, PA
www.eeriehorrorfest.com
Due to public demand, the Great Lakes Independent Film Festival created a separate festival in 2004 to give filmmakers and writers in the horror/sci-fi genres a venue to have their work showcased to people in the industry and to share their hard work with other filmmakers and fans.

EXOFEST, EDMONTON, CANADA — www.exofest.com
ExoFEST is a traveling film festival that takes place in various cities in North America: Edmonton and Calgary, Alberta; Detroit, Michigan; and Minneapolis, Minnesota. The first ExoFEST took place in October 2002. Throughout its history, ExoFEST has screened approximately 200 films, twenty North American premieres and eight world premieres.

FAUX FILM FESTIVAL, PORTLAND, OREGON
www.fauxfilmfestival.com
A film festival dedicated to spoofs and mockumentaries.

FANTASIA FILM FESTIVAL, MONTREAL, CANADA
www.fantasiafest.com
Since its inception in 1996, FanTasia has been showcasing the exciting, innovative, and individualistic examples of contemporary international genre cinema, with an emphasis on unveiling films very rarely seen in North America.

FARGO FANTASTIC FILM FESTIVAL, FARGO, ND
www.valleycon.com/filmfest.html
This film festival celebrates film, video, and other media with connections to science fiction, fantasy, horror, adventure, thrillers, and all other "fun" genres.

FEARLESS TALES GENRE FEST, SAN FRANCISCO, CA
www.fearlesstales.com
This annual film festival celebrating independent filmmaking is held in San Francisco and additional surrounding Bay Area cities.

FESTIVAL BUENOS AIRES ROJO SANGRE (RED BLOOD), BUENOS AIRES, ARGENTINA
http://rojosangre.quintadimension.com
An international festival of fantastic, bizarre, and horror films.

FRIGHTFEST, LONDON, ENGLAND *www.frightfest.co.uk*
A premier UK sci-fi and horror film festival established in 2001.

HAUNTED NEWPORT HORROR FILM FESTIVAL, NEWPORT, RI *www.hauntednewport.net/horrorfilmfest.htm*
Based on the interest in her book, *Haunted Newport*, local writer/editor Eleyne Austen Sharp first proposed the idea for Haunted Newport Week in 1996. After five years as a month-long event, Haunted Newport became a 10-day celebration in 2005 and celebrates Halloween while helping to extend the Newport tourism season. The event includes a horror film festival.

NEVERMORE HORROR & GOTHIC FILM FESTIVAL, DURHAM, NC *www.carolinatheatre.org/nevermore/index.html*
Established in 1999, NEVERMORE offers an extraordinary lineup of first-run domestic and international horror, gothic, and fantasy films.

NEW YORK CITY HORROR FILM FESTIVAL, NEW YORK CITY, NY *http://www.nychorrorfest.com/*
The first horror film festival in New York and the largest in the country; discussed in detail in chapter 13. It boasts prestigious "lifetime achievement" honorees and makes a concerted effort to hook up buyers and sellers.

LEEDS ANIME HORROR FILM FESTIVAL, LEEDS, ENGLAND *www.leedsanimehorrorfilmfestival.co.uk*
This festival offers free screenings of films gathered from different distributors, film houses, and independent directors in Japan, the Far East, and America, including titles from famous eastern film distributors such as MVM and Hong Kong Legends.

PHILADELPHIA FILM FESTIVAL, PHILADELPHIA, PA
www.phillyfests.com
Founded in 1991, the Philadelphia Film Festival has become one of the fastest-growing film festivals in the country. Part of the festival includes Danger After Dark, a celebration of genre film from around the world.

SALEM AMATEUR HORROR FILM FESTIVAL, SALEM, MA
www.salemfilm.com

With a history shrouded in fear, due to the tragic witch trials of 1692, the city of Salem, Massachusetts recently began celebrating its past during the Halloween season with the inclusion of the Salem Amateur Horror Film Festival.

SCREAMFEST, LOS ANGELES, CA *www.screamfestla.com*

Screamfest was formed in August 2001 by film producers Rachel Belofsky and Ross Martin, in order to give filmmakers and writers in the horror and sci-fi genres a venue to have their work showcased to people in the industry.

SHOCKERFEST, MODESTO, CA *www.shockerfest.com*

Sponsored by the Fireside Foundation, Inc., a California nonprofit corporation dedicated to the promotion and perpetuation of independent film. Proceeds from the festival provide film funding and scholarships and assist the development of independent films.

SHRIEKFEST, LOS ANGELES, CA *www.shriekfest.com*

Established in 2000, Shriekfest is dedicated to getting horror, thriller, and sci-fi filmmakers and screenwriters the recognition they deserve.

SITGES INTERNATIONAL FILM FESTIVAL, SITGES, SPAIN
www.cinemasitges.com/uk

The Sitges International Film Festival of Catalonia is the number-one fantasy and horror film festival in the world. With a solid 37 years of experience, the Sitges Festival is a stimulating universe of encounters, exhibitions, presentations, and screenings of fantasy films from all over the world.

WEEKEND OF FEAR, ERLANGEN, GERMANY
www.weekend-of-fear.com

A ten-year-old festival celebrating obscure, horror, science fiction, and crazy comedy movies.

Building Your Fan Base

As a growing number of horror film festivals and conventions attest, there are legions of fans out there devoted to the genre. The fans, like the filmmakers, usually have a lifelong fascination with horror and particularly avid ones can be found aplenty, creeping around horror conventions. Conventions are a great place to get in touch with fans, find out their likes and dislikes, and promote your movie.

The Internet has helped connect fans and filmmakers in unique ways, from interchanges on filmmakers' Web sites, blogging, chat rooms, and an abundance of fan sites with eclectic reviews of lesser known releases. Tapping into this fan base, whether via Internet or in person at conventions and festivals, is an obvious asset for the new filmmaker. Understanding your potential fans' loyalty, support, and affection for your unique type of projects is also critical to winning their respect.

Horror Conventions

WORLD HORROR CONVENTION, LOCATION CHANGES ANNUALLY *www.whc2006.org*

World Horror Convention includes Guests of Honor, readings from renowned horror authors, and panels ranging from getting published to horror movies. The convention includes a film festival for both professional and independent work.

HORRORFIND WEEKEND, BALTIMORE, MARYLAND *www.horrorfindweekend.com/state/maryland*

Features horror film celebrities, horror writers, Halloween seminars, and supernatural speakers as well as a giant dealer's room, rare movies, and many special events.

CINEMA WASTELAND, DAYTON, OHIO *www.cinemawasteland.com*

This three-day Movie and Memorabilia Expo showcases classic films, drive-in movies, independent films, and shorts. There are also special events such as Q&A sessions, live movie commentaries, guest talks, and movie introductions.

THE INTERNATIONAL CLASSIC MONSTER MOVIE CONVENTION AND EXPO, LOCATION CHANGES ANNUALLY *www.creepyclassics.com/bash.html*

This convention celebrates the best of classic monster movies with guest speakers, movie screenings, a wax museum, and more.

summary

Today, making a horror film is a possibility for anyone with access to a digital camera and editing software. However, making a *great* horror film requires an understanding of the genre and filmmaking process, a creative and unique script, careful planning, a team of seasoned professionals surrounding you, effective promotion of your film, and decent distribution opportunities.

There are pros and cons of making a low-budget horror film. Despite the challenges, the pros are very encouraging—low-budget horror films have a built-in fan base, cost very little to make, do not require Hollywood name talent, and have many distribution outlets available.

Any great horror film starts with a great story. Crafting one is a long-term process, but the quality of the final product—your film—depends on the important up-front work up of developing original and unique characters, plots, and themes, building suspense, and remaining budget-conscious during every step of the process.

Once your script is ready, significant time should be devoted to pre-production planning. What you do in this early stage will have a direct impact on the production and post-production stages.

As you make your film, don't expect everything to proceed smoothly; countless things will go wrong. Filmmaking is a learning process, and each film you create will add to your knowledge for that next film still in your head. You will learn much from the people in your crew, who bring their own experiences and to a project. Working collaboratively, communicating, and being open to other people's suggestions will only enhance your original ideas.

Special effects are fundamental to horror filmmaking. An experienced special effects person is a great asset to your project. It's necessary to bring an effects person on board early to allow adequate time for designing and, if possible, testing your effects ahead of production. Technology has changed the effects world in many ways, so having knowledge of the types of effects are available at low cost, whether mechanical, visual, or a blend of both, is invaluable.

Although Hollywood name talent is not required, name recognition can help in the distribution of a film. If your story includes a scream queen, selecting one with experience and her own fan base will help generate excitement for your project. Knowing how to direct talent, especially in special circumstances such as fight scenes or highly charged emotional moments, is a special skill that requires openness, collaboration, and an understanding of the actors' process for bringing your characters to life.

Editing, scoring, and sound mixing your film will undoubtedly take longer than the actual filming. An experienced editor will have an objective point of view and know how best to cut your film to build tension, suspense, and shock. A composer will bring your film to life, enhancing the mood and thematic elements and intensifying important moments.

Once your project is complete, you need to find an audience. Your masterpiece will not see the light of day without marketing and distribution efforts. Fortunately, many straight-to-DVD and cable opportunities exist now, and finding out about these opportunities is a mouse-click away on a search engine. The trick is to come up with an ingenious marketing plan and then choose a distributor wisely so you don't lose all rights to your film and never see a penny. Read terms and contracts carefully, spend time finding out about a distributor's history, and talk to other filmmakers whom they represent.

As is patently clear from the film professionals in this book, making horror films is a passion. If it's yours, go out there and make your movie . . . we're all waiting to see something new. As Alfred Hitchcock, the godfather of horror, once said, "Give them pleasure—the same pleasure they have when they wake up from a nightmare."

about the author

Sara Caldwell, Amphion Productions, Santa Clarita, CA

Since forming Amphion Productions in 1991, Sara has written and produced over 200 film, television, documentary, Web site, and satellite teleconference projects for national and international clients, specializing in healthcare and education. She has worked in producer roles on various horror projects and produced the short horror film *Crawlspace*. Sara teaches film production and theory courses at the College of the Canyons in Santa Clarita, CA. She is a frequent workshop leader, guest speaker, and screenplay consultant.

Sara has authored several other books for Allworth Press, including *So You Want to be a Screenwriter: How to Face the Fears and Take the Risks* and *Jumpstart Your Awesome Film Production Company*. She has received many awards for her work including first place in the Illinois/Chicago Screenwriting Competition and a Golden Apple in the International Educational Film/Video Festival.

Prior to forming Amphion Productions, Sara was a writer/producer for MotionMasters of Charleston, WV and at WORLDNET Television in Washington, DC where she wrote and produced live satellite video teleconferences for audiences in Africa, the Middle East, and East Asia.

Sara lives in Valencia, CA with her children, Dylan and Chloe.

about the participants

Alex Afterman is the co-founder and Vice President of Heretic Films, an independent DVD label specializing in cult, horror, and genre films founded in 2003. As label head Alex is responsible for managing everything from acquisition of new titles for distribution, coordinating the creation of key art, authoring, production and replication of the DVDs, logistics, and marketing and publicity, including determining advertising budget, co-op purchases, and handling all media relations. Prior to founding Heretic Alex spent five years working as a Product Manager and Account Manager for various new media companies including Internet content syndication company iSyndicate and Web-based real estate portal LoopNet. In addition to his responsibilities for Heretic Films Alex has also co-produced the documentary *24 Hours on Craigslist*, theatrically released in late 2005 and due on DVD in 2006. *www.hereticfilms.com*

Katherine Bulovic is a freelance production designer in Los Angeles. Some of her film and television credits include *Secret History of Religion* (Morningstar Entertainment), *Cubicle the Musical* (7 Engine 7), *Easy* (Over Easy Productions), *Gangland* (Dominion Entertainment/Universal), *Blasphemy* (Mean Doggie Productions), *Crawlspace* (Amphion Productions), and *Southern Man* (e-Motion Pictures). She has also worked as a set director, scenic artist, and assistant on many projects including *Dennis the Menace* (Warner Bros.), *Normal Life* (New Line Cinema), and *The Public Eye* (Columbia Pictures). She has worked as a production designer and set decorator on numerous theater productions at venues such as the Stella Adler Theater in Hollywood and Steppenwolf Theater in Chicago. Katherine received her BFA from the School of the Art Institute in Chicago and was a theatrical design major at Columbia College, also in Chicago.

Ross Byron Boughton is an editor, producer, and camera and sound guy primarily working in the New York film scene. He is also a teaching consultant on Final Cut Pro at the Harlem Media Center. Ross has over seven years of freelance editing experience with feature credits that include *Dead Serious*, *Good Humor*, *Fender Saves the World*, and *Don't Get Me Wrong*. Other credits include *Woulda Shoulda Coulda* for Silverfox Video, Candies, Mercedes Benz, Caribbean Joe, and American Express. Ross completed his MA and AA at Berklee College of Music in Boston, an MA and BA from the University of Massachusetts in Amherst, MA, and also attended Roger Williams College in Bristol, RI.

Randy Cabral has been working in the motion picture business for thirty years and is the special effects coordinator for the *Charmed* television series. A handful of his other special effects credits include *The Fugitive*, *Amistad*, *Hook*, *Dante's Peak*, *The Indian in the Cupboard*, *Casper*, and *Back to the Future Part II*. He describes how the industry has changed over the years: "When I first started working at the studios, they looked just like you would think a studio would look with elephants going down one street and cowboys going down another. A lot has changed since those days."

You no longer work for just one studio, such as Universal, Disney or Warner Bros. Most of the departments no longer exist; in fact, the only studio that has a real special effects department is Paramount. We are now like independent contractors, working for all of the studios. It is still a lot of fun though, even more so looking back once all the work is done."

Larry Fessenden, founder of Glass Eye Pix in Manhattan, is the writer, director and editor of the award-winning art-horror movies *Habit*, *No Telling*, and *Wendigo*. As an actor, he appears in Scorsese's *Bringing Out the Dead*, Steve Buscemi's *Animal Factory*, Brad Anderson's *Session 9*, Jeff Winner's *You Are Here*, and stars in *Habit*, the Sundance pictures *Margarita Happy Hour*, and *River of Grass*. Since 2003, Larry has been involved as producer on numerous projects, including James Felix McKenney's *The Off Season*, Ti West's *The Roost*, David Gebroe's *Zombie Honeymoon*, Jeff Winner's *Satellite*, and *The Escape Artist* from Michael Laurence. For twenty years, he's been making movies his way: low-budget, independently financed pictures about addiction and self-delusion, ecology, medical ethics and the consequences of living a life out of balance. Not that all of his films are earnest: Larry is best known for his loose trilogy of horror pictures, and they're as much a twist on the genre's usual fare as everything he's done. *No Telling* (1991) is an animal rights-oriented riff on mad-scientist stories. *Habit* (1997) rethinks the delicate dependence between vampires and victims, while the icily anxious *Wendigo* (2001) mixes Native American myth and Deliverance-style backwoods anxiety. Together, the trio take three major horrors—bogeymen/vampire, man-made monster, shape-shifter—and rethink them in fiercely unusual ways. In 1996, Larry won the 'Someone to Watch Award' for *Habit*, a $20,000 cash unrestricted grant sponsored by Swatch and given annually to "an independent filmmaker who has demonstrated unique vision and talent and has not yet received recognition." *Habit* also garnered him Best Director in the 1997 Independent Spirit Awards. *www.glasseyepix.com*

Bud Gardner is a New York City–based cinematographer who specializes in low-budget independent films. As a member of the NABET and IATSE local 52 trade unions for nineteen years, Bud has worked on over 1,000 commercials and industrial films as gaffer, assistant cameraman, and director of photography. He has owned Northern Lights, Inc., a lighting and grip rental company, since 1982. Bud has done the lighting and/or cinematography for numerous low-budget independent films in the New York City area, including *The Shore*, *Atrocity Exhibition*, *Biohazardous*, *Made Men*, *Gratuitous Sex*, and *Dead Serious*. He has shot title sequences for Spike Lee's *Mo' Better Blues*, the Coen Brothers' *Hudsucker Proxy*, Barry Sonnenfeld's *For Love or Money*, and Bernard Bertolucci's *Little Buddah*. His advertising clients include: Lintas, Young and Rubicam, Grey Advertising, Ogilvy and Mather, Grandview, PT Katina, and Rama Advertising.

Vincent Gillioz was born in Geneva, Switzerland and studied jazz at Berklee College of Music in Boston, earning a dual bachelor's degree—summa cum laude—in Film Scoring & Performance. After graduating, Vincent returned to Switzerland to study composition and orchestration at the Geneva Conservatory of Music. He moved to Los Angeles in 2001 and assisted renowned film composer

William Goldstein (*Fame*, Wes Craven's *Shocker*). A recipient of many scholarships, Vincent was selected for the 2002 Sundance Institute, where he had the opportunity to work under the supervision of noted film composers Edward Shearmur (*Sky Captain & The World Of Tomorrow*), Rolfe Kent (*Sideways*), George S. Clinton (*Austin Powers* trilogy), Mark Isham (*Men of Honor*), and Thomas Newman (*American Beauty*), among others. Vincent won the Gold Medal for his score to *Sonata* at The Park City Film Music Festival, and the SUISA Prize for Best Score (*God's Waiting List*) at the 58th Locarno International Film Festival. *www.vincentgillioz.com*

Michael Hein, president of Moodude Films and founder of The New York City Horror Film Festival, has been working in the New York City independent film scene for over fifteen years. Through his company, Michael has produced six films—*Dead Serious*, *Biohazardous*, *Oldham County*, *Cyclone*, *This Is How My Brother Died*, and *Killer Shorts*—two of which have gained worldwide distribution. In 1999 Michael wrote, directed, and co-produced his first feature film, *Biohazardous*. To date the film has screened at eight international film festivals and received six "killer-B" award nominations, two B Movie Film Festival Awards, and Director's Choice for best special effects at the Oklahoma Bare Bones Film Festival. Michael is the director of The New York City Horror Film Festival. He recently completed the vampire feature film *Dead Serious* and is co-producing and hosting his own national cable show *Killer Shorts* for Fangoria TV.

Brandon Johnson graduated from the University of Wisconsin with a BFA in Comprehensive Theatre and currently lives in New York City. Some film credits include *The Notorious Bettie Page*, *Rave On*, *Rick*, *Invisible Evidence* (shot entirely on location in Guatemala), and *Little Erin Merryweather*. Most recently he was the host of *FOX Soccer USA* and *Rally America* and also completed work on *One Life To Live* as the recurring character Michael McBain. His other television credits include *Law & Order: Special Victims Unit*, *The Guiding Light*, MTV's *Face Biters*, as well as a number of national commercials. Brandon is currently the lead host of NYC TV's *Cool In Your Code*. In his off time Brandon can be found playing with his two bands ILL ROCKET and PROGRESS, doing yoga, writing, and enjoying Central Park.

Lisa Morton's career as a professional writer began in 1988 with the horror-fantasy feature film *Meet the Hollowheads* (aka *Life on the Edge*), on which she also served as associate producer. For the Disney Channel's 1992 *Adventures in Dinosaur City*, she served as screenwriter, associate producer, songwriter, and miniatures coordinator. She has also written numerous episodes of the animated television series *Sky Dancers*, *Dragon Flyz*, and *Van-Pires*. Her first book, *The Cinema of Tsui Hark*, about the legendary Hong Kong director/producer of such classics as *Peking Opera Blues* and *A Chinese Ghost Story*, was recently published by McFarland, who also published *The Halloween Encyclopedia* in 2003. Her television movie *Tornado Warning* was chosen by the Pax cable station to launch their 2002 fall season, and 2005 saw the release of three horror films, the vampire thriller *Thralls* (aka *Blood Angels*), the mutant shark story *Blue Demon*, and *The Glass Trap*, about genetically altered fire ants.

Lynn McQuown is a freelance costume designer in the Los Angeles area. In theater she has worked for the Colorado Shakespeare Festival and Actors Ensemble and

Nomads Playhouse in Boulder, Colorado. She also designed and coordinated costumes for the Purple Rose Theater in Michigan (actor Jeff Daniels' theater company), CalArts, Santa Clarita Rep's Shakespeare in the Park, Canyon Theater Guild, Pasadena City College, and the College of the Canyons Vital Express Center for the Performing Arts. She has also worked in film and television on projects such as the television pilot *Lily's Light*, Miss Absolut (Absolut Vodka), and Extreme Poker Challenge. She also works for Palace Costume and Prop Company, a professional rental house exclusively for industry professionals where she pulls costumes for film and television, does costume research and illustration, and organizes and catalogs stock.

Stevan Mena began making short films at the age of eleven in his backyard with his brother and friends. While they outgrew it, he never did, and ever since has dedicated his life to pursuing his dream of becoming a feature filmmaker. *Malevolence* marks Stevan's debut feature. But the road has not been easy. Many years were spent trying to raise the financing for the project, and when that was done, many more years of struggle lay ahead, from lost locations to crew mishaps and car crashes (that weren't in the script). One actor even suffered a brain aneurism during filming (who has since fully recovered). Since much of *Malevolence* was financed on credit cards, Stevan was forced to wear many hats to save money, including writing, producing, scouting locations, financing, casting, catering, directing, editing, and scoring his own music. When asked what he looks forward to doing next, his answer is "someone else getting the coffee in the morning."

TJ Nordaker was born and raised in Seattle, Washington. A self-professed horror buff and film fanatic, his interest in B-movies began at an early age when he and junior high school chums would have film-fest sleepovers and rent the most obscure genre films they could get their hands on. TJ enrolled at the Seattle Film Institute where he studied the technical side of the filmmaking process. As a side project he created the number-one viewer rated, darkly humored, and controversial cable access show *Sickening Conceptions* under his production company Stalemate Productions. *Sickening Conceptions* was ultimately picked up for distribution on DVD. In 2002, TJ made the leap to Los Angeles where he has created short films and edited portfolios for established actors and comedians. TJ hooked up with his partner Andy Signore to create Cleankill Productions. Together they co-wrote and co-directed *The Janitor. www.janitormovie.com*

Anthony Pepe is a special makeup effects artist for the film and television industry under his company, Demonic Pumpkins FX. In 2000 he met Michael Hein of MooDude Films and worked on Hein's first feature, *Biohazardous*, receiving a makeup award from the B-Movie Film Festival. Since then, Anthony and Michael have worked on numerous feature projects, including *Dead Serious*. Together they instituted the New York City Horror Film Festival. As the Program Director, he is in charge of over 300 horror film submissions and reviews each year. His film and television credits are long and varied. He worked for several years running the makeup department for Sudden Impact Entertainment Company's Madison Scare Garden, a full-blown seven haunted house attraction from which he gave a makeup demonstration and interview with *NBC's Today Show* with Matt Lauer and Katie Couric, and was showcased on ABC, NBC, CBS, FOX, and NY1. *www.demonicpumpkins.com*

Isabelle Stephen is rising B-movie scream queen from Montreal, Canada. Her horror film credits to date include *Escadron Delta III and IV*, *The Thrill Gasp Stranglers*, *The Shychopath*, *Sins of the Father*, *The Stalk-Holme Sin-Drome*, *Tales From The Crapper*, *Cold-Blonded Murder*, *Vampire Sisters*, *The Other Side*, *Dirt Bag*, *Le Cycle Infernal*, *Second Cup*, *From Skin to Scream Orion X*, *Descend into Darkness Part 2*, *Sandman*, and *Demon of Temptation*. She has also been profiled in a documentary about the popular seduction cinema actress, late-night cable TV sensation and B-movie starlet Misty Mundae. *www.isabellestephen.net*

Julie Strain reinvented herself at the age of twenty-eight and has since been merchandised on everything from a Zippo lighter to an interactive CD-ROM, all carefully orchestrated and planned by her and husband Kevin Eastman, publisher, producer and co-creator of the *Teenage Mutant Ninja Turtles*. Julie has been featured on television, in music videos and laser disc, and has appeared in *Penthouse*, *Femme Fatales*, *Vogue*, and *Cosmopolitan*. Julie's recent media endeavors are as the main character in the Columbia/Tri-Star $15 million animated feature, *Heavy Metal: F.A.K.K.2*, and she co-produced and starred in the art house Irish family dramatic comedy *St. Patrick's Day*. Julie also played Judge Julie on Playboy TV's *Sex Court*. *Premier Magazine*, observing her list of credits in movies such as *Fit to Kill*, *Dark Secrets*, *Day of the Warriors*, and *Sorceress*, to name a few, proclaimed her officially "Queen of the B Movies." *www.juliestrain.com*

Resources:
suggested Reading
and web site Links

Web site and Magazine Links

Buried—www.buried.com
A horror buff's Web site that includes information and links for horror movie and fiction reviews, interviews, conventions, editorials, contests, and more.

Cinescape Magazine—www.cinescape.com
Mania Entertainment is a media company that focuses on genre entertainment, such as science fiction, fantasy, horror, animation and comic content through multiple delivery platforms, which include conventions, publishing, fan clubs, retail, gaming, original content, and the Internet.

Dark Side Magazine—www.darksidemagazine.com
Britain's longest running horror and fantasy magazine.

Dread Central - www.horrorchannel.com
The Horror Channel gives independent filmmakers a voice and avenue to have their features shown and get some exposure. Their goal is to create the first and only twenty-four-hour cable and satellite network dedicated to the horror genre and to become the branded television gateway for the underserved horror fan base. Plenty of great information on this site.

Fangoria Magazine—www.fangoria.com
Probably the most famous horror zine out there that now boasts Fangoria TV (aka FangoTV), a new outlet for horror filmmakers to find an audience. The site is chock full of great "insiders" information.

Film Threat Magazine—www.filmthreat.com
Film Threat Magazine was created in 1985. For over a decade Film Threat has covered cult films, underground shorts, alternative films and independent features. Film Threat's mission is to champion the increasingly popular explosion of independent and underground films. The magazine was retired in 1997 but lives on in cyberspace. An Internet presence since 1996, Film Threat ranks in the top one-half-percent of all sixty million Web sites on the Internet, according to Alexa.com.

Hammer Films—www.hammerfilms.com
Hammer is one of the great names in screen entertainment and produced some of the best-known films in the horror genre, including *The Curse of Frankenstein*, *Dracula*, *To the Devil a Daughter*, *The Curse of the Mummy's Tomb*, *The Devil Rides Out*, and *Dracula Has Risen from the Grave*.

Hell Horror—www.hellhorror.com
A site for horror, fantasy, and science fiction fans with content on all aspects of horror movies, games, books, serial killers, unexplained mystery, demonology, vampires, werewolves, and promotional services.

Horror-Asylum—www.horror-asylum.com
The Horror Asylum was launched in 2001, and includes a fully searchable movie database containing nearly 4,500 titles, a movie, DVD, literature, music, and video game review section that contains over 570 reviews, daily horror-related news articles, exclusive interviews, horror television guides, competitions, and even a horror hunt service.

Horror Movie Fans—www.horrormoviefans.com
A chat forum for fans to give their personal reviews and discuss their favorite horror movies.

Low Budget Horror Film Society—http://lbhfs.proboards18.com
A forum for discussing all aspects of low-budget horror film production, finding cast and crew, film reviews, and more.

Pretty-Scary—www.pretty-scary.net
A unique site for women in horror by women in horror.

Rue Morgue Magazine—www.rue-morgue.com
Web site for one of North America's first magazines devoted exclusively to horror. It includes features, regular columns, and insightful editorials on everything related to the genre.

Scream Queen—www.screamqueen.com
This site features the "hottest ladies in horror" with a different scream queen featured monthly. An excellent resource for finding a scream queen for your next project.

Shock Cinema Magazine—http://members.aol.com/shockcin/
This magazine is a guide to cult movies, arthouse oddities, drive-in swill, and underground obscurities. Each issue is crammed with movie reviews, interviews and original poster art.

Troma Entertainment—www.troma.com
Since 1974, Troma has produced, acquired, and distributed more than one thousand feature films from all regions of the globe and in all genres. Best known for the *Toxic Avenger*, Troma has helped bring to the world the best and brightest talents in entertainment, ranging from master Japanese animator Hayao Miyazaki (Troma's 1993 release of his *My Neighbor Totoro* was the first Miyazaki movie to be given a wide American theatrical release) to American humorists Matt Stone and Trey Parker (Troma's 1996 release of their *Cannibal! The Musical* would shine the spotlight on their incredible humor almost two years before their deserved success with *South Park*).

Books

Corman, Roger with Jerome, Jim. *How I Made A Hundred Movies In Hollywood And Never Lost A Dime.* Da Capo Press, September 1, 1998.
Independent filmmaker Corman (*The Beast*; *The Little Shop of Horrors*) helped launch directors Francis Ford Coppola, Peter Bogdanovich, and Martin Scorsese, and actors Jack Nicholson, Bruce Dern, and Sylvester Stallone. In this revealing autobiography, written with the coauthor of *Papa John*, Corman tells amazing tales of shooting full-length films in mere days with budgets under $100,000, and states his conviction that cinema is a fusion of art and money—which explains, he believes, why Americans do it so well.

Dipaolo, Michael. *The Six Day Horror Movie: A No-Nonsense Guide to No-Budget Filmmaking.* McFarland & Company, November 4, 2004.
In his book, Dipaolo describes how he produced a low-budget horror film in six days on a budget of $5,000. The book breaks down the production of his film through a detailed diary, emphasizing the most important aspects of achieving a successful production.

Hantke, Steffen. *Horror Film: Creating and Marketing Fear.* University Press of Mississippi, December 1, 2004.
A book of essays focusing primarily on how film technology, marketing, and distribution effectively create the aesthetics and reception of horror films.

Harmon, Renee and Lawrence, James. *The Beginning Filmmaker's Guide to a Successful First Film.* New York: Walker & Company, June 1, 1997.
Combining classroom theory with practical, hands-on advice, Renee Harmon and Jim Lawrence offer helpful tips and detailed guidelines on choosing the right kind of project, from a slice-of-life video to a documentary or short dramatic film; writing a script that can be produced within the resources and time available; assembling film financing and preparing a budget; casting the right actors and making the most of the rehearsal process; and selecting and entering the more than 35 film festivals that showcase new films nationwide.

Harper, Jim. *Legacy of Blood: A Comprehensive Guide to Slasher Movies.*
Critical Vision, May 15, 2004.
 The "slasher" movie is the bloodiest incarnation of the modern horror film, tainted by criticisms of misogyny, yet remaining—on and off—a box-office draw for 30 years. Combining in-depth analysis with over 200 film reviews, *Legacy of Blood* is the most comprehensive examination of the slasher movie and its conventions to date, from *Halloween* and the notorious *I Spit on Your Grave*, to *Scream*—the redefining genre hit of the '90s—and beyond.

Hutchings, Peter. *The Horror Film.* Longman, June 21, 2004.
 This book considers the reasons for horror's disreputability and seeks to explain why, despite this, horror has been so successful.

Jancovich, Mark. *Horror, the Film Reader.* Routledge, December 29, 2001.
 This book brings together key articles to provide a comprehensive resource for students of horror cinema. Mark Jancovich's introduction traces the development of horror from *The Cabinet of Dr. Caligari* to *The Blair Witch Project*, and outlines the main critical debates.

Jaworzyn, Stefan. *The Texas Chainsaw Massacre Companion.* Titan Books (UK), March 1, 2004.
 Jaworzyn gives the inside story of *The Texas Chainsaw Massacre*, one of the most successful, controversial, and influential horror films ever made, as well as in-depth coverage of the three sequels, various documentaries, and other movies also based on the life of serial killer Ed Gein.

Koster, Robert. *The Budget Book for Film and Television.* Oxford: Focal Press, February 27, 2004.
 This guidebook is intended to help both the novice and the experienced producer to create and fine-tune their budgets. Based on the top budgeting software packages, Movie Magic and EP Budgeting, this book takes the reader through each line item in the budgeting software and describes the background for that item, how it fits into the overall production, and any issues or pitfalls that may arise from it.

Levison, Louise. *Filmmakers and Financing: Business Plans for Independents.*
Oxford: Focal Press, December 5, 2003.
 With its easy-to-follow format and its step-by-step approach, this book teaches readers how to create a business plan that can be presented to a potential investor. Whether you want to create a plan for one film or multiple films, this unique guide bridges the gap between the filmmaker and the business.

Litwak, Mark. *Contracts for the Film and Television Industry.* Silman-James Press, 1994.
 A no-nonsense guide to the complex world of contractual law in the entertainment industry.

McDonagh, Maitland. *Filmmaking on the Fringe: The Good, the Bad and the Deviant Directors.* Carol Publishing Group, September 1994.
 Contains interviews with American exploitation directors who worked during the 1970's, 80's, and 90's.

Russo, John. *How to Make Your Own Movie for $10,000.* Zinn Publishing Group, February 1, 1995.
 Independent filmmaker John Russo gives a step-by-step account of how to make a professional, marketable movie for under $10,000 in this practical and informative book. Using his own self-financed film *Midnight 2* as an example, Russo reveals the triumphs and pitfalls inherent in microbudget production while also providing extensive insight into sales and distribution.

Russo, John. *Making Movies.* Dell, February 1, 1989.
 Veteran independent filmmaker Russo outlines the moviemaking process step by step, from developing an idea to selling the finished product, including sections on budgeting, pre- and post-production, raising money, technical aspects of shooting and editing, and dealing with agents, lawyers, and distributors. There are interesting interviews with other successful indies like George Romero (with whom Russo started *on Night of the Living Dead*), Lizzie Borden, Sam Raimi, Tom Savini, and Tobe Hooper, and an appendix of sample contracts.

Russo, John. *Scare Tactics.* Dell, July 1, 1992.
 Authored by the screenwriter of *Night of the Living Dead*, this book is an insider's guide to making your first horror movie, from concept to saleable package. Winner of a national award for Superior Fiction.

Schneider, Steven. *Fear without Frontiers: Horror Cinema Across the Globe.* Fab Press, August 2003.
 What do foreign horror films look like? What are their conventions, their aesthetics, their sources of inspiration? Who are their major actors, directors, and monster-stars? And what are the dynamics of cross-cultural horror exchange? In this groundbreaking volume, an international collection of leading authorities on the World Horror Cinema phenomenon addresses all of these questions and others besides, seeking to answer them through a mixture of historical background, comparative analysis, and close readings of particular films and subgenres.

Silver, Alain & Ursini, James. *Horror Film Reader.* Limelight Editions, April 2001.
 This book includes collection of essays that uncover the roots of the horror genre and explain its wide-ranging, indestructible appeal.

Warren, Bill. *The Evil Dead Companion.* St. Martin's Press, December 1, 2000.
 Acclaimed film critic Bill Warren gives a no-holds-barred behind-the-scenes tour of the making of *The Evil Dead*, *The Evil Dead II: Dead By Dawn*, and *Army of Darkness*, including exclusive interviews with key cast and crew; rare and previously unpublished photographs, story-boards, and concept sketches; harrowing tales of hardship, discomfort, and practical jokes; and much more.

Wells, Paul. *The Horror Genre.* Wallflower Press, September 15, 2001.
 This book offers a comprehensive introduction to the history and key themes of the genre.

Stern, Bret. *How to Shoot a Feature Film for Under $10,000 (And Not Go to Jail).* Collins, September, 2002.
 This book offers encouragement and advice for filmmakers without funding.

index

Books from Allworth Press

Allworth Press is an imprint of Allworth Communications, Inc. Selected titles are listed below.

Jumpstart Your Awesome Film Production Company
by Sara Caldwell (paperback, 6 x 9, 208 pages, $19.95)

Making Short Films
by Jim Piper (paperback, 7¾ x 9¼, 272 pages, includes DVD, $24.95)

Producing for Hollywood, Second Edition
by Paul Mason and Don Gold (paperback, 6 x 9, 288 pages, $19.95)

Hollywood Dealmaking: Negotiating Talent Agreements
by Dina Appleton and Daniel Yankelevits (paperback, 6 x 9, 256 pages, $19.95)

Documentary Filmmakers Speak
by Liz Stubbs (paperback, 6 x 9, 240 pages, $19.95)

Technical Film and TV for Nontechnical People
by Drew Campbell (paperback, 6 x 9, 256 pages, $19.95)

The Filmmaker's Guide to Production Design
by Vincent LoBrutto (paperback, 6 x 9, 216 pages, 15 b&w illus., $19.95)

The Health and Safety Guide for Film, TV and Theater
by Monona Rossol (paperback, 6 x 9, 256 pages, $19.95)

Shoot Me: Independent Filmmaking from Creative Concept to Rousing Release
by Roy Frumkes and Rocco Simonelli (paperback, 6 x 9, 240 pages, 56 b&w illus., $19.95)

Making Independent Films: Advice from the Filmmakers
by Liz Stubbs and Richard Rodriguez (paperback, 6 x 9, 224 pages, 42 b&w illus., $16.95)

Directing for Film and Television, Revised Edition
by Christopher Lukas (paperback, 6 x 9, 256 pages, 53 b&w illus., $19.95)

Get the Picture?: The Movie Lover's Guide to Watching Films
by Jim Piper (paperback, 6 x 9, 240 pages, 91 b&w illus., $18.95)

Please write to request our free catalog. To order by credit card, call 1-800-491-2808 or send a check or money order to Allworth Press, 10 East 23rd Street, Suite 510, New York, NY 10010. Include $5 for shipping and handling for the first book ordered and $1 for each additional book. Ten dollars plus $1 for each additional book if ordering from Canada. New York State residents must add sales tax.

To see our complete catalog on the World Wide Web, or to order online, you can find us at
www.allworth.com.